THE COMPLETE

PHOTOGRAPHY

CAREERS HANDBOOK

SECOND EDITION

THE COMPLETE PHOTOGRAPHY CAREERS

HANDBOOK • SECOND EDITION

EXPANDED TO INCLUDE ELECTRONIC IMAGING

by

George Gilbert

THE PHOTOGRAPHIC ARTS CENTER
New York, New York

PUBLISHED BY:
THE PHOTOGRAPHIC ARTS CENTER
163 AMSTERDAM AVENUE
NEW YORK, NEW YORK 10023
(212) 838-8640

Susan P. Levy, Editor

ISBN: 0-913069-41-8

LIBRARY OF CONGRESS CATALOG CARD NUMBER: 91-51236

Library of Congress Cataloging-in-Publication Data

Gilbert, George, 1922-
 The complete photography careers handbook : how you can find the
right career in photography : expanded to include electronic imaging
and more / by George Gilbert. -- 2nd ed.
 p. cm.
 Includes bibliographical references and index.
 ISBN 0-913069-41-8 : $19.95
 1. Photography--Vocational guidance. I. Photographic Arts
Center. II. Title.
TR154.G54 1992
770'.23'2--dc20
 92-66
 CIP

Distributed by: Career Press
 180 Fifth Ave.
 Hawthorne, NJ 07507
 1-800-CAREER-1
 FAX 201-427-2037

Acknowledgements

The author is especially indebted to a number of specialists who contributed significantly to the contents of this book: Pamela Diamond who originally proposed its concept; Robert S. Persky who later suggested its expansion into electronic imaging; N. M. Graver of Rochester, New York for current data on the medical photography scene; Lt. Albert Coli of the Nassau County Police Department; the many representatives of the military services who offered line-of-duty assistance; Harry Amdur, formerly President of Modernage Photographic Services, Inc., New York; Marvin Weil of the United Nations Library; the Trade Show Bureau Staff of New Canaan, Connecticut; Ms. Linda Cohen of the Art Institute of Chicago; Bill Kipp of the Illinois Telephone Company Photography Section; Jim Bowman of Pratt & Whitney for assistance in updating changes in the world of military photography and for his liaison with Steve Fletcher at Pratt & Whitney.

I especially wish to thank the team of Ferry and Pearl Fine of Brooklyn, NY for gracious consultation and hands-on assistance with the desktop publishing areas that make this book a reality. Finally, I wish to express appreciation to unnamed photographers, friends and associates whose magnanimous support assured the accuracy of this introduction to the multidimensional world of photographic careers.

New York, N.Y.

George Gilbert

TABLE OF CONTENTS

INTRODUCTION

There's more than enough room for you in the photographic industry. There's a real need for you, especially if you have learned at the hands of a good master, have shown that you have a bit of get-up-and-go, and have proved some talent with your camera or in the darkroom.

At first I knocked on doors of every building in New York where studios were located. I knew no one. I had prepared for my career only by making prints with an enlarger made from a twelve dollar camera which I used during the day to make portraits of my neighbor's children.

My first job in photography was in a top New York advertising illustration studio. Two years in that job more than doubled my salary and readied me for a role in the U.S. Army as a WWII photography instructor. Army photography and some commercial studio experience led to my first public relations photography business which, in turn, led to documentary photography for a number of newspapers and weekly and monthly periodicals.

Pictures I have taken helped families on a mountainside in the barren West to get water. Pictures I have taken have illustrated travel shows, sales presentations, and, in a few cases, have earned awards and even acceptance in prominent American museums. But it all started with a first job in a studio where I had no friend and could offer only a box full of amateurish prints to prove my enthusiasm.

I thought I was fairly bold in knocking on strange doors and asking to meet studio owners, but when I researched the book I learned about one young woman, for instance, who set across the country from her own hometown. She put herself on one photographer's doorstep and with the only job application she made, she won her first position in the world of photography. I also met a young man who has the knack of endlessly getting short-time jobs as an assistant in the leading studios of his city. He holds these jobs just long enough to support himself for a later time when he does his

own photographic work. When he needs cash again, he puts the telephone to work to line up his job for the next weeks.

In this book you'll discover areas of specialization that open the doors to photography for a person who would only be happy as a self-employed photographer. Some of these careers start with merely ownership of today's popular 35mm camera and basic shooting skills. No darkroom experience is necessary.

If you have decided that you must seriously consider a photographic career, you will find encouragement in these facts:

· There are over 125,000 employed and self-employed photographers.

· Half of all photographic work is by portrait and wedding photographers whose studios are found throughout the country.

· One photographer in five works for commercial operations serving local businesses.

· One photographer in four works for industry, making over $25,000 per year.

· One photographer in fifteen works for some government agency, with a minimum starting salary of $17,000 per year. A few raises and a few years of experience almost doubles that salary.

· An army of technicians, administrators, editors, photographic scientists, and business people with photographic interests and expertise are required to produce the films, cameras, lenses, papers, publications and other elements that make up the photographic industry.

From one who has worn many hats suited to the careers described in this book, one suggestion: fill your camera bag with enthusiasm, and replenish it continuously with practical behind-the-camera experience. Nothing clears the mind faster than putting your head under the darkcloth and viewing the world upside down.

The Education of a Photographer

Studying with a master is still one of the best ways to learn photography. It was also the first. The first American student of photography was the painter and scientist, Samuel F. B. Morse, who later invented the telegraph. Morse was in Paris in the spring of 1839, and there he learned of the miracle of the daguerreotype from the painter-experimenter Louis Jacques Mande Daguerre himself. Returning to America, after the August revelation of the chemical secrets, Morse taught the skill to an astonished group of fellow artists and their apprentices.

One of the apprentices was upstate New Yorker Mathew B. Brady. Brady supported himself by making protective leather cases for daguerreotypes by day; in the evening he studied photography with his patron, Morse. By 1846 Brady was acclaimed one of the nation's foremost practitioners of the new art of photography. He eventually opened two studios in New York City and one in Washington, D. C. before he undertook to direct the photographic teams who documented the Civil War battles, the work for which he is best known today.

Apprenticeship remained the only dependable way to learn about photography until the turn of the century. By the 1870s, though, the field had grown to the point that the National Photographers Association was calling annual conventions where new technology and practice could be freely discussed in an atmosphere of education and progress. Yet in 1877, in order to learn the practice of photography for an upcoming vacation, George Eastman had to pay a local photographer one hundred dollars for private lessons because there was still no actual school available to him.

By 1901 the Illinois College of Photography was offering enrollment to the general public, promising, "You learn the Art-Science of modern photography in all its branches in three to six months." The full course fee was one hundred dollars, room and board three to ten dollars per week.

Fifty years later it was possible to attend a few two-year trade schools on the East and West Coasts to learn the fundamentals of photographic practice in classes taught by men and women with actual studio and field experience. Also, interest in photography was beginning to manifest itself in some college art departments. And yet, for the most part, working photographers at newspaper offices still learned camerawork after years of "hypo-splashing" (assignment to darkroom duties), and cameramen in commercial studios spent their introductory years loading plate holders, moving lights and backgrounds, and sweeping studio floors (sometimes an onerous chore after, say, four tons of sand had been dumped on the studio floor to simulate a beach for a thirty-minute session with bathing-suit models).

The road to camera handling started in the messenger room, the darkroom, and the broom closet for an entire generation of photographers.

Following World War II the government-paid veterans' training programs encouraged private schools of photography to rapidly expand and gave America its first generation of formally trained photographic technicians for commerce and industry.

Colleges and universities as a result of requests for courses in basic photography as well as the allied courses which extended this foundation knowledge, expanded their curricula. The burgeoning fields of photography, cinematography, and videography first gave birth to new departments, then new buildings, and finally added the dignity of scholarship with fellowships, doctorates, chairs, and honors programs. The handful of institutions with more than a basic course or two in photographic practice has evolved into over 1,000 institutions of higher learning where training as a photography professional can be structured as meticulously as that for a specialist in maritime law or political science.

Approximately 80,000 college students were enrolled in photography and related courses in 1970; by 1977 this number had doubled to over 162,000. Today, almost

100,000 students graduate annually from colleges offering associate, bachelor, masters and doctoral programs in cinematography, still photography, and graphic arts.

Choosing A College

The "MIT" of photography is unquestionably RIT, Rochester Institute of Technology, located in the upstate New York city of Rochester, where photography's technological development and science have been centered ever since the twenty-year-old George Eastman rented a factory loft there in 1880.

The growth of Eastman Kodak generated numerous photographic support industries in the Rochester area. And out of the city's overall need for engineers, chemists, optical science wizards, and similar geniuses came the determination to establish in Rochester a study center that would graduate the executives and leaders of tomorrow's photo-related industries. Graduates of RIT are actively engaged at all levels in every niche of the world of photography.

RIT is essentially a center for scientific exploration of the sources of photographic practice, uniquely offering study programs in the theory of chemistry, optical sciences, and manufacturing processes for film and paper, along with the day-to-day practical camera-handling procedures in all of the various systems of cameras. Students at RIT study history, technology, administration, and research, along with class-and-field-work in the solving of photographic problems. A class in darkroom procedure at other typical American photography schools only synopsizes what would be a year of studied endeavor at the RIT level. Students of the typical practical school of photography are readied for immediate employment in the field; RIT students are readied additionally to engage in photographic research that will provide tomorrow's film for X-ray photography and lenses suited for the Space Age.

RIT has been ranked among the nation's top 200 universities by both *The New York Times Selective Guide to Colleges* and *Petersen's Selective Guide to Colleges*. The

editors of *Studio Photography*, *Darkroom Photography* and *Technical Photography* magazines have each featured the school in major profiles as a center which is, "giving its students some of the best career preparation possible."

As far as other colleges and universities that teach photography are concerned, as of 1990 one could study photography with a nationwide faculty pool of nearly four thousand full-time faculty members in forty-nine states, the District of Columbia, Puerto Rico, and in most provinces of Canada. The largest states, New York and California, naturally have the most colleges and universities offering a variety of photography courses. But residents of such smaller or distant states as Alaska, Nevada and Hawaii can opt for basic photographic courses in local institutions.

Size is not always a major factor; some smaller institutions have real strengths. The photography department of the University of New Mexico, for instance, once structured around Beaumont Newhall, former curator of photography at the Museum of Modern Art and longtime head of the George Eastman House, continues as a dominant educational and publishing center for photography. This specialty has attracted many other scholars and researchers to the university. Another tiny school, the Fashion Institute of Technology in New York City, has a small but powerful photography department. This school uniquely zeros in on the special needs of fashion-related studio practice, which get only minimum classroom time in any other school of photography, public or private.

Major Regional Centers

The University of Southern California at Los Angeles is the RIT counterpart in the West, centering on motion-picture art and technology in the manner that RIT locks in on camera, lens, chemistry and related aspects of still photography. USC at Riverside CA maintains the fine California Museum of Photography. California also has extensive

photography programs at California State University, at Long Beach and at the City College of San Francisco.

The University of Colorado at Boulder teaches photography in five departments: Communications, Education, Film, Fine Arts, and Journalism and Media.

Southern students have a choice between course offerings at the University of Georgia in Athens and the Art Institute of Atlanta.

Midwesterners will find a giant array of courses at the Illinois Institute of Technology in Chicago and at Illinois State University and Southern Illinois University at Carbondale. Indiana State University at Terre Haute provides a large number of photography programs within the structure of its art, printing, and science departments. The University of Iowa and University of Northern Iowa have art, industrial design, and journalism or media departments providing everything from basic photography instruction to motion-picture production.

The University of Texas at Austin is one of the foremost study centers for the history and practice of photography. It houses the world's most acclaimed collection, that of Helmut Gernsheim, author of the most definitive history of photography extant. He discovered the photograph considered by most to be the world's first photograph (Niepce - 1826 or 1827). It too is at the U of T.

Today most schools offer a few photography courses within the fine arts or industrial technology department; these courses will be adequate for a basic introduction to camera handling and elementary darkroom skills.

It's easy to determine which colleges or universities have a basic program of interest to a person seeking photography as a secondary area of education that would complement one's primary effort to become a scientist, teacher or businessman. Determine from the school catalogue if more than three departments offer photography as programs within their disciplines. Next, if the school has a large photographic

program, review that curriculum to note if it is specifically oriented toward motion pictures, television, fine arts, or science and theory.

It's possible that the kind of photography program you seek may be on a more practical, basic level. Your college time may be better spent in your major discipline; the practical aspects of photography can be learned in an intensive six-month or one-year private school program taken independently.

A career in photography as a camera handler or darkroom person does not require a college education. On the other hand, if one is to be a teacher of photography, or a photographic administrator or photo curator at a museum or historical society, the MFA degree (Master of Fine Arts) is a necessary goal . The choice of a college which offers a degree program culminating in MFA honors can only be determined by careful study of the college catalogues or interviews when visiting colleges during the selection period.

Private Photography Schools

Photography's most practical aspects are intensively studied in three basic groups of schools: residential private schools offering one- and two-year programs; photo and art centers; and workshop schools providing one- and two-week programs, usually at resort areas. The latter also schedule groups that combine vacation travel with personal guidance in photography by a skilled professional.

There are further educational opportunities in night school programs offered by some of these institutions, or by museums, in addition to weekend programs conducted by camera makers such as Nikon, and lecture seminars offered by the maker of Leica cameras. In New York City one major retailer, Olden's Camera on West Thirty-second Street, has periodically organized a series of weekend seminars led by East Coast professionals. Additionally, in many cities professionals have conducted classes at their own studios such as the program developed by Norman Snyder, a well-known

photography writer and commercial photographer in New York, or that of photographic illustrator Robin Perry of Connecticut.

In Providence, Rhode Island, the Rhode Island School of Photography limits enrollment to students seeking a professional career. The first year of 1,050 hours of classroom, studio and field-trip work is completed in a September to June schedule. Not only do students learn the technical aspects of the profession, but a special required course teaches "Business for the Professional Photographer." This includes basic accounting, advertising, marketing and other operation factors that may spell the difference between career success and failure. A course of this type is not taught at any other college or university.

A second-year program of a further 1,050 hours extends the student's knowledge into advanced work in portraiture, commercial photography, illustrative work, audio-visual planning, photojournalism, and other aspects of photography that build on the technical and practical aspects of camera handling learned in the first year. RISP's address is 241 Webster Avenue, Providence, RI 02909.

In Boston one may study photography at almost every college in this educational vineyard, but for intensive photographic concentration the New England School of Photography in the Kenmore Square area has a three-floor school in an office building. The faculty is staffed in part by professional photographers so that the two-year program offers the advantages of schoolroom theory and practical studio work side-by-side with working professionals. The courses are developed around a program of lectures, reading and hands-on experience, with the emphasis on practical camera-handling problem solving. NESOP is at 537 Commonwealth Avenue, Boston, MA 02215.

On the West Coast, the well-known Center for Photographic Studies in Los Angeles (2020 South Robertson Boulevard, Los Angeles, CA 90034) has a longtime reputation for development of talent with one- and two-year programs. Not as well

known perhaps, but equally respected, is the one-year program offered at Sacramento by the Glen Fishback School of Photography, a school founded prior to WWI to develop working professionals. The one-year program of lectures, demonstrations, one-day field trips, and one-to-one working sessions is available under a plan which permits you to start the program optionally in March, August or November. The school is at 3307 Broadway, Sacramento, CA 95817.

New York City, the national center for the advertising and publishing industries, has long offered prospective students a variety of schools where they can develop their photographic skills. They include such full-time institutions as the legendary Germain School of Photography in the Woolworth Building at 225 Broadway, New York, NY 10007. The School of Visual Arts at 209 East Twenty-third Street, New York, NY 10010, draws its faculty from photographic scholars and practicing photographers alike. The New School for Social Research, a liberal arts institution, is the parent body of the Parsons School of Design, which has the largest choice of photography courses in New York. Parsons offers over fifteen hundred courses; there are over one hundred courses in photography, from basic programs to esoteric-aesthetic studies. Both daytime and evening programs are offered at the school, located off Fifth Avenue in an elite section of Greenwich Village (66 West Twelfth Street, New York, NY 10011).

Evening classes are also offered at the International Center of Photography on upper Fifth Avenue and at the Photography Institute of the Educational Alliance in lower Manhattan.

One of the internationally known schools of photography, the New York Institute of Photography, has a variety of study programs available from its location at 880 Third Avenue, New York, NY 10017.

Continuing Education

A unique school in the Midwest is the Winona International School of Professional Photography at Winona Lake, Indiana 46590. Here a wide variety of one-week seminars, workshops and study courses cover every aspect of professional practice. Programs are scheduled almost every month of the year with popular general courses repeated often. Prior work at the introductory level is required for advanced studies. The one-week programs cost about four hundred to five hundred dollars each.

As photography has changed, its curriculum has kept pace with the times. Today it is possible to spend one week at the "Introduction to Video Photography," workshop program which has expanded as the tools for creative video effects and the interlock with computers have advanced. Business courses have been added to provide operating efficiency to the already technically proficient studio owner.

Winona is a wholly-owned subsidiary of Professional Photographers of America, Inc., the oldest and largest association for professional photographers. Further information on short and long term studies are available from WISPP, 350 N. Wolf Rd., Mt. Prospect, IL 60056.

The Palm Beach Photographic Workshops is a Florida center affiliated with Palm Beach Community College. One look at its year-round teaching and workshop schedule would convince anyone that it is really affiliated with the Eastman Kodak Company! In fact many of the programs are sponsored by both the Eastman Kodak Company, Professional Products Division and by Canon USA.

The programs offered are usually one-week introductions to everything from the simple to the sophisticated and from the mundane to the utterly professional. The reason? The nation's leading photographers are enrolled as one-week teachers and demonstrators for saturation programs in studios, darkrooms and work centers. Programs offered are for one day, one weekend and one week, generally at about $100.00 a day, and lab fees plus housing and food costs. It's a foot-in-the-door to photo

topics otherwise out of reach for any prospective professional. The PBPW is located at 2310 East Silver Palm Road, Boca Raton, FL 33432-7955.

One of America's most unusual private photography schools is the Veronica Cass School of Retouching at 2779 New Jersey Avenue in Hudson, Florida 33568. This center provides short courses in the traditional techniques of pencil retouching and coloring necessary for quality portraiture.

The advent of electronics has made the computer a tool of the retoucher. The science of digitalization of the image and the alteration of even the tiniest areas of any image or its merger with another are simple projects for students at the advanced computer centers and at such schools as the Rochester Institute of Technology.

Entering The World Of Electronic Imaging

The single most important technological development of the last half of the twentieth century has been the merger of the newly born computer industry to photography. An unusual marriage, that of the foremost American company in the field of traditional photography to the foremost leaders of the computer industry, has occurred. The Eastman Kodak Company, Apple Computer, Adobe Systems and some of the brightest, imaginative visual thinkers have brought new life to an old New England shipping town: Camden, Maine.

The Center for Creative Imaging is unique in the Western world. It is a year-round center for those seeking entry into the world of graphics with a computer. No cameras. No darkrooms. Photographers, editors, art teachers, graphic designers and filmmakers have made this center their doorway into the newest electronic technologies.

At Camden, ME, an array of the new technologies provides scanning, film-recording, and high resolution electronic cameras, and high performance Apple MacIntosh computer workstations are active every day with electrostatic, thermal and film printing technologies. There are over 80 courses. Some are as short as a few days, but most are longer. All are hands-on, ranging from introductory programs, through intermediate and specialized studies. Complete details may be obtained from Center for Creative Imaging, 91 Mechanic Street, Camden, ME 04843-1348; (800)-428-7400.

Summers With Your Camera

The Maine Photographic Workshop offers what is most likely the most extensive array of summer workshop courses. It also offers a three-month residential program of professional training in color photography, photojournalism and commercial photography. Over seventy different one-week to one-month study programs, including overseas study-travel groups, are led by some of the nation's best-known magazine and illustrative photographers. Courses generally start in early June, and a few continue into

the fall. Details are offered by the Maine Photographic Workshop, Rockport, ME 04856.

Maine also has the Ogunquit Photography School (Box 568, Ogunquit, ME 03907), where seminars are scheduled in four-day periods through July and August.

Institutions such as Cornell University and photography centers such as The Catskill Center for Photography in Woodstock, the Chilmark Photography Workshop on historic Martha's Vineyard, and a number of museums and local art centers also offer workshop programs.

Summer workshops are scheduled annually, and some of them disappear from the scene after a few years. The current listings of summer study programs are best found in spring issues of such magazines as *Popular Photography* and *Camera and Darkroom*. *Afterimage*, a publication of the Visual Studies Workshop, 31 Prince Street, Rochester, NY 14607 offers the most complete nationwide list of workshops, seminars, travel programs and formal study courses.

Developing a Photographic Career in the Military Services

The Navy photographer's camera is a weapon
just [like] a ship, an aircraft or the H-bomb.
Photographer's Mate 3 & 2,
Bureau of Naval Personnel Rate Training
Manual, NAVPERS 10355 A

According to Robert Taft, author of *Photography and the American Scene*, the earliest known photographic records of war are the daguerreotypes made during the Mexican War (1846-1848).

During the Civil War, a report on the activities of a railroad battalion of the northern forces was illustrated with black-and-white photographs made by the wet-plate process. But the Navy had earlier permitted civilian Mathew B. Brady to set up a tripod on the deck of the Federal ironclad Monitor and expose a photographic plate. This was to become one of the first "photographs following the battle" to be placed in United States government record files.

Photography within the Navy for the next eighty years was confined almost exclusively to the pictorial. No accurate record is available to establish the first use of photography in the official business of the Navy. The first technical use of photography was made by the Bureau of Ordnance to photograph the splashes of the fall of shot during gunnery exercises.

The first formal effort to train photographers in the Navy started at the Naval Air Station in Miami, Florida, in 1918 as World War I was drawing to a close. A second Naval Photography School was created in January 1920. The rating of Photographer in the Navy was created after 1921. In 1923 the Navy's photography training was centered at the Naval Air Station in Pensacola, Florida, and there much of it remains today. Graduates are awarded the rank of Photographer's Mate.

For several years, the size of classes was set at a maximum of twelve men and women with two classes per year. A maximum photographic crew for the entire naval establishment was then set at two hundred fifty; it is somewhat less now. The training program at Pensacola has taught up to two hundred trainees annually to operate different kinds of cameras on a variety of assignments. The advanced courses are taught at Rochester Institute of Technology and at multi-service schools maintained by the Department of Defense. The Photographer's Mates learn to cover news events and to prepare pictures for release to Navy and civilian publications or for use in historic documents.

Classes include portrait photography, photocopying, aerial photography for map making and reconnaissance, and the preparation of training films and other types of motion pictures. They learn to be responsible for camera maintenance and repair and for film processing. Increasingly the thrust is on electronic imaging as all services revise age-old working systems.

The basic program is a twelve-week plan of twelve sections, and members of each class are personnel on training assignment from the Coast Guard and Marines. The graduate of this course has already completed boot camp training which is approximately eight to ten weeks, so that for the first half-year of service of the new recruit, the Navy is a world of school books, class assignments, and basic military procedures.

The entry of electronic photography, still and video, has begun. Consequently, there are dramatic shifts to labs that are computer centers and cameras which make images seen only in computers.

On completion of this Class A Technical School program, the Photographer's Mate may be assigned to a battleship, aircraft carrier or a large amphibious ship. He or she may be assigned to the Newsphoto Division in Washington, DC or to a shore station, Navy photo center, naval air station, or other naval activity in the United States

or overseas. With this heavy investment of individualized training, it is no wonder that the enlistee seeking a career opportunity in photography in the U.S. Navy is required to enlist for a minimum of five years of service. Twenty percent of all such photo personnel today are women.

Because of the limited facilities at the Pensacola training school, and because the trainee can perform useful service to the Navy during a training period, there is also an active on-the-job Navy training program. Under this program, enlistees who have been accepted for naval service for twenty-four or thirty-six month periods may request service in the Photo Section aboard a ship or at a shore station. First duties will be those of the photographer's apprentice in any commercial photographic studio: sweeping, mixing chemicals, drying prints or running errands for the photographers.

The on-the-job training program also applies to Navy personnel who are willing to use off-duty hours to learn photography. Navy procedures permit a volunteer to perform duties in the photo lab so that when an opening occurs for a Photographer's Mate (PH3) because of a transfer, retirement, promotion, or other eventuality, a request from the volunteer for assignment to the newly opened position (or, as the Navy says, billet) may be accepted. A significant percentage of Navy photo personnel have won the PH rating this way.

Navy photographers are assigned to further training in various technical specialties at the Pensacola school in what are known as Class C schools. These are choice six-month assignments at Rochester Institute of Technology. The newly acquired skills are the route to promotions to the higher PH 2 or PH 1 or even PHC (Chief) ranks. There will be Photographers qualifying for Combat Camera Crew training at the Navy Imaging Command at Norfolk, VA and San Diego, CA.

Navy photography duties are varied, and many will lead to profitable careers in later civilian life. Today's Navy Photographer's Mates have routinely been assigned to polar expeditions, to Sea Bee construction units, and to aerial reconnaissance duty. They

may operate as a single photographer at the New York headquarters of Navy Recruiting in Nassau County, New York, or as part of a thirty-six man team aboard a giant carrier such as the *U.S.S. Nimitz*.

During the past decade, new classifications of service have been formed with slots for the Video Photojournalists, with ratings JO1 and JO2. All service is under the direction of officers responsible for Public Affairs or Operations Departments, often a Lt. Commander or even a Captain ashore.

Such experience would later be invaluable to a magazine photographer, an aerial photographer, a newspaper photographer, a portrait photographer, an advertising photographer, or to an operator of a commercial studio.

Navy pay starts at $8,400 per year for the E-1 (new recruit.) If the recruit stays in the service and moves through ranks to Photographer's Mate 3, then PH-2, and all the way up to Chief (at $26,000) and finally to Master Chief E-7, earnings are at the $35,000 level. Since there are further benefits such as fully paid medical care for the serviceman and his wife and children, payments for housing, and other special benefits, the Navy Chief will earn more than many of his counterparts in an industrial photo plant.

Similar pay scales and support systems are provided to the Coast Guard and Marines personnel.

The basic Navy recruit (E-1 Seaman/Airman Recruit) has the opportunity to learn photography, as do recruits in the Army, Air Force, Marines and Coast Guard.

The Navy offers the PACE Program (Program Afloat College Education). Suppose a recruit would like to participate in a photographic college course. He can get together with nine other similarly inclined servicemen on his ship. The Navy will employ and house aboard ship a full-time civilian teacher in that subject. Schoolroom hours will be built around the off-duty hours of the ten individuals.

For Navy personnel on a ship who cannot get nine others pledged to share a formal class program, the Navy will pay for a Home Study Course; correspondence programs are offered by over seven hundred colleges and universities.

For Navy personnel stationed ashore (40 percent of all personnel) the Navy will pay up to 75 percent of the tuition for attendance at a local college during off-duty hours. Nearly 1,250,000 sailors have had Navy-paid training and education in fields of their choice (in this total Navy campus program) since 1974.

ASSISTANCE FUNDED BY THE VETERANS ADMINISTRATION

Finally, a variety of programs with Veterans Administration subsidies, loans and other benefits are available both before and after completing Navy or other military service. Full details are available in VA Pamphlet 27-82-2, available on request from any VA office.

For example, the VA provides assistance for 36 months based on three years of active duty, plus a further 36 months for those with five years of prior service. This program covers colleges, noncollege degree programs, apprenticeships, on-the-job training and even correspondence courses. On separation from the service, the VA will pay 100% of your post-service education under the Veterans Education Assistance Program. In short, if you don't get to do photography in the service, you will be trained for such a career at U.S. Government expense afterwards!

Choice Opportunities In The Army

The U.S. Army offers some choice opportunities to the recruit fortunate enough to win acceptance as a photographer recruit. He or she will be trained for service as part of a combat camera team or as a Photojournalist. If you have the writing skills to pass a comprehensive grammar test, you will be on the way to a journalism

occupational specialty. You will qualify for the intensive Photojournalism Course to earn the coveted J-8 Photojournalist's designation.

That J-8 tag is required to apply for the Army Advanced Photojournalism Course at the University of South Carolina at Columbia, SC. The plum positions for the Photojournalist J-8 are in the offices of *Stars and Stripes*, the Army's own daily newspaper published in Darmstadt, West Germany or in its Pacific Edition published from a Tokyo newspaper office. Within the United States, a slick monthly, the *Soldier's Magazine*, is published at Alexandria, VA.

In effect, a soldier with an interest in a subsequent career as a newspaper photographer has major learning opportunities during the entire thirty-six month enlistment; he or she could be assigned to photographic duty on the newspapers edited at every one of the numerous forts within the United States. One choice assignment as a Photojournalist J-8 could be with the Army newspaper in Hawaii, for example.

The Army has taken the lead of all the services in a remarkable transition program: the Army has gone electronic! The photo labs are largely dry. Trays and tanks have been replaced by Macintosh computers. The negatives in color are made by soldiers carrying the latest Canon and Nikon cameras. After film is developed, without making a print or slide, the negatives are imaged directly into the computers. The color results are readied by desktop publishing technologies, far from the smell of hypo or the wait for prints!

Other photographers in uniform are equipped directly with Canon, Nikon and Kodak equipment which make still video images: no developing necessary. Electronic photography is now in place for most applications. Link the diskette into the computer, and off the image goes to a publication, a satellite or to an Intelligence Office.

Some of the routine photography within the Army sphere has become the province of civilian photographers: medical photography, portrait photography, identification photography and the like are still fulfilled at every one of the basic Army

installations. But the Army use of photographic skills is set in two directions: The Combat Photographer and the Photojournalist J-8.

Aerial photographs are not made by the U.S. Air Force alone. The Army flies a ground support air command of its own which gathers photo intelligence at the local combat scene.

The rating that photographers hold is known in military parlance as "25 Sierra", the skill identifier regardless of whether the recruit is a basic soldier (E-1) or a higher level, seasoned soldier (E-4 or E-5 sergeant).

To get the "25 Sierra" identification, the U.S. Army provides schooling, jointly with the personnel of the U.S. Air Force at Lowry Air Force Base in Denver, Colorado, for four months. This training follows the basic 9-week recruit indoctrination program which teaches new soldiers the basics of Army life.

At the Lowry Base training, the soldier learns the essentials of basic photography, everything from camera loading and use to basic darkroom procedures. Brief courses are conducted in photojournalism, electronic imaging, color photography, and other related studio or lab practice procedures. It is expected that on-the-job training at the subsequent assigned post will sharpen the skills of the new photographer.

Today's Army has posts for twelve hundred visual information specialists, with one-third of these assignments now occupied by women soldiers. The pressure to win acceptance for one of these slots is high. Army pay scales are on a par with other service pay scales, job for job.

The Army provides advanced course training for selected individuals in the Photojournalist area who may be sent to the University of South Carolina for a 12-week program which colleges and universities accept as nine credit hours in any later degree program.

Even if daytime duty does not include photography, you have off-duty hours in which to pursue your career. The Army will pay 75 percent of the course costs at any

regular school (and credits earned help lead to unit promotions). Some Photojournalists J-8 have proven that being an off-hour volunteer member of the post's publication or at the local city newspaper provides the practical experience for post-Army career development.

Many soldiers have selected photography as an off-duty hobby, and those soldiers seeking later assignment to photography are sharpening their camera handling and darkroom capabilities by use of the Craft and Hobby Centers located on every Army post. Darkrooms are free; hobbyists pay only for the paper and chemicals used. Skilled amateurs among the soldiers offer help to the novices.

On post, every photographer in the service has the opportunity to prove and demonstrate his skills. Every fort has an Army-sponsored photographic competition with prizes of Merit Awards. Every major unit from division level up has further competitions. Finally, there is an all-Army competition. Winners of this event are matched in an Interservice Competition which awards a gold watch, a five-hundred-dollar bond, and a plaque to the "Military Photographer of the Year." The international publicity given to such capability makes it easy for the winners and the runners-up to seek employment at leading American magazines and newspapers.

The smaller military services, the U.S. Air Force, the Coast Guard, and the Marines offer programs parallel to those already described for the Army and Navy. There are Photographic Departments at every major installation. Ranks and ratings are close to those established for the other branches of the armed forces. Basic school programs are identical and are offered only after completion of the basic training program.

Airmen may qualify for the group which is formed four times a year to study Basic Photojournalism. Up to twelve candidates are assigned for 7-1/2 weeks of duty at Lowry Air Force Base in Denver, Colorado, for a workshop in advanced photo skills with its potential for higher promotions.

Once a year, six airmen qualify for the two semester advanced photojournalism training program at a university which in the past has been conducted jointly with representatives of the Navy and Marines.

Special emphasis is being made on rapid conversion of past facilities and work systems as the new state-of-the-art electronic imaging systems are increasingly integrated into service life. The new Photo Lab has the Macintosh computer as the platform and the end result is a multi-media presentation based on the capability of SONY, Nikon and Kodak equipment in the hands of skilled airmen. The future goal is for all Air Force publications to be created by desktop publishing technologies, and the airmen involved will be in high demand in the civilian life of the near-future.

Off-duty training opportunities at local schools or by correspondence courses are identical for all services. Full details can be given only by the Personnel Department of each branch. Interest in photography among new recruits is high; turnover at the local bases is small. The opportunity to immediately win assignment to a photography unit is minimal at this time. But chances do improve once a determined individual shows interest to the local officers.

Getting Your First Job

Young, enthusiastic Linda Van Meter arrived from Dallas with some education in photography, a portfolio of her best work, and one goal: she had picked fashion photographer, Arthur Elgort, of New York as her, "photographer I would most like to work for and learn from."

She decided to try to see the master. Her timing could not have been better. It was summer, vacation time, and there was a changeover in progress among personnel at his bustling midtown Manhattan fashion center. Linda won her first job on her first call.

Says Linda, "The work of an assistant is nothing if it is not various." Her work included everything from answering the phone to doing advance work on locations, to general assistance, printing and loading.

Vladimir Polchaninoff didn't find his niche in the glamour photography world that easily, he told Jack Soper of *Studio Photography*. Like Linda, he was a photography student at college. He opted to carry his portfolio to New York studio owners in the break between his junior and senior years. He armed himself with the information-packed *Madison Avenue Black Book* which is a special directory of photographers, laboratories, stock photo houses, and ad agencies. Book in hand, he started to call on all photographers between Fourteenth and Twenty-third Streets, a commercial-industrial section of Manhattan which has become known as "the Photo District."

At his twentieth knock on the door, King's Studios, changes were occurring. The senior photographer was leaving; all staff members were being promoted one step on the ladder. Vlad walked into a bottom-rung situation, and his career in photography began. Like Linda, he had the coveted title of "Assistant Photographer."

"When I started," said Vlad, "garbage was my big thing. I took out the garbage, washed the dishes, got the breakfast. Anything and everything."

The role of Assistant Photographer is probably the route to a photographic career for one-third of all photographers. For others, the route has been through the darkroom, through free-lance photography, or through the launching of a business in any of the most active fields (but usually in the portraiture of children or adults in a "Main Street" studio situation).

Some freelance photographers such as Tom Galbraith, a West Coaster who sought a photographic career in New York, accept occasional jobs as an Assistant Photographer to bring in income between assignments or other opportunities. Tom, a

San Diego photographer, first considered Los Angeles but then elected to follow up connections in New York.

"You are wasting your time on the telephone," he told *Studio Photography*. But telephone calls to numerous studios can open doors to work for two to three days each week as an assistant. Sometimes the need for help in a studio is such that one may be expected to work even through the night. On one occasion, Tom worked straight through a day to the next morning and finally fell asleep up against a set.

The Assistant Photographer is a busy person. (See the Assistant Photographer in these pages.) The pay is low, but the opportunity to learn and to expand your horizon is unmatched.

The studio assistant is necessary at every location where a photographer works at a ground glass in any camera. While he watches the ground glass, a set may need to be moved into position, a light adjusted, a model's dress pinned to a new silhouette, and tiny items on the table beneath the lens moved a fraction of an inch.

Another entry-level post is in the finishing room. Busy studios must dry and mount prints, dry and mount slides, number and file negatives and proofs, organize supplies, and deliver packages. The darkroom may be the next job level, and the route to the studio from the darkroom is popular in the world of newspapers, commercial studios, and industrial photography.

Finishing-room jobs, like Assistant Photographer jobs, are more open to the youthful student of photography than to the photographic innocent, though for either, you generally do not need a resume. The employer is often looking for a mix of enthusiasm, intellect, and commitment. Imagine the confusion if a negative is misfiled in a storage section of one hundred thousand negatives. Imagine the problems of a studio laboratory committed to delivery of an uncompleted job at day's end with a staff unwilling to work overtime.

Harry Amdur, formerly President of Modernage Photographic Services in New York, one of the nation's largest custom finishing centers, emerged from U. S. Army Intelligence as a photographer. His entry into commercial photography was in the darkroom of a wedding photo studio. Today, that original four-person operation employs over one hundred, and Harry administered a company active in a variety of fields: quality photofinishing for professionals, custom finishing for amateurs, mural-making for interior decorators, mass production portrait printing for the theater industry, and dozens of kindred services.

Harry has employed a large number of photography novices. Most recognize that in the laboratories of the active quality center they will obtain the experience of working under deadline pressures which cannot be encountered in photography school.

"I interviewed at least one person a week seeking entry into the photographic field. Many approached me through my employees, customers, relatives or suppliers, hoping that I had access to the general photography scene. Only a few recognized that we were a quality laboratory center," explained Mr. Amdur.

"Some brought in portfolios seeking to establish their credentials with photographs. Others showed school certificates and proof of school photography participation. None of this helps in getting started in this kind of photography."

Mr. Amdur emphasized that anyone wanting to work with a camera must start at the assistantship level with a photographer somewhere. "The problem is to establish with a photographer your willingness to learn, to show enthusiasm and to be ready for the chores that each day brings. Often it's luck in finding a photographer who needs a beginner-level assistant.

"Not all are newly graduated students; one of my recent employees is a middle-aged family man who sought a new career. He had been with the U.S. Post Office, but he wanted to start in photography in a darkroom. He's doing nicely.

"If a candidate does not have rudimentary darkroom skills, we can't start him. We have no training program; that's what schools are for. The photographer requiring an assistant does actually conduct an on-the-job training program. It's the kind of education at first hand that school money won't buy."

Few photographers find the need to advertise their search for an assistant or to list their job openings with the State Employment Office or with private job placement agencies. A lucky phone call or visit a certain week or a letter on a desk a certain day is what most often wins the opportunity for an interview and probably for the customary ninety-day job trial. Persistence is really the key.

Changes in any studio are a constant factor. The fastest changes take place among the assistants, who, after a year or two of studio experience, seek a role as a photographer. News of job openings in the field is brought from one studio to another in large part by the visiting salesmen from film, paper, chemical or equipment suppliers. Studio owners invariably ask these men who may be qualified or ready for an opportunity. A reference from one of these salesmen is enough to insure an interview. Interviews lead to job changes.

Retailers who specialize in selling the large-size papers and other studio materials are also often sources of leads to employment. The novice photographer should leave his name and address with the employees of such supply centers as a way of being introduced to prospective employers.

Women And The Job Market

Women have played a vital role in the craft and business of photography from the very first days. One of the most renowned photographers of the nineteenth century was Julia Margaret Cameron, portraitist of the arts, science and belle lettres intellectuals of her day. Female gallery operators and technicians were numerous. Retouchers, oil colorists and finishing-room employers were heavily favorable to the female employee.

Unquestionably, the role of the female photographer, which had been blooming in the Victorian Era, blossomed fully in the twentieth century. There are a myriad of famous personalities identified with each decade. Some starred in a way that assures that they will become legendary: Margaret Bourke-White and Berenice Abbott of *Life*; Ylla, the premiere animal photographer; Toni Frissell, the fashion photographer; Dorothea Lange of the Farm Security Administration; Ruth Orkin, the documentarist; Marie Cosindas, the instant-image experimenter in the fifties; Annie Leibovitz today.

Numerous magazines have female staff photographers. Annie Leibovitz of *Rolling Stone* has made history with her portraits of music and entertainment industry celebrities. Remember Whoopi Goldberg in the bathtub of milk? That was by Annie! It is no longer unusual to find camerawomen behind the rolling TV studio cameras in many cities of the U.S.

At newspapers, many photo crews remain all male. But at *The New York Times* there are frequent bylines for the work of Marilyn K. Yee, a Chinese-American photojournalist and for Suzanne DeChillo. Look at the photographs on TV as the Washington photographic corps presses forward to get photos in the Hearing Rooms or at Presidential Press Conferences. You'll find female faces behind long lens cameras.

Three of the seven top editors of *Popular Photography* are Renee Bruns, Elinor H. Stecker and Julia Silber. The world's foremost photo scientist in the area of understanding of the technology of the daguerreotypes is Mary Susan Barger. The credentials of these women in the field of photography have long been unchallenged.

Photography has open doors for talented Afro-Americans and other minority group cameramen and women. Perhaps America's most famous Afro-American photographer is Gordon Parks of *Life* fame. Roy DeCarava and Chester Higgins, Jr. have cut niches as creative photographers and educators.

On campus, female students of photography are generally one-fourth of each class. Statistically fewer of this group will persevere in a photography career than the male group, according to educators, guidance counselors and employers at large studios.

In the Armed Forces, women photographers, photo lab technicians and photo crew members make up as much as 30 percent of some units, but this figure may be enlarged slightly by the inclusion of the necessary clerical personnel, which is heavily female in some sectors.

Presenting Yourself

The job applicant, male or female, Afro-American or white, is expected to show a high degree of enthusiasm for the craft of photography. While some industries require a leave-behind resume, a one- or two-page outline of job skills, educational and vocational experience, and some indications of job aspirations, the photographic job seeker essentially needs to show a portfolio of work to date. This neatly presented potpourri of portraits, landscapes, still life and experimental photographs simply attests to your ongoing interest in photography.

The leave-behind may be a neat file card with name, address and phone number, or a modest formal business card such as you might make up for freelance contacts.

Calls for an appointment to apply for a position will not usually get as many interviews as visits to the studio in late afternoon hours after most shooting sessions have been completed. In small companies, you should ask the receptionist the name of the owner, who generally is the sole hiring authority. In larger studios, there is often a business manager or even an executive with personnel responsibilities. Receptionists often know if the studio is seeking a new pair of hands, so don't make the purpose of your visit a mystery. Try to make a friend.

Graduates of private photography schools will receive some assistance in an organized job hunt from the Placement Office of the school. Local studios may

regularly ask these offices to watch for a talented youth for a beginner-level job opportunity; employment officers may keep in touch with studios that have occasionally employed school graduates. Since the typical assistant may leave a position within two years, the school may fill that post every two years on a routine basis.

Making friends with working photographers, offering to provide part-time assistance or overtime fill-in work for active commercial studios, making friends with the photo-lab chief or the head photographer at the local newspaper, and asking friends and neighbors if members of their families are engaged in the photo industry are all useful ways of making crucial contacts that can lead to that elusive first job.

CAREER

OPPORTUNITIES

Administrator, Photographic

With the burgeoning of industrial in-plant photography departments, medical and university photography departments, and commercial studios with a number of shooting galleries and teams of photographers on location, supervision and coordination of the total team effort has become a necessity. The photo-lab chief, the head photographer, and the photo-finishing department supervisor report to the one person in direct line of responsibility to the corporation: the Photographic Administrator.

Just as it requires a doctor to supervise a hospital and a printer to own and manage a lithography company, supervision of a photographic operation has to be assigned to a photographer with knowledge of the plant technology, basic understanding of good administrative practice, and, increasingly, an education in business procedures.

The Photographic Administrator usually reports directly to the corporate vice-president in charge of plant services or to the owner of a business. Usually the photographic section is but one service element of a publishing, printing, advertising or public relations operation. Not surprisingly, the salary of the P.A. starts at income levels few working photographers can ever hope to achieve.

At Standard Oil Company of Indiana the administrator of the photographic division, a section of corporate communications, heads a staff of twenty-five, which includes photographers, artists, designers, darkroom technicians, slide duplication teams and art services allied to the projects requiring the photography.

Within most small- and medium-size studios, in-plant photo departments and government photo operations, the department head is promoted from within as often as possible. The administrative position requires full knowledge of the operation's capabilities to properly organize, staff, schedule and budget in order to achieve quality service at profitable prices within suitable deadlines.

No wonder the best administrative posts go to the best-educated photographers, and those with degrees or special training in business practice are more promotable than

highly creative technicians who have little experience in traditional business problems like negotiations with individuals or unions, price schedule planning and personnel administration.

The photographer headed toward a career as a Photographic Administrator can prove his merit by showing leadership qualities and planning skills on the job in a large photographic establishment or by successfully establishing his own profitable business.

See also Commercial Photographer, Gallery Operator, Photographic Editor.

JOB DESCRIPTION ● Combines photographic background with the business acumen necessary to function as a department head. Establishes work guidelines, assigns duties, maintains operations with allotted budgets, provides leadership to the photographic team with mature judgments and in-depth knowledge of the problems that working photographers encounter.

TYPICAL ASSIGNMENT ● The National Park Service maintains a vast photographic center at a reproduction plant covering many acres near Harpers Ferry, Virginia. The administrator will schedule the activities of darkrooms and finishing rooms, exhibits, print booklets, produce trail-map illustrations and numerous other photo-related projects to fit within predetermined deadlines and budgets. This facility has a number of photographically experienced administrators for each of the key departments, plus other supervisory heads.

CLIENTS AND EMPLOYERS ● Photographic Administrators are employed by photographic studios, chain operations, photographic processing laboratories, commercial plants, medical photo departments, college photo departments, in-plant studio operations, and government agencies.

TRAINING ● A minimum of four years of business management at college, plus two years of college photography training and/or two years at photography school. Comparable military experience is service as the commissioned or non-commissioned photo-lab officer.

SALARY ● The salary will start at $25,000-$30,000 and will advance to $50,000 per year and more in large studios, large commercial plants or in giant corporations.

RECOMMENDED READING ● Cavallo, Robert M., and Kahan, Stuart. *The Business of Photography*. New York, N.Y.: Crown Publishers, 1981; *Photographic Studio Management*. Rochester, New York: Eastman Kodak Company. Publication 0-1. 1990.

TRADE ASSOCIATION ● Photographic Administrators, Inc., 1150 Avenue of the Americas, New York, NY 10036.

Advertising Photographer

It is the Advertising Photographer who creates allure and romance for tires, motor oil and bed springs either in a studio or by secluded Jamaican waterfalls. The work is demanding since, in all but rare instances, the photograph has been preconceived by an ad agency art director, modified by the client's advertising manager and engineering department, and only then exactingly recreated by the usually protesting photographer.

For the Advertising Photographer, the key skill is communication. The ranks of the advertising-oriented photographers are usually filled from the numbers of amateur and professional photographers who demonstrate writing skills. Some have been teachers, often of the sciences, with a special interest in photography. Some are business-course majors with a studied interest in marketing and advertising, plus a parallel strong hobby interest in photography. Many are photojournalists who have made the switch from camera handler to typewriter jockey.

The Advertising Photographer of necessity will open a studio or work for an agency in three primary markets: New York, Chicago and Los Angeles. Polaroid, which is based in the Cambridge-Boston area, and Eastman Kodak Company, which is in Rochester, New York, require employees for studio, advertising and literature departments, but the number of secondary cities is small; the careerist will best head for the Big Three cities to find fame and fortune.

Advertising Photographers are generally higher paid than their counterparts in industry. The cautious employee seeking a long-term relationship with an employer is more safely situated in corporate life than in the volatile agency life-style. Accounts change agencies on average about every five to seven years. Advertising Photographers must depend on and maintain skilled salesmen to keep their names and skills before the endlessly changing numbers of ad agencies and art directors.

To enter the photographic advertising scene, persistence, an outgoing personality, and a convincing ability to communicate with both the camera and words, can be the start of spectacular work that will be seen by millions and millions of readers of magazines.

See also Commercial Photographer, Photographic Educator, Photographic Writer, Editorial and Photographic Writer, Technical.

JOB DESCRIPTION ● Provides skills and ability to fit preconceived advertising layouts with photographs to size and proportion of the planned artwork, using the appropriate camera, studio and models to achieve the desired effect. Offers skills and techniques that permit a preassignment complete cost estimation for all work elements and assure a quality selection of photographs acceptable to the client within a profitable budget for the studio.

TYPICAL ASSIGNMENT ● An advertising agency requires four photographs for a construction industry advertisement featuring new insulating material. The photographs will illustrate ease of installation during house construction and will demonstrate the insulating strength of the new product with before-and-after photographs. The photographer's studio aides must actually erect a small wall of wood to be photographed from two directions before wallboard seals up the simulated interior and exterior walls.

CLIENTS AND EMPLOYERS ● Advertising Photographers may be employed as part of an in-house studio capability at larger corporations or in independent advertising photography studios, or may be self-employed.

TRAINING ● A minimum of two years of full-time photography school is required, with or without college education; or a military photography career for two or more years.

SALARY ● Advertising Photographers with full responsibility will earn $25,000-$75,000 per year. Self-employed photographers may earn more or less, depending on business acumen.

RECOMMENDED READING ● Hammond, Bill. *How To Make Money in Advertising Photography*. New York: Amphoto. 1979; Perry, Robin. *Photography for the Professionals*. Waterford, Conn.:Livingston Press. 1976; *Professional Photographic Illustration*. Rochester, N.Y.: Eastman Kodak Company. Publication 0-16. 1989.

TRADE ASSOCIATION ● The Society of Photographers in Communications, 60 East 42 Street, New York, NY 10017.

Advertising Photography Copywriter

A unique career is open to the individual with a detailed knowledge of photography and the ability to generate advertising copy: words and ideas must sell products. If the products are in the realm of photography, obviously the copywriter will have a technical understanding not generally available to the usual competent non-technical copywriter.

The Advertising Photographic Copywriter has that writing flair and that technical savvy. Such a copywriter in the agencies that create campaigns for Canon, Minolta, Pentax, Kodak, Polaroid or the myriad of high-tech equipment sold to professionals is truly a specialist. He or she has probably been a photographer, amateur or professional. Words that would faze the average college graduate are routinely understood by this specialist.

He is continually challenged by the blank sheet of paper in the typewriter or the empty screen of the word processor as he seeks the word and idea that most excitingly describes computerized enlargers or cameras built around chips of the computer industry.

His competitor for the job at agencies which will be located in New York, Rochester, Los Angeles and at times in Chicago, San Francisco or Atlanta may have been a teacher or a salesperson from a photographic retailing center. Some copywriters have been aspiring photojournalists without clients.

To enter the scene, read the *Standard Directory of Advertising Agencies* available at any ad agency and at all large public libraries. Check each agency for the client list which could include a manufacturer or importer of products of the photo industry. Those clients need Ad Managers, and your skill could put you in a key position in a major firm; or you could be the perfect person for the ad agency. The Directory has the names of the key personnel and the address information you will need.

See also Writer, Photographic Editorial; and Writer, Technical Photography

JOB DESCRIPTION • Provides skills and ability to study advertising of the competition and to create a copy concept which makes the client's products the logical choice for the consumer. Suggests headlines for ads addressed to the ultimate user or to the tradesmen who must stock and promote the product to the end user. Shares responsibility for recommending appropriate media (print advertising, radio, TV, billboard, catalog or other means of communication) with the Marketing Department of the ad agency. Teams with the agency's art director and ultimately with the client's own ad manager to hone copy to best reflect specific benefits to attract sales.

TYPICAL ASSIGNMENT • A new model of an earlier product is more costly, but it has far more features, incorporating never-before performance making it the leader in the field. The client has suggested that with the right idea, the budget might be expanded to include television advertising in major cities. The ideas must express a copy platform ("what the ad will say"), a direction ("How the art or photography in the ad will express those ideas"), and a realistic approach to budget considerations ("no photos requiring trips to Europe or the Caribbean for a team of ten").

CLIENTS AND EMPLOYERS • The employer at hand is the ad agency copy chief, the ad agency account executive, and finally the ad manager and marketing team of the clients of the ad agency.

TRAINING • The prior training is the earlier employment or service as a photographer or photo technician and a demonstrable level of writing skills related to selling experience, perhaps as a store clerk, or worker in a photo studio.

SALARY • The Advertising Copywriter may start at $25,000-$40,000 and earn $60,000 and up depending on the size of the ad accounts. The salary, if employed by the client side will be one-third less but will offer more job security and pension benefits in the long run.

RECOMMENDED READING • College textbooks on advertising with emphasis on copywriting chapters; *Advertising Age*, the industry weekly.

Aerial Photographer

Aerial photography is often an adjunct operation for many commercial photographers who have advised local realtors, public relations firms, nearby newspapers, and television stations that they offer aerial coverage. Owning a small plane is an open ticket to occasional well-paid assignments even if the subject matter is as dull as an angled view of swampland destined for new life as a shopping center.

The next-best thing is a friend among the charter plane owners at your nearby airport. Your contract rate for his flying services is far better than his one-time rate for anyone else: $350-$750.

For a full-time career in the field and endless hours aloft in light planes and helicopters, there are numerous private companies, mostly based at or near local airports, which already serve giant nearby industries in the oil exploration field, in forestry and in agribusiness, or which contract services to such government agencies as the Department of the Interior, the Department of Agriculture, and others who plan dams, highway construction, harbor improvement, and other man-made alterations of nature.

For some of these projects the same 35mm camera that is ideal for baby portraits is also appropriate for color slides of highway construction or progress in a land clearance project. Where large (mural-size) prints will be necessary for studying the photograph, larger cameras are used, including some just as specifically made for aerial observation as underwater cameras are created for that environment.

Companies seeking Aerial Photographers are usually not equipped to assign an airplane, pilot, and a project to the new employee. An apprenticeship starting with learning to load cameras, possibly even processing the exposed rolls of film and bag-carrying for the Aerial Photographer, will be the entry-level assignment for the novice.

On the other hand, the owner of any still camera (35 mm or 6x6cm or even a hand-held 4x5 press camera) can find occasional assignments. A first step is trial-and-error photography from a small plane during rides rented, begged or borrowed at the local airport. There are occasional listings of Aerial Photography Workshops in the monthly Calendar of Events in publications such as *Studio Photography*. One of the promoters of such events is Photographic Safaris, Sayville, NY, a Long Island suburb of New York City (516) 567-2985.

The most likely first customers for locally made aerial photographs are realtors who may have already occasionally paid for photographs of residences to assist their selling efforts.

JOB DESCRIPTION ● Depending on the assignment objective: top-view, oblique view, area map, or photographs related specifically to geology, topography or photogrammetric considerations, the Aerial Photographer selects the appropriate combination of camera, film and filter, and is airborne to the location.

TYPICAL PHOTOGRAPHIC ASSIGNMENT ● Aerial views serve the needs of government agencies monitoring land erosion, harbor and waterway conditions, fire fighting, and transportation situations. Geologists for oil companies, foresters serving the lumber industry, and realtors surveying land outlines, all depend on aerial views for vital information. Private and government agencies involved in mapping projects sometimes require staff photographers over many years. Occasional news stories usually relating to natural disasters such as earthquakes, volcanic activity, or hurricanes often interest news services and television stations that require spot coverage.

CLIENTS AND EMPLOYERS ● The independent Aerial Photographer is self-employed. Staff aerial photographers are employed by the oil, mining and forestry industries.

TRAINING ● Aerial Photographers are developed from apprenticeships and from within organizations in the field. Military training in this field has been the basis for the start

of many civilian careers. There are no aerial photography courses at college level or in private/photography schools.

SALARY • Depends on locale but usually in the $22,500 -$30,000 range.

RECOMMENDED READING • *Assignment Photography (pricing guidelines)*. American Society of Magazine Photographers. 419 Park Ave. So. New York, NY 10016. ($14 + 2.00 s/h.); Clarke, Robert G. *Profits in Aerial Photography*. 125 University Avenue. E. Hartford, CT 06108; *Gold Mine in the Sky*. Plan-A-Flight Publications. Box 7014. Nampa, ID 83651; *Photography from Light Planes and Helicopters*. Rochester, NY: Eastman Kodak Company, Publication M-5. 1985.

Agricultural Photographer

For the young man or woman who knows the differences between summer and winter wheat or corn grown for fodder and for the dinner table, there is a vast opportunity in agricultural photography. The needs range from the scientific reportage relating to studies of plant diseases or the improvement of fertilizer to the educational role of the Department of Agriculture in preparing information booklets for the next generations of American farmers.

Obviously the photographer already familiar with farm life and with animal handling is more apt to feel at home in the prototype farms at experimental stations and agricultural colleges. Students of food chemistry, botany and biology with additional skill in photography will find it easier to win research positions in the multibillion dollar food corporations and chemical industries.

Photography relating to agriculture has three major areas of opportunity: the field growth process; the laboratory: and the promotion of the product. Beyond scientific documentation, it is likely that the lab photographer may be asked to provide a color photograph of a candlelit banquet for the advertising program of the company.

The Agricultural Photographer for a major food firm will be a traveler. Companies bringing pineapple from Puerto Rico or Hawaii, coffee from Africa, bananas from Central America, and herring from the North Sea inevitably require photographic coverage for annual reports; educational training films for product salespersons; illustrations for trade show exhibitions; decorations for plant and executive offices; publicity photographs for the nation's press; and dozens of other sales and publicity-related projects created together with the corporate home economist.

Many companies require the photographer to maintain or direct the activities of a corporate darkroom. Inevitably the photography department is swept into the myriad of photographic requirements of the company: realty photographs for the legal department; identification portraits for the security office; chart slides for the sales

department; executive portraits for corporate public relations; and even photo reportage for the company newspaper at such events as the annual Christmas party.

Job entry may be through the regular personnel office of the company or through contracts with key individuals in the technical section of the company.

See also Botanical Photographer.

Department of Agriculture photographers are located in many states. The government's extensive experience with photography for technical services to the farming community has inevitably led to numerous projects dependent on still photography; exhibits for the farming community fairs; booklets for general circulation; illustration of bulletins to clearly identify pests and to advise of newly developed pesticides; and publicity photographs for government publications and national news media.

In smaller companies where the photographer is the administrative officer of the team, the position includes interesting ventures such as travel to trade shows and fairs and even possibly overseas assignments. The salary level is equal to that of the head of similar departments where technical services are in-plant, such as the company printing department, computer section and maintenance division.

In larger companies, the photographers on staff will be paid at the level of the laboratory technicians in the research and development sections.

See also Biomedical Photographer, Botanical Photographer, Forensics Photographer, Wildlife Photographer.

JOB DESCRIPTION • Selects equipment suitable for the monitoring of plant growth; understands use of special color filters and special-purpose films such as infrared sensitive emulsions. Supervises laboratory procedures. Maintains a full-service photographic studio. Expert in still-life food photography. Selects equipment suitable for travel projects. May be called upon for videography and should be familiar with video cameras and post-production editing.

TYPICAL ASSIGNMENT • In a laboratory where treated and untreated plants are in various stages of growth, the photographer makes matching photographs for periodic comparison and records purposes in black-and-white or in color. In the field on an actual farm or in an experimental agricultural station, he makes comparison photographs of fruits, vegetables, shrubs, trees, transplants, and vines for scientific purposes. He maintains carefully filed, numbered and dated negatives along with indexed proof prints for later recall.

CLIENTS AND EMPLOYERS • Numerous food, forest and other agricultural corporations, university and research centers and government agencies.

TRAINING • Appropriate college courses in botany and food sciences. College photographic courses or two-year courses at photography schools. Three years of military photography will satisfy most needs of private and public employers.

SALARY • Depending on years of service, the photographer will earn from $20,000-$35,000.

RECOMMENDED READING • *Close-Up Photography*. Rochester, New York: Eastman Kodak Company. Publication KW-22. 1989; *Scientific Imaging Products*. Rochester, New York: Eastman Kodak Company. Publication L-10. 1989.

Alternative Photographic Printing Processes Specialist

If you matured in a household where a computer was your best friend instead of a puppy, and if you are keen on a career in photography that is as state-of-the-art as the latest laptop computer, then there is a role for you as an Alternative Photographic Printing Process Specialist.

In the fields of audio-visual program creation, newspaper and book publishing, television craft, advertising photography, filmmaking and in a hundred other places where a photographer is needed to start or complete a project, the photographer will find innovation and support in the electronic darkroom. This is a brightly lighted computer workstation, not a hypo-smelling chamber.

The first group of Alternative Photographic Printing Process Specialists are now at work. The Weather Map in color on the Late Night News Show puts these computer specialists to work in every major city. Color pages for newspapers and magazines take specialists to electronically merge photos to new backgrounds with a headline and a column of type. In moviemaking special effects graphics put the scare and thrill into comedy and horror scenes. Alternative Printing Process Specialists at computer workstations serve the objectives of the retoucher, the graphic artist and the quality control center of the printing house.

This career starts with a fundamental understanding of traditional photographic imaging, but then it requires a quantum leap into the world of pixels and bytes of the computer workstation.

See also Electronic Audio-Visual Specialist, Electronic Imaging Consultant.

JOB DESCRIPTION ● Operates a computer workstation with a variety of software options and related accessories to create on-monitor images for a variety of effects with an end product in the form of photo film, electronic data or a telecommunication to another station across the country.

TYPICAL ASSIGNMENT • At an electronic retouching service, the client has requested modifications of a slide received by mail from Spain. A visible telephone wire is to be removed from a corner of the image where it was inadvertently captured by the lens; the sky color must be changed to a deeper blue of a specified color density as provided in a paper swatch; one window must be removed from a wall since its area will be used for type which must be readable against the whitewashed stucco; and the foreground female model is to appear to be slimmer. The end product is to be provided electronically to the waiting workstation at the client's catalogue house printer late in the same day.

CLIENTS AND EMPLOYERS • The Alternative Printing Processes Specialist is employed by any of a number of companies and services serving communications companies.

TRAINING • Training is available at such centers as the Kodak Center for Creative Imaging, the Rochester Institute of Technology, and in apprenticeship at companies presently engaged in such work.

SALARY • Beginners will have starting salaries of $15,000 - $18,000 per year with rapid advancement.

RECOMMENDED READING • *Photo/Electronic Imaging Magazine.*, 1090 Executive Way. Des Plaines,IL 60018; Manuals and publications of the Desktop Publishing shelf at Public Libraries and some universities.

Archaeological Photographer

If you have skills with a camera, you have the beginnings of a career in archaeology, paleontology or related sciences. If you apply at any university, any expedition headquarters, or at any "dig," your demonstrable photographic skills could prove more useful than excavating prowess.

Next to the tiny shovel and brush, the camera loaded with film is the archaeologist's best friend. After dark, when the "dig" has been abandoned by field workers anxious for food and a shower, the photographer is still able to make his contribution. Even though each and every bone, flint tool or shard is photographed in situ to precisely document levels and layers by time period and fire sites, all samples will be photographed with key numbers to facilitate later study, reconstruction and the inevitable written and illustrated reports.

The camera of the archaeologist afield is almost invariably the 35mm system with wide angle lenses that permits expansive coverage and macro lenses for close-up detail of tools, weapons and even teeth marks. With these lenses, bowls made by the potter's coil method can be seen to reveal the impression of fingertips, and details within the fire-baked design can help identify different tribal cultures.

Acceptance for a position in a university laboratory as a photographer for researching materials brought back by an expedition, or for participation in planning for an expedition, or for similar work in a natural history museum, will largely depend on an expressed interest in the field. Preparatory work for such a position is study for a degree in the related sciences, volunteer or paid work on American projects studying pre-Colonial Western hemisphere history, or fieldwork with ongoing studies in such distant sites as Mexico, Guatemala, Turkey, Israel, Syria or wherever "digs" are in process.

A two-year study program in college or at a private art or photography school in basic camera handling and darkroom techniques is a second course area to be

mastered by the student archaeologist. Proficiency in still-life photography and an understanding of the distortion controls feasible with the view camera will help the field photographer. He will learn to minimize angle-induced distortions inherent in cameras without tip/tilt lenses or adjustable swing-back ground glasses.

Check the library for back issues of *National Geographic* to see how often the finds from recent "digs" have become worldwide news. Check the college library for journals of general science, archaeology, paleontology and related sciences. Note how skillfully the field photographer arranges identification information and uses a ruler or other aid for scale indication.

See also Museum Photographer.

JOB DESCRIPTION ● Provides services as a 35mm documentation photographer. Maintains records, supervises film processing, slide filing and related administrative follow-through. Offers darkroom proficiency.

TYPICAL ASSIGNMENT ● A student field trip to a Native American site has returned with fragments of basket weaving, some sand-colored pottery shards and one intact small bowl. These are to be photographed as a group for reference to that particular week's finds, individually with code number for later examination, and with lighting and background drama suitable for a story for the university newspaper.

CLIENTS AND EMPLOYERS ● The photographer may be a full-time research associate employed by the university, college or museum science department; or may be employed under a grant of the patron sponsor, or foundation.

TRAINING ● Four years of college photography or two years of photography school or military photographic service.

SALARY ● Entry-level positions on "digs" are often under volunteer conditions. Full-time positions as a staff photographer pay at levels ranging from $18,000 to $22,000 per year.

RECOMMENDED READING • *Scientific Imaging*. Rochester, New York. Eastman Kodak Company. Publication L-10. 1989.

TRADE ASSOCIATIONS • American Institute for Archaeological Research, 24 Cross Road, Mt. Vernon, NY 03057; Society for American Archaeology, 808 17th St. NW, Washington, DC 20006

Architectural Photographer

In 1945, when she was eighty-one years old, photographer Frances B. Johnston was named an honorary member of the American Institute of Architects for "her notable achievement in recording photographically the early architecture of the United States." She was honored for the ten thousand photographs of America's buildings which she had made, structure by structure, while touring the country in her automobile, averaging twelve thousand miles a year during the Depression Years, 1933-1939.

Today Frances Johnston's work resides in the Library of Congress, the Metropolitan Museum of Art, and the Virginia Museum of Fine Art as a permanent record of yesterday's architecture. Without her photographs, today's bricklayers, iron workers and designers of staircases, porticos and bow windows would have little clue to the construction techniques of the past. It was a project she began when she was in her sixties and climaxed a lifelong photographic career.

Current Architectural Photographers may not have the dramatic impact on their culture of a Johnston, but they play a vital role in the building and construction industry where today's glass-walled triumph is only a fanfare leading to the debut of tomorrow's monolith. For the past four decades, the skill of Ezra Stoller, a master photographer of the most magnificent structures of twentieth-century America, rests on a grand tradition of meticulously planned photographic statements that date back to the days of wet-plate photography and the mammoth albumen prints of the finest mansions, such as those exhibited periodically at the Museum of the City of New York.

Currently Wayne Cable of the Midwest has combined a liberal arts education with a traditional appreciation for building construction and design. Admittedly, with three generations of architects in the family preceding him, his idea to combine his love for buildings with his love for photography assured almost in advance that by the 1990s he would have already seen his work in print in *Architectural Record, Architecture, Interior Design, Interiors* and other publications of the field.

Barbara Karant was trained in art in the Rhode Island School of Design and the Art Institute of Chicago. She has specialized in interior photography. She works exclusively in 4x5 and larger camera formats. Out West, Marion Brenner, an architectural photographer who grew up in the darkroom of her father who operated a retail camera shop, has made a career specializing in work with architects and interior designers.

Architectural photography permits a creative effort with camera angle, montage, color filters and tonality denied to all but a few photographers. Examples of the best of the craft may be studied each month in the exterior and interior views published in *Architectural Forum, Better Homes and Gardens*, and even in such publications as *Business Week*.

One of the endlessly seen credit lines beneath fine architectural photography is that of Hedrich-Blessing, Ltd. Once this was the studio of Hedrich and Blessing; now they have eight photographers around the country ready to serve clients. While most photography requires worry about film and processing, Hedrich-Blessing Ltd. keeps tabs on the weather!

You enter this field by the standard apprenticeship route, carrying the requisite 8x20 view camera, cases of plateholders, a giant tripod and a ladder. For some, independent work in assembling a portfolio of sparkling photographs has won assignments from local architects. Such photographs, published in local advertising or in national trade publications, open the doors to other architects, builders, realtors and editors.

Andrew Garn in New York City completed studies of photography and carved a unique career by first doing the impossible and improbable, making photographs of buildings by the light of street lamps, the moon and even passing cars. His long-exposures created unusual color effects and startling, off-beat visual impressions which won him assignments in the design world.

See also Interior Design Photographer, Real Estate Photographer.

JOB DESCRIPTION • Uses 8x10 and larger view cameras for daylight and nighttime views. Maintains a darkroom for processing and printing of large negatives.

TYPICAL ASSIGNMENT • A newly built downtown office building is the joint creation of an architect and a construction firm, both eager for promotionally valuable photographs. Because of its location, the photographer must arrange for a vantage point from a window in a building across the avenue. The main visible areas of the building will be photographed during the two hours in which the sun reaches that building's face and then by night when window and street illumination will provide a dramatic view. By using a wide-angle lens and correcting the camera lensboard and plateholder alignments, distortion created by the low camera position will be minimized.

CLIENTS AND EMPLOYERS • The Architectural Photographer is an employee of a commercial studio with this specialty or is an independent entrepreneur. As an independent he serves a variety of clients but primarily the architect or the contractors who bear the actual construction responsibility. His next important customer is the new owner of the structure, especially if it is a bank, a government agency, a hotel chain or a major industrial firm, all of which will seek dramatic photographs for their stockholders, clients or prospective customers.

Realtors will require photographs when the building is to be placed on the market, especially if prospective buyers are located across the country or elsewhere in the world. Trade publications of the design, construction, finance and business worlds seek photographs that illustrate the news made when the building design, completion, sale or transfer is announced.

TRAINING • Commercial studios seek entry-level employees with some photographic background. College training of two years or less does not provide sufficient experience with view camera handling. Two-year and four-year photography school programs

provide the view camera training to expand the student's horizon. Military training does not prepare one for a civilian job in architectural photography.

SALARY ● Entry level jobs start at $15,000-$20,000. Larger studios pay experienced photographers $$25,000-$35,000.

RECOMMENDED READING ● *Photographing Buildings and Cityscapes*. Rochester, NY. Eastman Kodak Company. Publication LC-10. 1990; *Photography with Large-Format Cameras*. Rochester, New York. Eastman Kodak Company. Publication O-18. 1988.

TRADE ASSOCIATION ● Professional Photographers of America, 1090 Executive Way, Des Plaines, IL 60018.

Art Photographer

The Art Photographer offers skills and precision-based procedures unknown to the Child or the Sports Photographer. Working with large view cameras, carpenter's levels, sand-bagged tripods and a variety of polarized lights of varying Kelvin temperatures, he makes photographic reproductions of paintings, sculptures and other objets d'art to meet the most critical demands of expert curators. Since color emulsions vary, further color shift is inherent in long time exposures. Exposures are modified still more in the processing procedure so the Art Photographer must be a skillful practitioner of color filtration and film exposure.

From his expertly reproduced copies will come the color catalogues, the souvenir postcards, the museum posters and the public relations kits that build audiences. His 35mm slides may become the basis for art study in colleges and universities.

The Art Photographer is a permanent member of the museum staff. His department plays a vital role in promotion of museum events and in the creation of the permanent record of holdings. His photographs must be precise for Insurance Department needs. Since usually only 5 percent of the assets of a museum are on display at any given moment, much of what will be recorded may remain unknown to the public for many years. Art files, insurance records, scheduled books, posters and numerous other projects keep the photographer busy throughout the calendar year.

In smaller cities, and for private galleries, independent specialist Art Photographers have established clients in curators, dealers, painters, patrons and the numerous publications of the art world such as *Art News, Art in America* and *Art Forum*. Since paintings may have the coarse textures of a Van Gogh or the smooth surface of a Dali, Art Photographers must master lighting techniques that illuminate a canvas without "hot-spotting" and without distracting glare and highlights from paint swirls.

The Art Photographer will often be expert with infrared photography techniques such as those used in police photography to detect forgeries. He will be the master of both view cameras and 35mm cameras. He will have the patience to perfectly align lens, camera back and painting for precise horizontal-vertical representation.

An art major's knowledge of the fine arts, a definite ability to appreciate minuscule color shifts and subtle nuances of light and shade, plus a basic knowledge of the photographer's craft are prerequisites to success in this field. The color-blind need not apply.

A visit to the photography section of any major museum is a starting point for the search for a career in this very challenging work for the art lover and historian with a camera.

See also Museum Photographer.

JOB DESCRIPTION • Provides skilled use of the view camera, meticulously filtered and controlled exposure, and development of color films under rigid studio arrangements. Maintains detailed knowledge of 35mm camera systems and close-up photography.

TYPICAL ASSIGNMENT • A gallery owner will exhibit the first major show of a new non-representational artist and wants advance photographs in black-and-white and color prints suitable for reproduction in an elaborate catalogue, show announcement, and a poster to be sold to the public. The Art Photographer must bring camera, lights, film and other aids to the rural studio of the painter where works are in storage. Thirty photographs must be completed within three workdays, and a week will be left for processing, retakes and delivery.

CLIENTS AND EMPLOYERS • The Art Photographer is one member of a large museum staff. Some individuals have successfully established one-person operations to serve publications that document foreign art collections, artwork in cathedrals, and so forth.

TRAINING ● The Art Photographer is the product of a broad combination of art history and basic photography studies. He may enter this field as an apprentice in the service of a commercial studio where occasional copy photos of paintings are made for painters or local art dealers.

SALARY ● The museum's Art Photographer is usually paid a start-up salary in the $18,000-$25,000 range of assistant curators or research assistants. The entry-level in a commercial studio is at the $15,000-$18,000 level with slow growth to $25,000 over a number of years.

RECOMMENDED READING ● *Camera and Darkroom Photography (magazine).* 9171 Wilshire Blvd. Los Angeles, CA 90210; *Darkroom Techniques (magazine).* 7800 Merrimac Ave. Niles, IL 60648; *Guide to 35mm Photography.* Rochester, New York: Eastman Kodak Company. Publication AC-95. 1989.

Assistant Photographer

Most men and women holding this title don't expect to make a career of this almost-the-photographer position. In fact in most cases, within two to five years, none of today's hundreds of photographic enthusiasts holding this key responsibility in advertising, illustration, wedding, or baby photography studios will be there to load film holders, answer the phone, or iron the model's dress.

If they follow the trend and find photography to their liking, they'll be chief photographers in studios. The Assistant Photographer is the nearest employee in the photographic world to the traditional Old World apprentice. An astonishing number of top photographers of the fashion world and the lucrative advertising illustration field trace their beginnings in photography to the opportunity to be a studio assistant.

New Assistant Photographers learn that a studio apprenticeship starts at the bottom -- sweeping the floor. The purpose of this exercise is to teach photography's most cardinal rule: cleanliness is NOT next to godliness; it is godliness. Dust, grit, air-borne particles of soot, flora, moisture and so on are the enemies of quality results. The Assistant Photographer will be guardian of the condition of the studio, finishing laboratory, and sometimes, both the film and print darkrooms.

When the studio is in operation and a bride or a frozen ice cream dessert is the sole concern of the photographer, the distractions of phone, doorbell, or darkroom timer become the province of the assistant. When there is not enough sand, too much heat, a need for more breeze to flutter a skirt or ruffle foliage on a rented palm, it is the Assistant Photographer who must take instant action. When the baby cries for warm milk, and the view camera needs more film holders, and the model is just dying for a cold drink, it is the Assistant Photographer who proves that some people do have more than two hands.

In return for cleaning up the sand in the evening so as to scatter plastic snow the next morning, developing all of the black-and-white rollfilm and ordering sandwiches

delivered for the client, models and the studio crew, the Assistant Photographer becomes the conferee of the photographer, reviewing in whispers, for example, how it might be possible to add light to a background without spilling it onto the model. He will often confirm meter readings for floodlights and make flash-exposure tests before the two hundred dollar-an-hour models arrive for the shoot. In the field, he will carry baggage to taxis, count luggage coming off the airport baggage carousel, arrange for hotel rooms, and handle cash and receipts that will confirm later studio billing to accounts.

The pay ranges from almost nonexistent to modest; the hours are long, and the work is hard. But three months as an Assistant Photographer in a leading studio is equal to three years in any photography school and provides a strong foundation for building a career.

See also Baby and Child Photographer, Specialty Studio Photographer.

JOB DESCRIPTION • Maintains camera equipment, loads and unloads film, develops test rolls and film sheets, adjusts lighting, provides all personal services for the working photographer.

TYPICAL ASSIGNMENT • The studio has been assigned to photograph ten pages in a product catalogue, which includes five pages of fashions with sample clothing available to the photographer for forty-eight hours only. The Assistant Photographer determines that background colors in paper rolls are on hand in the colors selected by the art director; that the film for the cameras is on hand in sufficient quantity; that the dressing rooms are neat and tidy with enough coffee, cream, sugar and cups; that arrangements for the models and any necessary props (gloves, hats, umbrellas and so forth) are on hand from rental sources. As the shoot begins, the Assistant Photographer will keep track of expended film, adjust lighting as directed send exposed film to the laboratory in properly designated batches fill special requests for sandwiches, take messages, call taxis, and so on.

CLIENTS AND EMPLOYERS ● Advertising and bridal studios, school yearbook portrait contractors, commercial studios primarily in the ten largest U.S. cities, and in-plant studios of the giant corporations.

TRAINING ● Minimum of two years of full-time photography school or a longer period of study at college where photography was only one of the majors studied; or three years of military photography.

SALARY ● Starting assistants often are paid only the national minimum wage or a slightly higher salary, plus an occasional year-end bonus of two to four weeks salary.

RECOMMENDED READING ● Perry, Robin *Photography for the Professionals*. Waterford, Connecticut: Livingston Press, 1976; *Professional Photographic Illustration*. Rochester, New York: Eastman Kodak Company. Publication 0-16. 1989; *Photo District News (magazine)*. 49 East 21 Street. New York, NY 10010. Kieffer, John N. *Guide to Professional Photography Assisting*. New York, NY: Allworth Press, 1991.

Audio-Visual Specialist, Electronic

His studio has no cameras; it is equipped instead with personal computers. The operators have no darkrooms; they depend instead on a stack of diskettes which will make the wildest days at Walt Disney animation studios look like beginner classes in art.

The Electronic Audio-Visual Specialist starts with a script and a stack of slides or a batch of prints and his thousands of pre-digitalized images, all on stand-by. Each item is waiting to be called into action on the computer monitor.

At the Portland, Oregon studio of Ron Panfilio, the daily photography output is shipped across America to Fortune 500 corporation clients of the all-electronic audio-visual center. The studio's output is a stream of training aids, sales presentations, speech illustrations, service case histories ... most of it as 35mm slides electronically generated in this no-camera, no darkroom studio.

The miracle of a studio without a camera starts with desktop computers specially set up with software capable of generating millions of different colors as backgrounds or as titles. With the computer already storing thousands of images, bringing up a specific image onto the screen is about as simple as dialing the telephone for the Information Operator.

Photos or drawings, parts of photos or parts of drawings, type in any font size and in any color are all combined on the screen with the art. The merged image is then processed into a new memory, and Slide No. 1 is finished. Images not in the computer may be "scanned" to fit the technology of the computer system.

The same work with a camera would require typesetting, combination color-merged slide images, and 2-3 days of effort by typographers and processing labs along with stand-by guidance from the studio with the assignment. Electronics is near-instant, with no material costs and less man-hour time per image. It is faster, cheaper, professional -- and Better!

The electronically driven system has three performance options. Panfilio spends about half of his time providing slides made from his rolls of computer-exposed rolls of 35mm color film. Processed standard slides are only an hour or so away. Federal Express has the completed slide show on the client's desk before lunch anywhere the next day in the U.S. But he may also be asked to deliver only a diskette. At the showing, a computer loaded with his diskette is linked to a projector that projects a 12-16 foot full color image on screen for an auditorium-size audience. But that's not all. He can link his computer directly to the computer at the offices of the client anywhere in the world by telephone line, sending pictures instead of words in normal computer (modem) telecommunications (Electronic Bulletin Boards).

TYPICAL ASSIGNMENT • The FAX machine brings in a list of 12 slides required in 48 hours at a trade show meeting in Las Vegas. The client requests that images from a recent meeting with his salesmen be incorporated along with new material to be created on screen in the studio. The new images include titles and some standard sunrise, sunset, and boats-at-sea effects. One set of 35mm slides must meet the client's VP, Sales by noon at the Las Vegas Hilton.

CLIENTS AND EMPLOYERS • The major users of the electronically-generated audio-visual aids are large corporations, hospitals, banks, various government offices and sales organizations.

SALARY • The electronic imaging studio has a large investment in computers and all of the related system aids to process electronic data in such a way that a color slide is formed. The operator will be trained by the studio owner, and a starting salary will be modest, befitting the specialist-apprentice.

TRAINING • Electronic imaging is taught at Rochester Institute of Technology and in some branches of the military, especially Army and Air Force.

RECOMMENDED READING • *A-V Video (magazine)*. 25550 Hawthorne Blvd Torrance, CA 90505; Larish, John J. *Industrial Photography (magazine)*. 445 Broad

Hollow Road Melville, NY 11747; *Photo Electronic Imaging (magazine).* 1090 Executive Way Des Plaines, IL 60018; *Presentation Products (magazine).* 513 Wilshire Blvd. Santa Monica, CA 90401; *Understanding Electronic Photography.* Summit PA: TAB Books.

Audio-Visual Specialist: Photographic

As America has changed from its role as a producer nation to a more service-oriented society, the art of selling has become a developed science. Photography has always played a part in education, and in the last half of the twentieth century, still photography has belatedly followed the movies with sound presentations to stir the emotions. The photographer with the special skill to link the visual image to words and music can become successful as an Audio-Visual Specialist.

In nearly every moderate-sized city, clients need slide sequences, filmstrips, television identification slides, animated illustrations and other special effects. The Audio-Visual Salesman must find the client; the Audio-Visual Photographer must capture the imagery; and graphics and sound experts enhance the production in their own areas of expertise.

Growing at 22 percent per year according to the Eastman Kodak Company and now serving five hundred thousand companies, the Audio-Visual Photographer creates his productions from theme material provided by the client. The need may be support materials for a speech, a series of business charts, photographs or drawings of new products, catalogue sheets, prototype photographs, factory scenes, or other essential project information. The slide show or film strip may be used to educate salesmen or production-line workers. It may be used to enthuse the company's dealers or even the customer.

Standard Oil Company of Indiana has a special audio-visual team. They annually make more than 175,000 slides to meet corporate requirements of Standard and its Amoco subsidiaries. The operation is based in downtown Chicago. In recent years, two of the senior photographers shared such assignments as a cold-weather project in Alaska and a study on overseas duty for oil company personnel shot in Egypt. In Peru the company needed photographs of its floating drilling platform.

The total team to make just this audio-visual section function exceeds twenty-five, with both photographers and artists providing input to the creation of slides, films, booklets and other projects assigned to the group.

The photographer can work on a table with equipment smaller than a darkroom enlarger. He can reproduce all or part of a 35mm slide or even a strip of amateur motion-picture film. He makes photocopies of photographs, artwork, charts and typography on 35mm for slides or in the half-frame size of the film strip projector. He copies from books, maps and computer printouts. With the magic of his systems, he can make black-and-white photographs appear in red and blue. He can double-expose, create montages, use multiple-image lenses for other special effects. With the marriage of some of these photographs to silent electronic "beep" signals in a tape recorder, he can generate shock and surprise when a cannon booms as the "explosive" news of a new product, price or service flashes on screen.

It is from the ranks of such Audio-Visual Experts that Hollywood has selected the special effects teams who generate the screen and TV excitement for their futuristic and experimental footage.

See also Audio-Visual Photographer, Electronic; Commercial Photographer; Industrial and House Organ Photographer.

JOB DESCRIPTION ● Provides knowledge of special photocopy equipment for photographing artwork, typography, stock photographs and other illustrative material. Coordinates musical backgrounds, special sound effects and other mood-creating visual or sound signals to fulfill script objectives.

TYPICAL ASSIGNMENT ● A bank seeks to speed the education of tellers for planned new branches. The training course materials and the script of a proposed film have been provided. Working entirely at his workbench with copy cameras, slide duplicating equipment, color filters, multiple-image lenses and other optical aids, the Audio-Visual Expert makes the photographs for a film strip sequence within two days. A recording

studio during that time has made a voice recording of the male announcer reading by the script. On the third and fourth days, the slides and script will be synchronized with an inaudible "beep" signal system. Musical lead-ins selected from hundreds of special recordings of suitable theme music are played during the titles, and sound effects of in-bank noises are added to the final production on the fifth day under the photographer's direction.

CLIENTS AND EMPLOYERS • Novice photographers may find employment in existing A-V production companies, in the graphics departments of universities, in large corporations, and some government agencies. Film and television centers, laboratories, special effects companies and other graphics services are often potential employers. Some commercial photography studios maintain A-V departments.

TRAINING • Two years of college or photography school, or three years of military photography.

SALARY • Entry-level apprenticeships start at $12,000-$15,000. Experienced A-V photographers who are department heads will earn approximately $25,000-$35,000 per year. Independent A-V photography company owners may have higher earnings, depending on business opportunities.

RECOMMENDED READING • *Audio-Visual Communications (magazine)*. 445 Broad Hollow Road Melville, NY 11747; Kemp, Dr. Jerrold, *Planning and Producing A-V Materials*. New York: Harper & Row, Publishers. 1980; *Planning and Producing Slide Programs*. Rochester, New York: Eastman Kodak Company Publication S-30. 1990.

Baby and Child Photographer, Chain Store

At Sears, at J.C. Penny's, at F.W. Woolworth's, at Caldor's in the East and its equivalent mini-department store chain to be found in malls across America, tens of thousands of American families have found an amazing value in professional photography. The under-$20.00 photo package makes possible quality (even if mass-produced) color photography of the youngsters of the family.

Announced with advertising in the local newspaper, with "99-cent"coupon distributions and flyers tucked under windshield wipers on every parked car, and with prominent signs and even reservation clerk desks at every entry, it is almost impossible for American families three and four times a year not to be aware that their communities are being visited by the Chain Store Baby and Child Photographer.

A direct offshoot of the School Photographer system which makes each student a captive subject, the visiting chain photography team offers both a way for the retail store to attract customers and for the store to add a small profit for a periodic ten-day loan of a tiny section of the floor space.

The crew of two which arrives at each location can travel in a single van or station wagon with backdrop system of changeable scenic or abstract patterns, a camera using long lengths of 70MM rollfilm and a simple electronic flash set-up which assures perfect exposures through each day of the stay. The deposit required at each sitting covers the cost of materials so that even if there is no customer satisfaction, there is only loss of time, less than ten minutes per family!

This mass-production look-alike picture making may not be the most creative way to quality portraiture, but the family expecting a "smile-at-the-camera" portrait gets more than its money worth in numerous prints, large and small. The sale may swell well beyond the $8.95 or $19.95 offer if the photo is especially satisfying and many larger prints are ordered.

The new photographer gets onto a team by checking with the Store manager in his own area to learn the name of the photography company providing the in-store program. With some luck, an apprenticeship opens, and the newest member joins the team. He learns the techniques of small studio portraiture in a single week as an extra hand on an experienced crew. Then it's into a car of his own with a clerk-assistant.

This is like Cruise Photography, but there is no boat; the store will be at the same port each day of the visit! Success in this field could lead to ultimate management of a Main Street studio of one's own.

See also Baby and Child Photographer, Home and Studio; Bridal and Wedding Photographer, Traditional; Specialty Studio Photographer, Novelty.

JOB DESCRIPTION ● Operates a special longroll 70mm camera including loading and unloading of film which must be sent to a distant city for processing. Suggests backgrounds from among the 6-12 rolled backgrounds available for each customer, adjusting color of background to clothing of the sitter. Sets lights to illuminate subject, watching for hard shadows under hat brims or strong forward curls. Plays with toys to attract a smile from each tot. Takes two exposures per child and suggests possible additional sales by including parents in further exposures.

TYPICAL ASSIGNMENT ● The parent arrives as scheduled with twins dressed in identical garb. Mother insists on a blue background which will provide a dark setting for the pastel blue dresses of the little girls. Sits the children on two boxes, facing towards mother who holds lollipops. Tries to win smiles to meet mother's idea of the photo she seeks.

CLIENTS AND EMPLOYERS ● The employer is the chain photography company located at the processing plant in a distant city. Contact is made by seeking employment information from a member of a visiting store crew.

TRAINING ● Two years of college photography classes or two years at a private photography school.

SALARY ● Employer will pay $12,000 - $15,000 per year plus a mileage and per-diem allowance.

RECOMMENDED READING ● *Professional Portrait Techniques*. Rochester, NY: Eastman Kodak Company. Publication O-4. 1987.

TRADE ASSOCIATION ● Professional Photographers of America, 1090 Executive Way, Des Plaines, IL 60018.

Baby and Child Photographer, Home and Studio

The portrait of the baby next door has been the start of a million photographic careers the world over. Taking pictures of the neighbor's child is about as natural a start-up opportunity for the novice pro photographer as the equally certain silhouette he'll make of the tree, bridge or lamp against the sky.

Baby Photographers fall into a number of categories: those who make appointments for sittings in the home; those who open "Main Street" studios for formal sittings; others who specialize in providing everything from in-hospital newborn portraits right through to a regularly scheduled camera coverage of baby's progress for twenty-four or thirty-six months.

Of all kinds of photography, child photography may be the most fun. According to Joseph A. Schneider, "Photography of all kids must become a recreational activity and not an ordeal...a game between yourself and the child."

Today's studios are using 70mm roll-film in larger single-lens reflex cameras. Some use 35mm cameras. Each type is small enough to permit good angles and quick posing changes.

It's easy to start with confidence when one has built a portfolio of sample portrait successes. A portfolio of samples is better than a college degree in winning an entry-level job in any local portrait studio or in chain systems operating in department stores and banks. An independent career can start with a 35mm camera, some flood-lights, and the support services of mail-order photofinishers. These photography factories are specially equipped to meet the demands of the professional and are readily found among the advertisers in *The Professional Photographer* and *Studio Photography* magazines.

See also Chain Store Baby and Child Photographer, Specialty Studio Photographer.

JOB DESCRIPTION ● Operates 35mm and 6x6cm cameras in the home or in formal portrait galleries. Maintains a professional manner with the parents and utilizes a skilled psychological approach with each child to insure professional results.

TYPICAL ASSIGNMENT ● A family has agreed to have a four-year-old tot photographed at ten o'clock in the morning. The photographer arrives by a quarter to the hour and sets up lights in the largest room available. He gets acquainted with the child's toys and favorite games. The youngster meets the photographer as a friend. They play games, often using the flashing lights that will be required, before the photographer brings the camera into the scene. After a while, the game changes to permit a number of exposures. The photographer packs up by eleven o'clock to depart for his next appointment and will make four to six such stops each day.

CLIENTS AND EMPLOYERS ● Baby Photographers are self-employed or employed by chain photography companies or in "Main Street" studios.

TRAINING ● Photographic experience should be a minimum of six months in photography school or three years in military photography.

SALARY ● Door-to-door photographers are paid a small amount per sitting (to cover travel costs and time) plus a substantial share of the final sale if the sitting is successful. Small studios pay apprenticeship salaries at entry level, but photographers can earn $20,000-$25,000 after some years of experience.

RECOMMENDED READING ● Salomon, Allyn. *Child Photography*. New York: Amphoto, 1981; *Photographing People*. Rochester, New York: Eastman Kodak Company. Publication AC-132. 1990; *Professional Portrait Techniques*. Rochester, NY: Eastman Kodak Company. Publication O-4. 1987.

TRADE ASSOCIATION ● Professional Photographers of America, 1090 Executive Way, Des Plaines, IL 60018.

Banquet Photographer

Many years ago, the sign outside a commercial photography studio might have read BANQUET-COMMERCIAL-COPY PHOTOS-ONE FLIGHT UP. The one assignment relished least was the occasional banquet.

Today's Banquet Photographer, equipped with small, extremely wide-view cameras and the truly portable electronic flash system, would find it hard to believe the effort required in the past to deliver one photograph showing thirty to forty tables of smiling guests. A special camera with a giant back had to be set up on a balcony or on a high tripod. Hundreds of feet of wire were strung along the balcony edge to fifteen or twenty flashbulbs, each of which cost nearly one dollar. At the moment the speaker called for attention, everyone looked up from his dining pleasures, and the photograph was flashed onto film. Without a number of assistants to replace the exploded flash lamps, it was impossible to get the "safety shot," a second negative of the event.

Today, the Banquet Photographer in almost any large city has a successful business because of wide-view cameras not much bigger than a 35mm camera. Just a few electronic flash units with a remote slave operation totally eliminate the need for wires along the balcony and make possible a number of exposures. Follow-up photography (the speaker at the podium or head table and dinner-table scenes) uses procedures long employed successfully by Wedding Party Photographers. These make banquet photography easy and profitable.

Banquets are scheduled months in advance, and the banquet department of every hotel and major restaurant maintains a registry of events to come. A meeting with the banquet manager and the promise to him of a modest commission will ordinarily open the registry to a photographer anxious to contact the chairman of each society's banquet committee.

With follow-up on all hotels and restaurants each week, the Banquet Photographer can develop assignments for months in advance. Some photographers

prefer the quick-handling 35mm cameras; others prefer the larger negatives of the twin lens reflex or the eye-level 6x7cm cameras. Giant banquet cameras are still made today. Processing can be provided by any commercial laboratory already serving the wedding trade. The photographer need not own much more than his basic cameras, lights and a car to reach his clientele.

An unusual advantage available to those with banquet camera skills exists for imaginative photographers like Ira and Judy Rosen. They have made a new career by photographing stadium views with the giant camera system. Their company, Stadium Views, makes large color photos for fans that, according to *The New York Times*, "captures the fans' attachment to ballparks."

Presumably the 20x30-inch photographs, unframed at $75.00 and framed at about $200.00 are only part of the income the Rosens receive. Their photographs are reproduced in smaller sizes too. Photographers with comparable equipment and skills could easily select subjects with appeals beyond that of sports.

See also Exhibit Photographer.

JOB DESCRIPTION ● Provides skilled use of special wide-angle cameras and extensive remote-control lighting for photography of dinner groups. Operates hand-held cameras and offers flash photography skills.

TYPICAL ASSIGNMENT ● The Chamber of Commerce in the city has organized an annual banquet to honor the retiring officers. The banquet department at the dinner site advises that forty tables will be set up with ten guests per table plus a head table. The photographer arranges in advance for a twelve-foot ladder; he sets electronic flash units with radio-operated remote-control firing devices and wall clamps on three sides of the hall. Photographs are made from the ladder for the overall view and for telephoto views of the head table and speakers. The photographer poses the retiring and newly elected officers in an anteroom or hallway before the dinner.

CLIENTS AND EMPLOYERS ● Few Banquet Photographers are employees except of major commercial studios in the largest cities. Most Banquet Photographers are self-employed, usually as a service of a commercial studio operation.

TRAINING ● Two years of photography school or the equivalent military training.

SALARY ● The earnings of self-employed photographers depend on the number of annual events covered, the charges per job and the related costs in commissions, materials and travel.

RECOMMENDED READING ● Cavallo, Robert M., and Kahan, Stuart. *The Business of Photography*. New York:Crown Publishers, 1981; *Photography with Large-Format Cameras*. Rochester, New York: Eastman Kodak Company. Publication O-18. 1988.

TRADE ASSOCIATION ● Intl. Panoramic Photographers Assn., 1739 Linwood Lane, Orlando, FL 32818.

Biological Photographer

The young scientist with a curiosity about how things work, why flowers bloom, how the human body resists disease, how to get more money to get a better camera, and with an invitation to visit the photography center of the large downtown hospital is already on the road to a great career: Biological Photographer.

This young man or woman is another potential Roman Vishniac who was called upon by everyone from *Life* and *National Geographic* magazines, the Eastman Kodak Company and DuPont to photographically reveal what their own photographic teams could not show them. Vishniac, in his photographic studio established in a living room of his cluttered Brooklyn, NY apartment was the consummate Biological Photographer.

His understanding of biological processes was combined with an exquisite understanding of photography through the microscope, by ultra-violet light, by filtration of his own design, and with optics he assembled for his systems. His pictures live on in countless textbooks of chemistry and biology and in life-process articles in major publications. He could make pictures in a fishtank or on a microscope slide. He was unique.

The world is looking for new Vishniacs. He and she will come from the ranks of the curious and the dedicated among America's young scientists.

See also Biomedical Photographer, Forensic Photographer, Police Photographer

JOB DESCRIPTION ● Provides a worktable studio for extreme close-up photography, microscope imaging and similar high tech procedures. Will offer electronic imaging for either still images or videotapes for processes best studied in extreme magnification.

TYPICAL ASSIGNMENT ● A major drug maker is experimenting with a new chemical to protect white blood cells and seeks photography of the actual moments when the chemical in the bloodstream reaches white cells. The Biological Photographer will take the maker's data and determine if the photography can be successful with laboratory

animals or in a test tube, in fresh blood drops or in another manner which meets the project specifications.

CLIENTS OR EMPLOYERS ● Biological Photographers are either independent specialists on call by government or private bodies requiring this specific capability or are employees of a major drug, food or agricultural center, university or experimental laboratory.

TRAINING ● The specialist skill level will require a well-trained photographer with a scientific background, possibly someone who might have been a doctor, a pathologist or some other medical practitioner. Training will be in photography and in the sciences, possibly with some laboratory experience at a hospital or animal care center.

SALARY ● As a specialist this photographer will command high fees for services not otherwise available to large corporations seeking technical assistance with "impossible" projects. As an employee of a hospital or laboratory, the photographer will enjoy normal technical staff salary levels and benefits. See Appendix for Government salary ranges.

RECOMMENDED READING ● *Scientific Imaging Products*. Rochester, NY: Eastman Kodak Company. Publication L-10. 1989.

TRADE ASSOCIATION ● Biological Photographers Assn., 115 Stone Ridge Drive, Chapel Hill, NC 27514.

Biomedical Photographer

His world is the hospital, and his laboratory may be part of the Pathology Department. He or she knows as much about body tissue and the reactions of tissue to drugs, dyes and shock as an experienced doctor and, especially, the pathologist.

He makes the photographs, usually as slides which will help preserve information that in the long run will save the lives of others. He has learned to slice tissue into thin segments that permit their examination on slides under a microscope and to make photographs through the microscope optics onto 35mm film.

He may be called upon to make photographs during surgery as a permanent record of a special procedure or in the morgue as part of a post-operative study. He is a team player with the doctors, nurses, laboratory specialists and others whose combined knowledge and dedication serve the public. He is a Biomedical Photographer.

It is not unusual for the skilled Biomedical Photographer to serve at an agricultural research facility; one recent graduate of the Rochester Institute of Technology has a position at the Montana State University's Veterinary Lab as Director of Biophotography.

See also Agricultural Photographer, Biological Photographer, Forensic Photographer, Police Photographer.

JOB DESCRIPTION ● Operates 35mm cameras and other special recording equipment necessary to create images necessary for scientific investigation or records needs of a major hospital, experimental center or other facility studying human or animal behavior. He is a key team member at a pathology center since he alone understands the use of "black" light or other systems which will capture images otherwise unseen by the human eye. He uses the electron microscope for photographic recording purposes.

TYPICAL ASSIGNMENT ● A tissue sample of unusual nature has been sent to the laboratory for study and identification. The Biological Photographer has been asked to photograph the sample as it has been presented, in major segments and then in tissue-

thin sections under the microscope. Slides will be kept for permanent identification of this unusual specimen.

CLIENTS AND EMPLOYERS ● Almost all Biological Photographers are employees of large hospitals, of all teaching centers for medicine, at various government health centers, at the U.S. Army Medical Department and in similar centers. There are very few independent Biological Photographers.

See also Agricultural Photographer, Biomedical Photographer, Botanical Photographer.

TRAINING ● A minimum two-year photography school course, or course completion at the Rochester Institute of Technology's Biomedical Photographic Communications, or three years at college with specialty classes in commercial photography. Courses in chemistry and biology will be a requisite. The hospital may require a laboratory assistant internship as a first position before entering into the photography area of lab operations.

SALARY ● The beginner assistant in the Pathology Laboratory will be paid a starter salary in the hospital staff salary schedule.

See Appendix for Government salary ranges.

RECOMMENDED READING ● *Scientific Imaging Products*. Rochester, NY: Eastman Kodak Company. Publication L-10. 1989.

TRADE ASSOCIATION ● Biological Photographers Assn., 115 Stone Ridge Drive, Chapel Hill, NC 27514.

Botanical Photographer

The why and how of growing things, the love of the search for a perfect specimen, and the patience for the close-up photography of delicate tendrils and fragile petals give the Botanical Photographer thrills. Part of such a career is to lend photographic support for scientific research efforts; part is promotion of botanical gardens and creation of publications for the nature lover; and the balance is support of the giant seed industry with its glorious catalogues of blooming plants that entice mail-order dollars from gardeners in every state.

Botanists are hard at work exploring flowers, leaves, stems and roots for the valuable ingredients that remain hidden in the 750,000 different species of higher plants on the face of the earth. Only 1 percent of these, according to Dr. Norman R. Farnsworth, head of the Department of Pharmacology at the University of Illinois, have been investigated. Photography plays a role in their identification and in record-keeping, from actual photographs of the species, its leaves, its blossoms and roots, to microfilm photography of the accumulated data for later review.

The Botanical Photographer may not always function in a laboratory or in a garden. Jeffrey Rotman had to plunge to a depth of 150 feet in the Red Sea to capture views along the 250,000-year old coral reef that offered feeding grounds for a variety of sea life. His results made an eight-page spread in *Discovery* Magazine.

The Botanical Photographer is a master of the close-up. His photography is often performed under less-than-comfortable conditions on marshy shorelines, only inches above the soil on frosty mornings, or in the humidity of an experimental hothouse. Usually working with a 35mm camera on a small tripod, he knows which lens and bellows arrangement is suitable for the 1:1 close-up of a fragile petal, and which zoom-lens aperture will provide the necessary depth of field for a sharper background. He learns to aim bits of mirror to bring gleaming highlights to a dark leaf and to aim a camera while supporting a velvet-black background panel behind a blossom.

The Botanical Photographer may be the cameraman for a research facility or for an agricultural corporation. He may have a government position with the Department of Agriculture or a civilian one with an environmental study group. He can also use his unique talents to create an entertaining assembly of photographs for major magazines such as *National Geographic, Natural History, Adventure Travel*, or science magazines.

Well-known magazine photographer, Patricia Caulfield, created botanical studies for a major feature of *Adventure Travel* titled, "Close-Up Okefenokee Swamp." The opening photograph of gray Spanish moss and a water lily set the mood for the writer, Sam Curtis, a Montana-based freelancer. Supporting photographs showed pine and palmetto hummocks on the swamp's dry areas, and a Georgia ground orchid isolated against a black background detailed three side-lit flowers on a stem. A close-up of a sundew plant with its long spines was shown in contrast to a general view of cypress trees and the extended root system within the swamp.

The interest in botanical photography may start with the hobby of gardening or as a by-product of one's college science courses. Development of skill in the field is as easy as a walk through any garden with a camera. It takes only one roll of film to begin to develop a sense of the need for the macro lens, the bellows, the zoom with tele-extender, and other tools that help get one in close and up close.

If science is your thing and photography is your tool, there's a role in botanical photography for you. You can find it first in your very own garden.

See also Agricultural Photographer, Biological Photographer, Biomedical Photographer, Forensic Photographer, Wildlife Photographer.

JOB DESCRIPTION • Combines expert knowledge of photography with a scientific knowledge of plant life. Uses camera appropriate for field trips. Offers experience in studio systems for plant details best created indoors under controlled light situations.

TYPICAL ASSIGNMENT • An experiment in cross-pollination will be photographed starting with the actual individual plant types and then showing plant growth in stages through emergence from the soil, slow maturation, and then blooming.

CLIENTS AND EMPLOYERS • Few Botanical Photographers operate as independent photographers except for freelance magazine work. Invariably the Botanical Photographer is an employee of a college, agricultural business (a major nursery, seed seller or food grower), or of a government agency conducting plant-life research.

TRAINING • A minimum of a four-year college program in the natural sciences, combined with a minimum of two years of college or military photography, or an apprenticeship at a commercial studio for six months to one year.

SALARY • Botanical Photographers will usually be paid in a range from $20,000-$30,000 per year. See Appendix for Government salary ranges.

RECOMMENDED READING • *Scientific Imaging Products*. Rochester, NY: Eastman Kodak Company. Publication L-10. 1989; *Audubon (magazine)*. 950 Third Ave. New York NY 10022.

TRADE ASSOCIATION • Botanical Society of America, c/o C.J. Anderson, U. of Ct., Storrs, CT 06269-0043.

Boudoir Photographer

Some believe that the growing requests for a "glamour" photo from single and married women, or from husbands-to-be or from longtime husbands stem from the personal freedoms of the last half of the twentieth century.

Some believe that the desire to be photographed in a negligee, in a bedroom setting, or almost entirely in the nude stems from the freedom of the woman from the limitations of an at-home sheltered life. Some suggest that a new personal self-confidence has created a widespread acceptance of the human body in contrast to the constraints of Victorian Era modesty.

American mailboxes are stuffed with catalogues from Victoria's Secret, a mailorder firm specializing in deliberately revealing underwear and bedroom garb. These have a delicacy and a high-fashion design that set their undergarments apart from the boldly wicked and mostly theatrical brassieres, panties and hosiery created by and for Frederick's of Hollywood, a company which long dominated the naughty-costume look.

Victoria's Secret has opened shops in shopping malls around the country, and the success of its merchandise has led buyers for traditional clothing stores to also offer delicately suggestive garments.

With items from such a wardrobe, and with the years flying away, many couples and many women seek to stop the clock forever with tastefully created provocative poses suitable for the privacy of Memory Lane and probably not for the wedding album.

So the Boudoir Photographer was born. There isn't a portrait photographer anywhere who does not look forward to sessions with a revealingly clad client seeking to be urged to "look sexy."

The monthly magazine of the portrait industry is *Studio Photography*. Its pages occasionally offer examples of successful boudoir photographs. Its advertising for

training programs and products includes offers of manuals, videotapes and lectures at seminars on the "secrets of posing" and "Boudoir Photography Made Easy."

Whatever the reason, whether it is the traditional wedding photographer accustomed to asking the bride to pose revealing the traditional blue garter on a well-shod leg or the bride herself boldly requesting a photograph a "bit more daring" ... the Boudoir Photographer emerged.

See also Bridal and Wedding Photographer, Specialty Studio Photographer, Theatrical Photographer.

JOB DESCRIPTION • Equipped to take photographs with 35mm, 6x6cm, 6x7cm or larger format negatives, he has the suitable array of small lights for close-up and full-length portraits to be created in the confines of an actual home setting or in a corner of a portrait studio on a chair, couch or lounge. He is prepared to make photographs in b/w or in color. The client usually provides appropriate costuming.

TYPICAL ASSIGNMENT • An actual case history: The client had received a hula dance costume from a husband stationed at a military post in Hawaii. He had requested that she pose in it for him, but he specifically stated that this was not to be an amateur indoor photo made by a willing friend. He suggested that the couple's wedding photographer make the photographs to fill his fantasies until his return from overseas.

CLIENTS AND EMPLOYERS • Clients are either females or couples seeking a set of sophisticated images of the wife or bride-to-be: slightly more revealing than a traditional portrait, slightly more risque than a wedding album photo. They may bring specific photos from books or magazines to illustrate their tastes in garments and poses.

TRAINING • The successful boudoir photographer will need two years or more of private photography schools or three years of college courses. The training period is considerably less for the apprentice in an active portrait or wedding studio.

SALARY • The salary of a boudoir photographer will vary by a number of factors with starting salaries at $12,000 to $15,000. An independent photographer, sometimes

sharing space with an existing portrait or commercial studio, who can attract a boudoir-portrait clientele will usually enjoy significantly larger earnings.

See also Specialty Studio Photographer.

RECOMMENDED READING ● *Photographing People*. Rochester, NY: Eastman Kodak Company. Publication AC-132. 1990; *Studio Photography (magazine)*, 1090 Executive Way, Des Plaines, IL 60018; Numerous library books on portraiture and figure photography.

TRADE ASSOCIATION ● Professional Photographers of America, 1090 Executive Way, Des Plaines, IL 60018.

Bridal and Wedding Photographer, Photographic

For the family committed to spending thousands of dollars for a formal wedding, the arrangement with the photographer is not considered an extravagance. The lifelong souvenir album for the bride and groom and for the parents of each of the happy newlyweds, plus a framed enlargement of a formal portrait for the home of the bride, makes this happy occasion even happier for the photographer.

The Bridal Photographer may be commissioned to provide only the documentary coverage at the ceremony and subsequent dinner party locations, but more customarily, the photographer is also engaged for formal portraiture at a studio in advance of the ceremony itself. When religious ritual or local custom makes a prewedding studio visit impossible, then the formal photographs are made in a hallway, sitting room, in a garden or other facility on the wedding day.

In most instances Wedding Photographers are owners of established studios with reputations built over years of exposure of sample wedding portraits in studio window displays. Many studios are so successful in their locale that simultaneous weddings make it necessary for the studio to hire contract Wedding Photographers or to employ staff members who are darkroom aides during the week and cameramen during the busier weekends.

It's easy to see how big the market is in any community; the figure for weddings each year is 10.7 per 1,000. In population zones with 100,000 that's well over 1,000 weddings per year. A new photographer who could capture only five percent of the market (50 a year) would be doing one wedding a week, an excellent and profitable start for any studio business.

Photographers hope to write orders for $350-$700 per wedding, but Monte Zucker of Silver Springs, Maryland, has commanded $1,500-$3,000. Helping the business to grow profitably is the aim of a special annual convention of Bridal

Photographers - Wedding Photographers International, an event well publicized annually in magazines such as *The Professional Photographer* and *Studio Photography*.

Ellen Bak, a professional in Orange County, California for ten years, has written that her typical customers spend between $1,000 and $1,500 per wedding, but many spend $2,000-$3,000. Package prices start from $795 for three hours of shooting time and provide a fine bridal portrait plus two albums for the bride and her mother. Nationally, $350 usually buys a professional album of twenty to thirty-six prints.

Wedding Photographers advise anyone interested in the field that the most difficult aspect of the art is not the photography; it's winning the contract from the cautious parents of the bride. Sample books of photographs will be reviewed and then some estimate of the potential costs for albums, enlarged prints and frames must be discussed.

There is a new wrinkle in wedding photography. Chris Norris of Cleveland, OH provides an electronic image preview of the entire wedding album with the parents and the bride-and-groom seeing the wedding unfold on a TV screen ... before ordering the albums and enlargements.

In the smaller communities of America, the typical portrait studio has a long-term family clientele. Families will likely turn to these studios for their wedding requirements, confident of their proven skills. In the larger communities, wedding photography freelancers make contacts through caterers, florists, bridal shop proprietors, and others who may have advance knowledge of a wedding schedule. From these sources, the freelance photographer obtains names to be researched. Phone calls and mail solicit an appointment for a personal visit with a sample album.

Both the wedding studio and the freelance Wedding Photographer have the bulk of their film processing and proofing finished in mail-order commercial laboratories. Their mass production not only assures economical processing, but it also assures a

higher standard of quality than the small town studio or the private processor working from his basement darkroom can provide.

Within a few days of the wedding or after the honeymoon, the photographer may invite the bride and groom to visit the studio to preview an electronic version of the album. This will be produced by the Kodak Photo CD Imaging Workstation, a system which only needs the negatives to provide a TV image of the finished print.

Examples of large prints, wood and other frames, and a price list are shown in the hope of an even larger-than-typical order of $500-$700 for the day's work. Even if the bride takes only the minimum print order provided for in the prewedding arrangement, the photographer has earned a handsome day's pay.

Franklin Matula, a former Wedding Photographer from Waco, Texas, has created a series of seminars entitled "Getting Started in Wedding Photography." These two-day study groups are held all over the country in meeting rooms at local inns. For details and costs, write to National Photography Seminars, 1101 North Fifty-sixth Street, Waco, TX 76710.

See also Boudoir Photographer, Baby and Child Photographer, Specialty Studio Photographer.

JOB DESCRIPTION ● Provides skills in studio and hand-held cameras for portraits and group scenes. Displays knowledge of remote-control flash photography. Operates studio view cameras for large negative photography. Has complete videotaping capability with post-wedding electronic editing for titles and sound effects.

TYPICAL ASSIGNMENT ● The photographer may be employed from the start of the day to photograph the dressing of the bride, formal portraits at the studio prior to arrival at church or temple, ceremony, reception party and dinner scenes.

EMPLOYERS AND CLIENTS ● The Wedding Photographer may be a self-employed photographer without maintaining a traditional photographic studio. The Wedding

Photographer may also be a part-time or full-time salaried employee of an established portrait or wedding studio.

TRAINING ● Basic camera crafts may be learned in two-year college photo programs, in one-year photography schools, and in military photography. Wedding Photographers are developed as apprentices to seasoned cameramen.

SALARY ● A weekend photographer working as a wedding specialist may earn $100-$150 per wedding. The studio owner with a successful wedding business may earn $50,000 and up per year, depending on business acumen, size of the local community, and the extent of competition.

RECOMMENDED READING ● Campbell, Keith. *Make Money with your Camcorder.* Amherst NY. Amherst; Gunn, Rocky. *Wedding Photography.* Los Angeles CA: Peterson Publishing, 1978; Lewis, Greg. *Wedding Photography for Today.* New York: Amphoto, 1980; *Media.* 418 Homecrest Dr. Amherst, NY 14426 ($17.95 + 2.50 s/h.)

TRADE ASSOCIATION ● Professional Photographers of America, 1090 Executive Way, Des Plaines, IL 60018; Wedding Photographers of America, Inc., Box 66218, Los Angeles, CA 90066.

Bridal and Wedding Photographer, Videographic

It was once a luxury for only the wealthiest of families. Few families at one time had the VCR (video cassette recorder) on which to re-enjoy a video of the wedding experience. But when American homes became saturated with video players and home-owned video cameras, the concept of the wedding without a video production was as unlikely as a wedding without a wedding cake.

The Wedding Videographer today is as much a part of the ceremony as the Wedding Photographer. The wedding photographer generally employs an assistant to hold the main light on a boom over each table or above the bride at most moments. Similarly the Wedding Videographer employs a boom-man for the light and, at times, for the sound.

Unlike the photographer creating an album of prints, the Wedding Videographer concentrates on the actual wedding itself, the arrival moments at church or temple, the ceremony, the reception line, the overall dining scene, close-ups of the cutting of the wedding cake, and then the dancing if this is part of the celebration.

The Wedding Photographer puts away his camera outfit and sends his negatives to a processor. The Wedding Videographer only then goes to work. All of this raw video footage must be assembled into a comprehensive entertaining videotape for VHS playback: titles, special effects, appropriate music, closing moments.

The technology for this part of the production is costly equipment with both audio and video capabilities.

See also Audio-Visual Specialist, Videographic; Specialty Studio Photographer, Videographic

JOB DESCRIPTION ● Provides full video location service using camcorder, lights, sound-mix equipment and support accessories.

TYPICAL ASSIGNMENT ● The bride and groom request a 45-minute production of their wedding to include: titles, special visual and sound effects, outside scenes, scenes

of the still photographer at his work, scenes of the chef and kitchen team, the bridesmaids helping each other during pre-ceremony; the ceremony, and the dining hall scenes. Departure by limousine to the airport will end the videographer's footage. Later the clients will add videotape from their honeymoon resort to be incorporated as closing footage for the production.

EMPLOYERS AND CLIENTS • Clients are the prospective brides and their families or a wedding studio who will sub-contract the video portion of a contract to provide wedding photography services.

TRAINING • The Wedding Videographer will get his best training as an apprentice in a wedding studio or two years at a private photography school. Film and Video College, 925 N. La Brea Ave., Hollywood CA 90038, offers degree programs in Video Production.

SALARY • An independent videographer will charge by the production with a complicated project starting at $1200 to $2500. If he can secure one wedding per month, he can make $25,000 - $35,000 after all costs of operations, assistants, raw material, travel, etc.

RECOMMENDED READING • Campbell, Keith. *Make Money with your Camcorder*. Amherst, NY.:Amherst; *Media*. 418 Homecrest Dr., Amherst, NY 14226. ($17.95 + 2.50 s/h.); *Videomaker (magazine)*, P.O. Box 4591, Chica CA 95927; *Videotape Editing* (64-min. video). Special EFX Productions. 18350 Mediterranean Blvd. Miami, FL 33015. $50.00.

TRADE ASSOCIATION • Professional Photographers of America, 1090 Executive Way, Des Plaines, IL 60018; Wedding Photographers of America, Inc., Box 66218, Los Angeles, CA 90066

Commercial Photographer

In every major city of the United States and in areas where there are heavy concentrations of industries and especially printing and publishing, the *Yellow Pages* telephone directory is a direct reference list to the world of commercial studio photography.

The Commercial Studio Photographer is equipped to create photographs of glass, metal, woven materials or baked foods in a style that would baffle the expert child photographer or wedding specialist. He knows that you can't photograph glass or plastic by playing lights upon their surfaces. He often works on a translucent glass-top table so that lights directed from below totally eliminate shadows cast by objects resting atop. His darkroom is stocked with the special commercial films of contrasts totally unsuited to the needs of the portrait or medical photographer. He mixes special developers which are matched to the unique characteristics of commercial emulsions.

His lenses and film sizes are alien to the photojournalist and to the sports photographer. His lighting systems are not ordinarily found in the portrait establishment. Many of his cameras have no shutters. He is accustomed to the time-exposure procedures with ten- and twenty-second or ten- and twenty-minute exposures necessary for photographing the proverbial black cat on black velvet in a coal mine at midnight.

Most commercial photography studios have two or three employees and perhaps a "go-for" (the messenger who goes-for coffee, a rented prop, or returns photographed merchandise to a client). However, like the famed Krantzen Studio of Chicago, it may grow to immense proportions: 350,000 square feet, a computer system that keeps track of 60,000 pieces of merchandise, with nearly 300 employees. There in not only a full-scale color finishing laboratory, there is everything up to a copywriting department. That's the kind of operation needed by such clients as Sears, J.C. Penney and Montgomery Ward. The 25 photographers have 38 assistants!

Industries that do not have their own photographic capabilities frequently require the services of a Commercial Photographer. He is often called by publishers and advertising agencies to provide specific photographic coverage, for example, the photographs of prepared foods in the advertisements in daily newspapers and in the food sections of the largest circulation magazines.

Food photography itself is a creative field that is not nearly as simple as one might think. Try making a few photographs of your next meal; then compare your photograph to the one on the package. In some photographs whipped cream will not come out nearly as well as shaving cream will. Peas that photograph too dark can be lightened by being cooked in bleach. Foods that seem to be glistening naturally on the page are probably spruced up with plastic spray or engine oil. This very specific area of commercial photography have such clients as magazine editors, food company publicists, or manufacturers of food-related products such as the waffle iron, the blender and the toaster; as well as the trade associations charged with public relations for the industry. General Foods and National Biscuit Company endlessly generate recipe books, press kits, reports to the industry and other printed aids, all of which depend on photography.

See also Advertising Photographer, Audio-Visual Specialist, Copy Photographer, Department Store Photographer, Exhibits Photographer, Museum Photographer, Photographic Administrator.

JOB DESCRIPTION ● Performs in a studio equipped with view cameras, lenses, lighting and an in-house darkroom suitable for the problems encountered in creating still-life photographs of home, food, clothing and industrial products.

TYPICAL ASSIGNMENT ● A handtools manufacturer famed for carpentry tools has decided to announce a new line of garden tools. The photographer has been asked to make individual tool photographs with each item isolated in a dramatic pool of white light. All tools are then to be photographed in the gloved hand of a woman.

Photographs will be released for publicity in trade and consumer magazines. Color photographs will illustrate the company's catalogue sheets sent to hardware stores and garden shops.

CLIENTS AND EMPLOYERS ● Printers, publishers, manufacturers, importers, sales organizations and others require frequent photographic services. Studios require a number of salaried photographers.

TRAINING ● Minimum of two years of photography school or three years of military service followed by apprenticeship as Assistant Photographer.

SALARY ● Commercial studio operators have excellent lifelong studio profitability, depending on such factors as nearby competition, business acumen and sales ability. Salaries for assistants start at $12,000-$15,000, and in large studios the experienced photographer will earn more than $35,000.

RECOMMENDED READING ● Corbell, Tony L. *The Ultimate Commercial Photographer's Handbook - Volumes I and II*. San Diego, CA: Colbur Publishers, Inc. [Looseleaf; features Sinar Bron studio equipment.]; Perry, Robin. *Photography for the Professionals*. Waterford, Connecticut: Livingston Press, 1976; *Professional Photographer's Handbook*. Logan Design Group. 6101 Melrose Avenue, Los Angeles, CA 90038; *Professional Photographic Illustration Techniques*. Rochester, NY: Eastman Kodak Company, Publication O-16. 1989.

TRADE ASSOCIATION ● Professional Photographers of America, Inc., 1090 Executive Way, Des Plaines, IL 60018.

Construction Photographer

Somewhere in the world this very minute there is a Construction Photographer at work in his hardhat. You'll find him at a dam, a bridge-building site, on a skyscraper or at a major industrial site. His job is as important to the project as the steelworkers, the foundation builders or the cement teams. His pictures assure the flow of money from the banks financing the project.

When something as large as a new oil refinery, a power station or a commercial or industrial building are to be built, photography is there from the beginning. The model of the finished product which has been assembled by the architect has to be photographed for the trade press. The photographs of the model will be attached to the papers furnished to document progress for the construction loans.

As the construction begins, there is area-by-area and step-by-step follow-up by the Construction Photographer for reasons as varied as the on-going publicity campaign or the planning needs of the engineering firm. In the event of a minor or major construction site disaster, those earlier photos will hold the key to the study of the roots of the trouble.

John Coffey II of Columbus OH, comes from a family of photographers. John is the third generation of a family that owned a company which started as a laboratory but which today is involved in a variety of photographic enterprises. When the family enterprise acquired a company which specialized in construction photography, it became his department. He now owns his own waders for sewer work, and his hardhat bears his name. There is no camera which is unavailable to him to meet the needs of the project. For aerial photography, for instance, his preferred camera is the motor-driven Pentax 645.

His start in construction photography was with aerial views of the site, some from just above ground level, only available from an airplane. But he soon learned that construction photography was not all the glamour of aerial work; his very next job was

to trudge six to seven miles through a 13-foot sewer project, to be available to document whatever the boss engineer asked.

"A typical job goes on for at least a year," says Coffey; some go on for two years. As with some of the other contractors, there are pay points at scheduled intervals, rather than per day or per-task payment. The job is won on the basis of a bidding procedure, exactly like the other work teams (plumbers, electricians, etc.).

See also Architectural Photographer, Industrial Photographer, Real Estate Photographer.

JOB DESCRIPTION ● Operates handheld and studio system cameras to meet the needs of indoor and outdoor photography for documentation and other requirements of the construction or architectural firm.

TYPICAL ASSIGNMENT ● A new shopping mall is to be erected in flatlands outside of the community. The photographer will launch total coverage with aerial views of the site, photographs of the first ground-moving, foundation-casting and the steelwork which will follow. Along the way he will make publicity photographs as requested with town officials, the sponsor, the officials of each major supplier of steel, cement, electrical systems, etc. for national trade magazines. He will provide weekly photo reports of construction progress, aerial views of the completed project, and finally photographs of the ribbon-cutting ceremony. The project will take 18 months.

CLIENTS AND EMPLOYERS ● The employer will be either the architectural firm, the construction firm with the major contract, or the project sponsor.

TRAINING ● The photographer will have commercial studio, industrial photography, experience following two years of college-level photography, or three years of military photography experience.

SALARY ● The photographer for an existing construction photography firm will be paid $25,000 - $30,000 as a self-starter, less as an Assistant Photographer in first activities for the new employer. The independent construction photographer will be

asked to bid on the total project, allowing for time, materials, travel and special costs such as aerial photography may require.

RECOMMENDED READING ● *Industrial Photography (magazine)*, 445 Broad Hollow Road. Melville, NY 11747; *Professional Photographer (magazine)*. 1090 Executive Way. Des Plaines, IL 60018. *Professional Photographic Illustration*. Rochester, NY: Eastman Kodak Company. Publication O-16. 1989.

TRADE ASSOCIATION ● Professional Photographers of America, 1090 Executive Way, Des Plaines, IL 60018.

Convention Photographer

Conventions fall into two basic categories: fraternal, social, religious and ethnic organizations meeting to honor their members for local club activities relevant to the purposes of the organization; and businessmen who meet so that their customers can visit prospective suppliers, spending days touring hundreds of booths and exhibits.

For the social groups, the Convention Photographer has the first two days of a three-day weekend event in which to capture four hundred to five hundred views of groups on color film. On the third day all of these photographs must be on display so that the guests can order prints prior to their departures. The objective is to sell three to five prints per negative, or a total of twelve hundred to twenty-five hundred orders at $3.50-$4.00 per print. This will provide a gross revenue of from $4,000 to $10,000, one-third of which will pay for the commercial photofinishing, leaving a balance (less the cost of film and the proof prints) as gross profit.

For the business convention, the photographer visits each display during setup time and leaves a business card and a price list for show photos. Return calls, with camera, are then made to obtain actual photography orders: display only; company officers standing in front of their display; close-ups of special aspects of the display, and so forth. Since these photographs will be sold at $15-$20 each, if from fifty to two hundred of the typical two hundred to five hundred exhibitors seek photographs for the record or for their sales promotion programs, the photographer will gross a revenue of $3,000-$10,000 for the few days' activity, less the cost of processing and delivery.

The opportunity for such convention photography has vastly increased as both state and regional, as well as national and even international groups, make local resorts, hotels, civic centers, giant auditoriums, special convention centers, and even cruise ships, fairgrounds and other large gathering places available for meetings.

In nearly every state, and especially in those states with proven resort interest (because of nearby ocean, lakes, golf, fishing, gambling and other activities and entertainments), established hotels offer excellent photographic career opportunities.

Would you like to live in Florida and enjoy year-round sunshine and daily work at conventions? The Orlando area has seen rapid growth because of the hundreds of millions of dollars invested by the Disney and M-G-M enterprises to bring profitable convention business to northern Florida. Southern Florida in 1990 alone hosted 525 Miami area conventions bringing in more than 625,500 delegates who spent in excess of $420 million dollars!

See also Cruise Photographer.

JOB DESCRIPTION ● Provides expert handling of 35mm and 6x6cm cameras. Directs operations of a color darkroom.

TYPICAL ASSIGNMENT ● With the objective of providing photographs suitable as souvenirs of a costly vacation, the convention photographer seeks to record the pleasures of games, pool activities, leisure in the sun areas, indoor photographs at all meals, and special occasions such as a holiday gala or other event. The photographer is responsive to the wishes of guests who seek special poses and also to the need for privacy of those who seek anonymity.

EMPLOYERS AND CLIENTS ● A number of companies have established contracts with convention halls, cruise ships and resort hotels.

TRAINING AND EMPLOYMENT ● Two to three years of college newspaper or yearbook photography; one to two years of photography school and/or service as a military photographer.

SALARY ● Salaries are small, but commissions are large. Annual income can be in excess of $20,000.

RECOMMENDED READING ● *Guide to 35mm Photography*. Rochester, NY: Eastman Kodak Company. Publication AC-95. 1989.

Copy Photography Specialist

One of the profitable sidelines of every portrait studio, every commercial studio and every photostat house is its copy photography center. Most photography there is aimed at quality copies of black-and-white photographs onto film specially created for requirements considerably different from those of ordinary portraiture, for example.

But what about photography of early sepia-toned photographs or of tinted photographs with blue skies and green lawns? What about copy photography of color pages from magazines, color prints from instant-picture cameras, or worse, from 8mm color film, or from aged Kodachromes? What color films will be suitable? What lens and camera setups and what color correction filters should be used?

The Copy Photography Specialist knows, or he has the materials with which to experiment his way to an acceptable result. Careful note taking, careful lighting, knowledge of polarizing filters and polarized light sources, an array of color correction filters, and different films arm this specialist with tools and technologies far beyond the capabilities and experience of the typical commercial photographer.

Being a Copy Photography Specialist is the ideal photographic occupation for anyone with a limiting physical handicap. It is the perfect career for the photographer who wants to be his own boss, to work in quiet confines and usually without the deadline pressures of the photojournalist or advertising studio photographer. He need not have the sales personality of the child, portrait or wedding photographer. He simply has to be the best Copy Photographer in town.

See also Art Photographer, Commercial Photographer, Darkroom Professional, Museum Photographer.

JOB DESCRIPTION ● Provides the special knowledge of copy-camera photography, including working familiarity with special films, filters, polarized and infrared lighting, and related technologies. Offers working knowledge of special photocopying equipment

such as the Repronar or Illumitran systems. Has working familiarity with 35mm close-up systems.

TYPICAL ASSIGNMENT ● The Department of Buildings has determined that records of architectural drawings of the city landmarks dating back to the nineteenth century have faded and blueprints are stained and bleached. The Bureau head has authorized copy photography to protect the basic information before paper aging has destroyed all data. The photographer selects films and filters suited to the task.

CLIENTS AND EMPLOYERS ● The Copy Specialist is a salaried employee of a large commercial studio, or he wins work from other studios, local museums, printers, artists, advertising agencies and others who require quality copy photography.

TRAINING ● Two years of college photography plus special courses in studio procedures; two years of private photography school; laboratory experience in any commercial or portrait studio.

SALARY ● The Copy Photographer is either an employee of a commercial studio or is self-employed. Salaries will be in the range of all Commercial Studio Photographers, starting at $20,000 -$25,000. The self-employed specialist with good business fortune can enjoy better earning power.

RECOMMENDED READING ● *Copying and Duplicating in Black-and-White and Color*. Rochester, NY: Eastman Kodak Company. Publication M-1. 1985.

Corporate Photographer

He will tell you that he doesn't know anything about technical photography, about how chemicals work, or about how cameras work. But he has been called one of the three top Corporate Photographers in America.

What is the Corporate Photographer? And how did Gary Gladstone of New York get to be one of the best? It's because he says he knows what pictures he wants and he'll do whatever it takes to get them. That confidence has made him the man that Wang Corporation, Pfizer, Inc., United Technologies, Price Waterhouse, Olin and Johnson & Johnson call when someone at a Board meeting demands, "Get our photographer!"

What he does is to illustrate what giant corporations do. He tells their stories in photographs that are in the Annual Reports that go to the Stockholders and to the Brokers around America who may have investment dollars to commit.

He started life as a prospective artist in the Art Student's League, and that driven sense of art and conceptual know-how means that he learned to make photographs that leap off the page. He got started as a newspaper photographer with just such a photo at an auto accident scene using a $3.50 Ansco box camera.

Now he travels the world with tiny footlockers of Nikon equipment and electronic flash systems. He usually travels with TWO footlockers, one a duplicate of the other in case of a lost luggage dilemma. He has had the thrill of being the Pratt and Whitney photographer for a three-day air show, commanding planes to land and lift off so that he could repeatedly shoot the puffs under the wheels at the instant of lift-off.

But being a corporate photographer, he says, isn't only sunlight photography at an airport. It also means that one day you will be sent down into a mine with a 44-inch ceiling. You will crawl through mud in blackness with rats at your feet to get to a mine point where someone who has never been in a mine wants you to make an exciting photograph!

Gary Gladstone's route to independence as a Corporate Photographer began with a few years of press photography followed by freelance assignments for magazines like *Seventeen, McCall's, Look* and *Life*.

Then one day corporate people with corporate budgets and corporate public relations needs call, and you are now a Corporate Photographer. You own no studio; occasionally you hire an assistant to fly with you and to carry bags and hold lights.

See also Documentary Photographer, Press Photographer

JOB DESCRIPTION ● Provides expert handling of 35mm equipment under difficult working conditions.

TYPICAL ASSIGNMENT ● The maker of the electronic timing gear that will figure prominently in the timing of Olympic ski races wants a photograph of their timer near the end of the ski run, hopefully with a large crowd and a thrilling moment of ski action. The photographer brings his kit of 35mm cameras, lenses, a small ladder and a Thermos of hot coffee.

EMPLOYERS AND CLIENTS ● The Corporate Photographer may be an employee of large corporations, or he may be an independent contractor. As an employee he will have Department Manager status. As an independent he will probably require an agent in one or more cities to locate work from large and medium size corporations who seek more skills than may be available in the local commercial photography scene.

TRAINING ● Prior work as a newspaper or documentary photographer.

SALARY ● As an employee he will command a salary of $40,000 - $50,000 with pension and other benefits. As a freelancer he will earn about the same if he is busy, sharing much of his income with his agent and assistants.

RECOMMENDED READING ● *Guide to 35mm Photography*, Rochester, NY; Eastman Kodak Company. Publication AC-95. 1989; Perry, Robin. *Photography for the Professionals*. Waterford, CT: Livingston Press.

TRADE ASSOCIATION ● American Society of Magazine Photographers, 419 Park Ave. South, New York, NY 10016.

Cruise Photographer

Guests arriving aboard ship know that their luxury vacations have really started as they step aboard a ship with a photographer on hand to greet their arrival!

They soon find that he or she is more on hand than the deck steward, the housekeeper or the table waiter. The Cruise Photographer has a boat load of clients who will find themselves in photographs alone at the gangplank, with friends at the fantail, and with the Captain if one is honored to be invited to share a meal at his table.

From the ports of New York and Boston in the Northeast and from the southern ports of Miami and New Orleans, gleaming white cruise ships, chartered from the major Greek, Dutch, German and Italian fleets, carry tens of thousands of American and Canadian vacationers to sea-borne adventure.

An annual tally of these vacations at sea reveals that one-quarter of a million passengers step aboard the gangplank each year. They are barely on deck when the first flash of the Cruise Photographer records their arrival.

The photographer with his twinlens reflex or 35mm camera will meet them after breakfast for posed pictures at the rail, at the shuffleboard court, at the skeet shoot, at the swimming pool, and at rest tucked under plaid wool blankets in lounge chairs after an active morning's athletics and a six-course lunch.

The cameraman may photograph each family greeted by the captain before the requisite Captain's Dinner, and again in their costumes assembled for the equally customary Costume Ball. Special activities for children, scenes on the ballroom floor, and a wall of candid exposures will join all the other photographs in a wall display which grows all during the voyage.

From the display, passengers may order one or a dozen of any of the photographs. In a darkroom aboard ship, color prints will be readied for delivery long before the ship docks. A family may spend from $20-$200 to bring back to shore-based relatives glimpses of their palatial life afloat.

The photographic team that makes this effort successful, even on small cruise ships, is usually a trio: Cruise Photographer, Assistant Cruise Cameraman and a Ship Darkroom Expert. The photographer meets a daily preset schedule during which five, ten, fifteen or twenty rolls of film are processed together. From these negatives, color proof prints, usually 5x7-inches, are readied.

To insure maximum financial success, and to prod the photographic crews to an effort that assures a large variety of photographs and quick service, small salaries for the work are augmented by giant sales commissions. The photographic team works twelve to sixteen hours each day and rests only after the ship has docked.

Photographers who head each of the ship crews are trained in assistant cameramen positions before assignments to crew leadership. The darkroom man has been trained by the maker of the automatic darkroom equipment or in apprenticeship on large ships. With no rent and food costs and little place to spend money, the sea-borne cameraman finds that a year or two in the sunny waters of the Caribbean will easily grub-stake a small dream studio in his hometown.

His earnings will be far in excess of those of his colleagues of the same age and experience, and the pleasures to be encountered in foreign lands, even if only one-day visits, are a further reward.

See also Convention Photographer, Resort Photographer, Specialty Studio Photographer

JOB DESCRIPTION ● Operates 35mm and 6x6cm TLR cameras and flash with ease.
TYPICAL ASSIGNMENT ● A one-week cruise to Bermuda from New York City has been announced was a passenger list of 400; a photography team is to be assembled. The ship has no equipment aside from a totally automatic darkroom for processing of negatives and prints. The team will meet two days prior to departure to define equipment needs and to assign hours and duties.

CLIENTS AND EMPLOYERS • The employer is the commercial photography company with the contract to provide ongoing shipboard photography service.

TRAINING • Prior work as a college press photographer for a daily or weekly newspaper; or three years of military photography.

SALARY • The salary of $40.00 - $100 for the week will be augmented by commissions which could be $150.00 to $250.00 for the week, depending on the success of the photographs offered.

RECOMMENDED READING • *Guide to 35mm Photography*, Rochester, NY; Eastman Kodak Company. Publication AC-95. 1989.

TRADE ASSOCIATION • American Society of Magazine Photographers, 419 Park Ave. South, New York, NY 10016.

Darkroom Professional

For many photographers, the joy of photography lies as much in the pleasures of darkroom creativity as in the act of picture taking. For them, a career as the owner-operator of a community photography laboratory or a salaried position as a Darkroom Professional is a way to get paid to have full-time pleasure. It's a way of owning the finest custom laboratory for personal use with all of its cost and a profitable business financed entirely by others.

Community photography centers have emerged as a result of the demands of superior color photography that require conditions totally unavailable to the average apartment dweller and which are only partially available to the suburban home-owner. Space for a darkroom may be found in a bathroom or in the corner of a basement laundry, but the custom laboratory - with circulating air, ample work tables, enlargers for both miniature and subminiature negatives and for the largest color negatives - requires space and investment beyond the means of the amateur photographer and many amateur photography clubs.

The operator of a community photography laboratory establishes a business that provides the equipment and expendables (papers, chemicals and so forth) on a profitable per-hour and per-box basis to the many thousands of Americans now enjoying a photographic avocation. His center has the opportunity to expand into other photographic areas: commercial photography, portraiture, weddings, outside daytime photo assignments during hours when the laboratory may be closed.

Since the demand for darkroom rental may be mainly at night, the full facilities are available for the personal or business use of the owner by day. The laboratory can provide custom finishing services for amateurs who require more photofinishing service than is within the capability of the local Fotomat or the mail-order photofinisher.

With rental income, sales of papers and frames, teaching income, and then occasional photo assignments, the laboratory can prosper. When growth has permitted

expansion of staff, the center can become the basis for other sales: photography in an adjacent shop, home portraiture, commercial photography on a card table setup, local scenics for calendar companies, and even stock photographs of the community sold from front-window displays or from displays at local hotels and better restaurants.

The thrill of owning or working in a custom photo laboratory makes one master of the work of a thousand cameramen, each dependent on the skills and expertise of the Darkroom Technician. Few of today's photographers realize that even the great master, Henri Cartier-Bresson, never entered a darkroom; his masterpieces were often generated from negatives salvaged only by the efforts of someone in the Paris darkroom where Cartier-Bresson prints were made.

Darkrooms develop more than paper; some become giant businesses. In New York City at Modernage Photographic Services, Inc., technicians serve the professionals of the world. This laboratory was once a one-room operation making prints for others in the hours when it was not active on behalf of the wedding photography business it had been established to serve. Now it daily converts 35mm negatives into wall murals and, in other departments, produces the thousands of color and black-and-white prints for the nation's press.

Scope, a similar but smaller enterprise in New York City, began in 1948 with a single operator; today it has a staff of ten in a 4000-square foot location.

There are Modernage and Scope counterparts in every major city, since today's wedding photographers, child photographers, photojournalists, and many industrial photography centers have come to rely on the support teams of numerous Darkroom Professionals.

For the photographer who prefers a career indoors and who finds satisfaction in the chemistry of photography, the custom laboratory offers a profitable job choice.

Having a quality laboratory of one's own is a sure way to wealth in beautiful prints from last winter's negatives. That is, if the press of business of making

outstanding prints of the customers' negatives leaves time for your own creative career as a cameraman.

See also Copy Photography Specialist.

JOB DESCRIPTION • Specialist in processing of negatives and enlargement of both color and black-and-white prints. Detailed understanding of chemicals, papers and related aids to darkroom process. Provides custom finishing service to camera shops. Rents facilities to amateurs and clubs.

TYPICAL ASSIGNMENT • In a photo center with hours from noon to midnight, six days a week, a local camera club pays a monthly fee for the reservation of certain evenings exclusively for its members; a number of individual amateur photographers arrange for occasional evening or Saturday rentals. Provides custom processing for photographic work brought to the laboratory.

CLIENTS AND EMPLOYERS • The custom laboratory is usually a small family enterprise seeking its clientele by a small amount of advertising and self-promotion: signs in local camera shops, presentations at local camera club meetings, and by the convenience of its location.

TRAINING • Background to justify the start-up investment might be a two-year course in a school of photography or a two-year position in a commercial studio; or the military equivalent.

SALARY • Entry-level salaries in photofinishing laboratories are $10,000-$12,000; expert technicians earn $20,000-$25,000, after many years of service. The operator of a laboratory may earn considerably more if he has skill, business judgment and a large pool of active customers.

RECOMMENDED READING • *Darkroom Technology (magazine)*. 7800 Merrimac Ave. Niles, IL 60648; Grill, Tom, and Scanlon, Mark. *The Essential Darkroom Book.* New York: Amphoto, 1981; *Kodak Black-and-White Darkroom DATAGUIDE.* Rochester, NY: Eastman Kodak Company. Publication R-20. 1988; *Kodak Color*

Darkroom DATAGUIDE. Rochester, NY: Eastman Kodak Company. Publication R-19. 1989.

Department Store Photographer

The department store photographic studio is a modern camera wonderland. Galleries are available for the fashion photographs necessary for the coat department, dress salon, sportswear boutique and the fur storage center. Tabletops of illuminated opal glass permit shadow-free photography of jewelry, watches, stemware and cosmetic displays. Tents of white fabric open to reveal systems for indirect-light photography of silverware and chromium-finish appliances.

Modern darkroom and finishing facilities permit same-day photography for the store's monthly clearance catalogue, winter/pre-Christmas newspaper supplement, and weekday and Sunday advertising. And occasionally, the photographer must stop everything for an executive portrait for the trade press to announce a promotion or change of staff.

Department Store Photographers work nights making documentary photographs of the store's major display windows. They will be on tap for any of the normal public relations events in the store and even employee functions. They live in the background world of the store's window decorators, sign department specialists, maintenance and interior design experts.

A few store photographers will "moonlight" extra dollars from vendors who want additional photographs taken for their own promotional purposes. Studio employees have the store advantage of 10 percent or 20 percent discounts on any purchases made. Vacation schedules are regular, and the medical and pension benefits that have become part of store life delight the skilled photographer who too readily recalls hungry days when self-employed.

At Macy's in New York City, staffs of eight and ten make up the photographic teams. Hecht's in Washington, D.C., Marshall Field in Chicago, and Stix, Baer and Fuller in Saint Louis all have active fashion and still-life studios.

For some photographers, the in-house commercial studio of the department store is a starting point for a career in the field of commercial photography. For other photographers, the security inherent in the department store world is preferred to the real world of struggle in the commercial studio.

Visit the local department store; ask to meet the studio manager. You may be permitted to earn some part-time pay while you learn the nature of the field. A summer job there might be your first career step.

See also Commercial Photographer, Exhibit Photographer.

JOB DESCRIPTION ● Operates view and hand-held cameras for fashion and product photography in black-and-white and color. Provides photofinishing and related services, often on a deadline basis.

TYPICAL ASSIGNMENT ● The department store will have a special armchair sale for Father's Day. Thirty different chairs from the furniture department will be brought to the store's studio in a warehouse section of the building. Each chair must be photographed in the position conforming to the layout of the advertising department's art director, in a uniform size so as to permit maximum photoengraving economy.

CLIENT AND EMPLOYER ● The Department Store Photographer is an employee of the store.

TRAINING ● The entry-level position in the department store studio in most cases is that of Assistant Photographer. College, a photography school two-year commercial studio course, or the equivalent military experience will usually be required for employment.

SALARY ● Photographers will earn $25,000-$30,000. Additional advantages are the experience gained, the store's employee's discounts, and the medical, pension and vacation benefits provided.

RECOMMENDED READING ● *Display and Design Ideas (magazine)*. 180 Allen Rd. NE #300 N. Bldg. Atlanta, GA 30328; Farber, Robert. *The Fashion Photographer.*

New York: Amphoto, 1981; *Professional Photographic Illustration*. Rochester, NY: Eastman Kodak Company. Publication O-16. 1989.

TRADE ASSOCIATION ● Professional Photographers of America, 1090 Executive Way, Des Plaines, IL 60018.

Documentary Photographer

The equivalent of the Pulitzer prize-winning investigative reporter for the field of photography is the Documentary Photographer. Sometimes he or she is the employee of a publisher, a foundation, or even a government agency; sometimes a crusading individual whose work, assembled at great risk of life and limb, finds a market after it has been created.

It was a government agency, the Farm Security Administration of the 1930s, that sent young photographers, Arthur Rothstein, Dorothea Lange, John Vachon, and others, out to the farm belts. Their assignment was to bring back the photographs that would dramatically show the American people the effects of erosion on the soil and the people. It was the staid *Fortune Magazine* of the 1940s that commissioned Todd Webb to document for its readers the city of Pittsburgh in the years immediately after World War II.

There was no government agency or publisher to underwrite the street-by-street documentation of the tragedy of the nineteenth-century slums undertaken by a social worker named Jacob Riis. But he has won his rightful position as America's pioneer Documentary Photographer. No one paid Sid Grossman of New York to capture with his camera the essence of life during the Depression in his own mid-Manhattan district, Chelsea.

The credo of the documentarian is to "tell it like it is." The photojournalist very often is assigned to soften a bleak story by depicting a more "rounded" picture.

Magazine editors, aware of the substantial intellectual differences between the outlooks of photojournalists and Documentary Photographers, usually find it necessary to commission projects from Documentary Specialists, which would not be forthcoming from the pool of photographers only a phone call away. Foundations committed to support special causes in the arts, sciences or humanities require detailed documentation of their projects for internal publication and promotional exploitation.

Whether it is "save the whales," the plight of migrant workers, or unusual experimental art, photographers with a missionary zeal will be needed to capture the flavor of the life experience under study. W. Eugene Smith, for example, will be remembered for his Minimata, Japan series on the effects of mercury poisoning.

Susan Meiselas is a photographer who has won accolades for her recent work which has appeared on the pages of *Geo, Time, The New York Times Magazine, Paris Match*, and other magazines from Scandinavia to Japan. Her photographs are sold by the well-organized photographers' cooperative, Magnum. What makes Meiselas special in the publishing field is that her own crusading involvement in life has taken her with her 35mm cameras to the battlegrounds and combat zones of modern Nicaragua and El Salvador. Her training was often a self-imposed kind of exile; she traveled with carnivals to create the basis for a book called *Carnival Strippers*.

Documentary Photographers don't make the Big Money of the Fashion Photographer; but they make more than a living: They put photography to work to make an impact on the rest of the world.

See also Magazine Photographer, Photojournalist.

JOB DESCRIPTION ● Provides expert knowledge of cameras, lenses, films, and lighting suited to the demands of candid photography indoors and outdoors.

TYPICAL ASSIGNMENT ● A foundation has funds available for a study of centers of orphaned and adopted children. The Foundation has commissioned a book, which will require visits to orphanages in six states during a one month period. Photographs will be made of the buildings, the educational facilities, workshops and hobby centers, medical facilities, food centers and other key areas within the institutions. All photographs must feature people at work, rest, play, or in some other activity.

CLIENTS AND EMPLOYERS ● The Documentary Photographer can obtain commissions from government and social agencies, foundations, corporations, unions, publishers, and political groups.

TRAINING ● A minimum of four years of liberal arts college, plus one or two years of college photography or military service.

SALARY ● Photographers are paid at the rate of photojournalists or government photographers of comparable age, seniority and so forth. See Appendix for Government salary structures.

RECOMMENDED READING ● *Assignment Photography (pricing guidelines)*. ASMP. 419 Park Ave. So., New York, NY 10016.

TRADE ASSOCIATION ● American Society of Magazine Photographers, 419 Park Ave. South, New York, NY 10016.

Educator, Photographic

Only thirty years ago, a handful of private photographic schools and an even smaller number of colleges offered the opportunity to prepare for a career in photography. Camera clubs, adult night-school classes and some additional evening programs were offered at the "Y" and similar centers in large cities. Teachers were often working photographers, or skilled amateurs, or volunteers from camera clubs.

Now more than a thousand colleges and universities offer basic photography courses; private photography schools have their own two-year and four-year programs; and there are not only night school classes for interested adults but also Saturday classes at some colleges such as at New York University and at the New School for Social Research in New York City.

In most colleges and universities, qualified instructors can be drawn from those with a desire for a career in the academic world, most often the faculty of the Art Department. Courses range all the way from basic camera handling and routine darkroom practice to the more esoteric studies leading to a doctorate: aesthetics, history, photographic chemistry, optical technology, and related engineering/arts/sciences.

Photography is also viewed and taught as an art experience for many people who will never be interested in actually handling a camera. There is a place in academia for the photographically enthused individual with an intellectual grasp of photography's origins and development. The esteemed Beaumont Newhall started as a curator at the Museum of Modern Art and pursued a parallel career as critic and historian before being tapped for the prestigious post of director at one of the world's major photography centers and museums, the George Eastman House. Finally, he took up a leadership post at the University of New Mexico. Newhall's career is the envy of many aspirants who seek the opportunities to do research and to help launch others into the growing field of photographic education.

A teaching career in the university starts with completion of one's own college education, most likely with a degree in education plus studies in art, science and photography. Requirements for appointments as lecturers, assistants and similar entry-level posts will vary from state to state and college to college. But all will require the minimum college degree; many will opt for the MFA (Master of Fine Arts.)

At the private photography school level, instructors are less art-oriented and far more practical in their approach to shaping student careers. Each student must achieve working proficiency in the mundane aspects of successful darkroom procedures: chemical mixing, proofing, printing by projection, flawless print finishing. The studio operations are divided into the essentials of film-holder loading and exposed film development, an understanding of the basic principles of lighting as applied to commercial products, and to the more artful demands of portraiture in, say, fashion photography. Students learn to use the newest computerized sensitometric equipment and advanced exposure meters for precise flash photography. They gain experience in outdoor nighttime photography under street lights, moonlight, and with portable artificial light. They leave school as novice cameramen.

Instructors for the private photography schools are primarily drawn from the ranks of small studio owners and other professionals.

Night school teachers need show only modest photography achievement credentials (a recent show, an existing small business, a published book or article, even officership in a camera club) to gain a position as a one-night-a-week instructor in Basic Photography.

A minimum of thirty-five hundred to five thousand Americans earn full- or part-time income as teachers of photography.

See also Fine Art Gallery Operator, Photographic Administrator, Photographic Writer.

JOB DESCRIPTION • Combines expert knowledge of the entire field of photography with the ability to communicate this information in a structured teaching program.

TYPICAL ASSIGNMENT • A community college is seeking to expand its education offerings to area students, primarily young married women, retired individuals and others who can attend day, evening or weekend classes. A budget has been established under a state grant for a modest amount of studio equipment, a darkroom for eight students and a finishing laboratory. An ad in the local press asks for a teacher who can develop a program that would attract new students to the college and assure growth of the photography program as a way of winning these and other students to related studies in the arts, small business operation and similar classes also taught at the school.

CLIENTS AND EMPLOYERS • Photography teachers are employees of public and private schools, colleges and universities, YMCA, YMHA and other organizations.

TRAINING • Requirements range from a minimum of practical experience as a working photographer, past military experience or active amateur photographer experience, up to formal education with teaching degrees, depending on the particular institution.

SALARY • Depending on school and circumstances, income ranges from $10,000-$25,000 per year. Self-employed operators of weekend, summer week or night programs add substantial supplementary earnings to another career, perhaps in small-studio photography.

RECOMMENDED READING • Nibbelink, Don. *The Handbook of Student Photography*. New York: Amphoto, 1981.

TRADE ASSOCIATIONS • National Photographic Instructors Association, California State University, Long Beach, CA 90840; Society for Photographic Education, Campus Box 318, University of Colorado, Boulder, Colorado 80309; Society of Teachers of Professional Photography, c/o Dr. George Whipple, 929 E. Foothill Boulevard,

Upland, CA 91786; Fellowship of Photographic Educators, c/o Mary Lou Osland, Box 102, Soda Springs, ID 83276; 208-547-4077.

Electronic Imaging Director/Consultant

America is in transition; the final years of the twentieth century will see a major shift from traditional photographic practice with cameras and films that require darkroom technologies shifting to the electronic transfer of imaging from camera onto magnetic recording materials. There are no darkrooms, no time loss, and no limits and costs directly related to silver-image negatives and prints.

The Electronic Imaging Director will be the specialist of the era, in demand in commercial studios, in television, in Hollywood and wherever a camera is pointed at a subject. He will direct the photographic output at all-electronic workstations far from darkrooms at newspapers, printing plants, industrial photography centers, hospital photographic units, record keeping establishments, identification photography centers as at Motor Vehicle Bureaus, in hospitals, the Armed Forces and in government.

With technology as king, the Electronic Imaging Director will head a technology section supporting photo crews, largely replacing darkroom teams at administrative centers at factories and in offices, and the individual will work on land, at sea and in outer space.

At NASA, ESC, the Electronic Still Camera system has been in test in on-orbit operations to verify the capability of sending pictures to the ground electronically. Autometric Corporation is a private firm which provided support through the NASA Office of Commercial Programs reviewing support offers from other private companies seeking to provide services and products they hope to market privately. Every one of the operations is dependent on Electronic Imaging Directors or Consultants.

In the case of NASA, a modified Nikon F4 camera is central to the up-in-space imaging; the back has a magnetic diskette where the 35mm formerly was positioned. The image is sent back to Earth by what is known as downlinking; again a role for the Electronic Imaging Director.

Tools beyond the Nikon are a laser typesetter down on the ground, a laptop computer aboard the Spaceship to control both focus and exposure, and equally impressive controls down on Planet Earth.

Down here on earth, a company known as the Epix Corporation is just one of many now making possible electronic albums. When used in wedding studios they show the bride and groom all of their wedding photos on a TV monitor working from standard negative images! The studio's Electronic Imaging Director will direct sales of the work of the working photographer. A Kodak Video CD System will store all photographs of the wedding and the future photos of the new family in a CD that plays just like a videotape, with single images instantly retrievable at home! The system employs a 4-part CD Workstation at photofinishing plants across the country. Every one of the plants will also need the Director or a Consultant.

See also Alternative Photographic Printing Processes Specialist, Audio-Vidual Specialist, Electronic.

JOB DESCRIPTION • Provides the knowledge of electronic systems to provide for conversion of standard photo practice at every newspaper, studio, factory and photo work center to make negatives instantly available as prints or electronic images at the center or across the world.

CLIENTS AND EMPLOYERS • This new field will permit experienced EIDs to become consultants to photographic centers seeking to enter the new field. Larger facilities at government, hospitals, newspapers, industrial photo plants, commercial studios and others will find it necessary to employ their own such experts.

TYPICAL ASSIGNMENT • A wedding studio with a high work volume has been offered conversion to electronic imaging by a supplier of the equipment. No one at the studio has more than a trade show indoctrination or slight understanding of the technical literature received from the prospective supplier. The studio seeks a consultant to advise

of alternate systems, cost comparisons, installation procedures and work methods with the new technology.

TRAINING ● The Electronic Imaging Director will have been an employee of the maker of such systems; or an advanced student at the Kodak Center for Creative Imaging, Camden, ME; the Rochester Institute of Technology; or of the U.S. Army where such systems are in full time use.

SALARY ● Salary at the studio will be in the higher echelons of payment, similar to that of the studio manager or plant photography director. Consultants will receive fees comparable to those paid to consultants installing computer systems in the accounting office.

RECOMMENDED READING ● Eastman Kodak Company literature: Kodak Photo CD System; *Photo Electronic Imaging (magazine)*, 1090 Executive Way. Des Plaines,IL 60018.

Entertainment Photographer

Amid the giant Rockefeller Center skyscrapers and their nearby neighbors in Manhattan is the impressive central headquarters of the Columbia Broadcasting System. There, few of the administrative personnel for television and radio stations, for the record companies and related enterprises of CBS know that a million-dollar photographic studio has been built into one end of the building, behind its elevator shafts and the amphitheater-like lobby.

A staff of nearly ten frequently maintains a seven-days-a-week schedule to keep up with the photographic needs of the various departments, each of which requires advertising publicity, sales promotion, catalogues, reports, displays, presentations, and almost every other kind of business communication.

Across America in Hollywood film crews and videotape centers command armies of actors, actresses, prop men, lighting engineers, set carpenters and painters, publicity "flacks," and advertising "gurus,' while photographers are at-the-ready to capture the scene stills, the creative conferences and the posed nonsense photos that feed the motion picture/television trade and fan press.

While the headquarters of the entertainment photography industry in America are New York and Los Angeles, a vast amount of photographic work is also required by the stage programs and recording centers in such diverse cities as Las Vegas, Nashville, Chicago and Detroit.

The Entertainment Photographer rarely functions alone. He requires the back-up of a studio system that includes a shooting gallery for costume portraits, a darkroom dressing room, prop storage area, and business office to guide coordination of all activities. The large studios maintain their own photographic teams; smaller companies may or may not maintain their own photo crews just as they may or may not own and operate recording studios.

Photographers are on call for, but are not full-time employees of the Metropolitan Opera, the American Ballet Company, the nearby New York City Ballet Company and the entire cultural complex of Lincoln Center where these organizations and others present an endless series of productions. Every city's own version of off-Broadway productions, concerts, and summer stock theaters at resorts need their preseason photographs and in-season publicity photographs too.

The Entertainment Photographer has nothing to do with the photography required for news programs of the television studio. The Entertainment Photographer will not be assigned to make the routine photographs necessary for the studio identification badges or the formal portraits required by the executives for business or personal reasons. His is the world of music, dance, late hours and far-out ideas for a record jacket, a publicity photo, or for an off-beat advertising campaign.

The hours are long; the work is hard, but there is hardly a more glamorous challenge for the creative photographer who will shrug off the demands of impossible deadlines and irksome egomaniacal personalities who balk before the lens.

Most time the photographer is an anonymous technician since obviously the spotlight must be focussed on the starring performer. Nonetheless, Philip Caruso of Universal Pictures gets his own credit lines when his photographs appear in the nation's press. On the other hand, photographers for Fox Broadcasting or Warner Bros. receive no credits in newspaper reproductions of their photos, and on theater programs and record jackets.

See also Fashion Photographer, Specialty Studio Photographer.

JOB DESCRIPTION ● Selects appropriate cameras and film, plus related lighting equipment, lenses and tripods for studio or stage photography.

TYPICAL ASSIGNMENT ● A light opera company has scheduled a dress rehearsal and requires overnight service in color and black-and-white of scenes of the opera taken from the wings and from the audience seats plus close-ups of the main costumed

players, a variety of overall views of dance action and photographs of the lead performers with the stage manager, the set designer and the music conductor. A maximum of four hours has been allotted.

CLIENTS AND EMPLOYERS ● Many motion picture companies, studios, television networks and similar large enterprises maintain a staff of photographers as a service to the advertising, publicity and sales promotion departments. Most entertainment industry photographers are either self-employed or employed by photographic studios serving smaller companies.

TRAINING ● Two years of photography school plus two to four years of college will provide the background for an entry-level position as an Assistant Photographer.

SALARY ● A new photographer in a small studio may start at $20,000 per year but after a number of years of proven performance may be earning up to $40,000 per year. A studio owner's yearly income may be much higher, depending on business skills.

RECOMMENDED READING ● *Photographing People*. Rochester, NY: Eastman Kodak Company. Publication AC-132. 1990; *Professional Portrait Techniques*. Rochester, NY: Eastman Kodak Company. Publication O-4. 1987.

TRADE ASSOCIATION ● Professional Photographers of America, 1090 Executive Way, Des Plaines, IL 60018.

Exhibit Photographer

At McCormick Hall in Chicago, at the Javits Convention Center in New York, at the Convention Centers in Las Vegas, Miami, Atlanta, Baltimore, New Orleans, or in dozens of other cities, there is an endless procession of trade shows and fairs. There are four thousand trade shows per year, with 35 million visitors. No wonder the Trade Show Bureau reports that the combined expenditures by exhibitors is $5 billion annually, a figure surpassed only by the $6-billion spent by the show's attendees.

If you have ever been to one of the few shows that invite the general public such as the Automobile Show, the Boat Show, the Food Show or the Comdex (computer convention), you've been permitted a glimpse of the costly structures, spectacular false walls, miles of temporary carpeting, light, sound and visual displays - and the seemingly millions of photographs on view: slides, murals, montages, transparencies, cut-outs and scenic backgrounds.

All these photographs were created by photographers, many of whom were employees of the display makers for thousands and thousands of industrial and distributing firms who maintain direct contact with their sales organizations through trade shows.

Exhibit planners need photographers to assist in design. Scale models of exhibits will be photographed for the advance publicity furnished to the publications of the exhibit sponsor and the display trade. Photographs of the products may be dramatized in the final display as forty-foot murals, as giant back-lighted transparencies, or simply as 35mm slides in an ever-changing slide show. "How-to" photographs of the models may be made to assist the installation team in a distant city in assembling the display. Other photographs of the models may be necessary to guide the Trade Show committee which sets the standards for use of the space allotted to an exhibitor.

The typical exhibit house is located in a low-rent industrial park or in a warehouse with giant lofts. One corner of this space will be allotted to the photographer

and his crew. The photographer is a key employee of the display company with a rank in the company hierarchy at about the level of a plant foreman or a project designer. He will be responsible for the other studio employees, usually one or more assistant photographers and, where there is a darkroom, the darkroom staff. He may spend part of his time in administration and billing, ordering supplies and maintaining studio equipment.

When exhibits are shipped to foreign countries, the photographer may be part of the team supervising the set-up and knock-down of the exhibit while he documents the entire enterprise with a 35mm camera. The work is indoors; the challenges are endless, and the pay is good. You can learn more about the field by visiting a major display maker who will be listed in the *Yellow Pages* in any large city.

See also Commercial Photographer, Department Store Photographer, Industrial Photographer, Museum Photographer.

JOB DESCRIPTION • Provides skills in black-and-white, still-life and color photography, using view and hand-held cameras. Offers experienced operation of studio lighting. Provides basic darkroom knowledge for film and print processing.

TYPICAL ASSIGNMENT • The designer of a new exhibit for a maker of office equipment seeks to dramatize the capabilities of new calculators, typewriters and copy machines. The theme of the exhibit is "Hands-at-Work." The photographer will photograph all of the sponsor's products with numerous sets of hands. The best of these photographs will be enlarged to wall-size. Others will be shown in slide presentation at the exhibit. All photographs will be made in the studio at the exhibit house within a one week deadline; a miniature model of the exhibit will have actual miniature photos on its scaled-down walls.

CLIENT AND EMPLOYERS • The photographer will be employed by the exhibit house or display maker. Exhibit companies too small to maintain a staff photographer will purchase necessary photography from a nearby commercial studio.

TRAINING ● Past experience as an Assistant Photographer in a display house or commercial studio after two years of photo school or three years of military photography.

SALARY ● The photographer in a major exhibit center will earn $25,000-$35,000 and will have working conditions and vacation-pension benefits equal to middle-management executives of the company.

RECOMMENDED READING ● *Professional Photographic Illustration.* Rochester, NY: Eastman Kodak Company. Publication O-16. 1989.

TRADE ASSOCIATION ● Professional Photographers of America, 1090 Executive Way, Des Plaines, IL 60018.

Fashion Photographer

Hidden behind the camera is a Cyclops, the photographer whose eye puts together beautiful fashions, beautiful women, and comes up with glamour. Town and Country

They make $100,000 a year, $150,000 a year, $200,000 a year. Their work makes possible a billion-dollar clothing industry and perhaps another billion dollars sold in jewelry, furs, cosmetics and accessories. They are Fashion Photographers, the elite of the commercial photography world. They become legends in their own time as authors of photography books, and their work is exhibited in the Museum of Modern Art. Some are young; some are old; most are men, and a few are women.

You can find their work in most libraries in alphabetical order under "Photography" or "Fashion Art". For example, look under A for Avedon, B for Beaton, H for Horst or P for Penn, to name a few. These are some of the prominent names of the recent past. Some of their successors are named Scavullo, Silano, and Paccioni. It is likely that someday their best work will be shelved in libraries as today's assignments find publication in *Harper's Bazaar, Vogue, Mademoiselle, Elle* and the other magazines read by women who spend a thousand dollars for a party frock or twenty times that much for an evening fur.

Then there are the working Fashion Photographers whose names will never become household words and whose work will not be published in books. They are the photographers for the smaller coat and dress manufacturers who require simple photographs for catalogue sheets and mail-order offerings to retailers. They are employees of the large commercial fashion studios such as Krantzen in Chicago, or they own small commercial studios in New York, Los Angeles and wherever a major clothing manufacturer has established his production facility and executive offices.

Partly because film is so costly and partly for camera handling ease, an amazing number of the photographs are created in the Nikon, Canon or Minolta 35mm cameras and 6x6cm cameras such as the Hasselblad or Bronica. Because prints are rarely needed

except where retouching is required to soften a shadow or to eliminate an undesirable crease, the printers of catalogue sheets or other advertising material work directly from the tiny transparencies. The photographer may sell his services by the day for $200-$500, or by the picture for prices as little as $25-$50 per garment. Commercial studios try to keep film and related costs down to less than 10 percent of any job cost.

The pay for photographs by such magazines as *Mademoiselle, Vogue, Glamour, Mirabella*, and *Gentlemen's Quarterly* is low: $500 or $1,000 for a full-color page; half that for a black-and-white page. Cover spots pay $2,000 or more. Such sales are sought by photographers as much for the potential enhancement of the photographer's reputation as for the immediate income.

In New York, advertising agencies budget a day's work for the photographer at $2,000 - $5,000.

A relative newcomer to the field, Andrea Alberts, spent seven years as a free-lance photographer before entering the fashion field. Three years of effort in that field doubled her income so that at age thirty-two she was grossing $60,000 per year, having earned a reputation for spontaneous photographs that are alive with action.

Part of the reason for recent success in this field has to do with diminished use of fashion illustrations by fashion publications in favor of photography. For example, as of 1991, *Women's Wear Daily* (WWD), literally the daily eyes-and-ears of that industry, closed its fashion illustration department of five artists. "All have been re-placed with photographic work, some freelance artists' drawings and computer-graphics", said Executive Editor Patrick McCarthy.

Fashion Photographers are usually made, not born. The road to success starts with an apprenticeship under anyone in the field, but it should be with a very successful studio. After a few years of absorbing the skills of the master, the time comes to invest in a studio of your own. Then it's a matter of showing samples to advertising agencies and clothing manufacturers to get your first, second and regular assignments.

Many try. Those who do not have the good fortune or talent to make a name as a Fashion Photographer may still succeed in the allied fields of photography of accessories, jewelry, handbags, shoes and the like. Department stores have their own needs, and large commercial studios seek staff members with a flair for fashion merchandise lighting and setups. Either way, the photographer will live in the glamorous world of beauty and sex appeal.

See also Department Store Photographer, Entertainment Photographer, Specialty Studio Photographer.

JOB DESCRIPTION ● Operates a major-city, large-space studio suitable for photographing of garments. Has full knowledge of all camera types, film capabilities and lighting arrangements to best meet the challenges of various colors, textures and other controlling factors.

TYPICAL ASSIGNMENT ● A dress manufacturer requires a basic front-view photograph of each of twenty-four different garments that will be available to the studio for the two days before a fashion show in another city. The photographer employs models of the garment size, usually a size 8 (small), and then meets with the art director of the company to select paper or painted backgrounds suitable for the goods. The planned printing may require solid color backgrounds in a bright value. The photographer sets a working schedule after meeting with a makeup artist to groom the models and a stylist to check each garment during its turn before the camera. Studio assistants keep the cameras loaded with film. Test rolls will be developed at the end of each session to confirm proper exposure or background coverage.

TRAINING ● All photography schools include practice sessions in fashion photography. Fashion studios maintain apprenticeship programs for future Fashion Photographers. College photography and military training are helpful in winning apprentice positions.

SALARY ● Fashion Photographers employed by commercial studios will earn $25,000-$35,000. Independent studio owners may earn as high as $200,000 per year.

RECOMMENDED READING ● *Assignment Photography (pricing guidelines.)* American Society of Magazine Photographers, 419 Park Ave. So., NY, NY 10016; Farber, Robert. *The Fashion Photographer.* New York: Amphoto, 1981.

TRADE ASSOCIATION ● Professional Photographers of America, 1090 Executive Way, Des Plaines, IL 60018.

Fine Art Gallery Director

The acceptance by museums and collectors of the photographic image as art, and the high regard for such photographers as Alfred Stieglitz, Edward Steichen, Edward Weston, Ansel Adams and Berenice Abbott have led to the establishment of new art galleries where only photographs may be acquired. Most of those new galleries have been started by knowledgeable photographers and students of photography's history. Who else would know the difference between the calotype and the cyanotype? The ambrotype and the ferrotype? An ivorytype and a woodburytype?

These gallery owners have searched out inventories of photographic prints and negatives and now provide a secure pricing basis for bids at auction houses where the marketplace determines worth. Their success beckons the photography collector with an understanding of the nature of past and present photographic technologies, an appreciation of the role of the dealer in bringing art to the lives of collectors and art lovers, and a background in fine arts. They are the raw material from which tomorrow's Fine Art Gallery Operators will be made.

The Gallery Operator provides expertise not only to individual buyers but also to the growing number of fine art museums in all communities now seeking to build photo print collections to match their etching end engraving portfolios. They make a marketplace for the private family seeking to dispose of family photographic heirlooms and for historical societies burdened with photographic assets and increased operating costs. They can conduct shows of contemporary local photographers and provide an appraisal service for others. They become a source of art for the downtown bank or for the local investor seeking diversification in art collectibles.

The Gallery Operator can become part of an elite group of enthusiastic photographic proponents like Marjorie Neikrug or Howard Greenberg of New York; Joe Buberger of New Haven; or Harry Lunn of New York & Paris or Cliff Krainik of

Virginia who are experts in identification of key photographs for the Library of Congress and the National Portrait Gallery.

With a love for old and new photographs, with a minimum of two years of photographic training in college or in photography school and a college degree (MFA) in the fine arts, the college graduate today can elect a career conducted in the gentle surroundings of the fine arts gallery, selling photography.

See also Photographic Administrator, Photographic Educator.

JOB DESCRIPTION ● Maintains a gallery during normal retail store hours open to the public and private collector. Inventories marketable examples of daguerreotypes, ambrotypes, calotypes, ferrotypes, stereographs, albumen and platinum prints and other examples of nineteenth-century photography, along with contemporary silver by both recognized and unrecognized practitioners of art photography.

TYPICAL ASSIGNMENT ● Procures Western photographs from the period after the Civil War up to the twentieth century for a private collector seeking to assemble all possible examples of Western life in such specific areas as cattle ranching and gold mining. Contacts other galleries which may have such material and arranges for reviews of this merchandise by his client.

CLIENTS AND EMPLOYERS ● The gallery operator is a self-employed, photographically knowledgeable individual whose clients may be individuals of institutions seeking photography as wall decor, as an investment, or as historically significant material for research or publishing purposes.

TRAINING ● A combination of studies in the fine arts for an expert knowledge of early and contemporary photo practice is ordinarily started at college. Photo school or military training will not provide the requisite photo-history background.

SALARY ● Earnings depend on the business skill, good fortune and depth of assembled inventory of the new gallery operator.

RECOMMENDED READING • *Camera and Darkroom (magazine)*, 9171 Wilshire Blvd., Los Angeles, CA 90210; Crawford, William. *The Keeper's of Light*. Morgan and Morgan: NY, NY 1979; Reilly, James M. *Care and Identification of 19th Century Photographs*. Rochester, NY: Eastman Kodak Company. Publication G-2S. 1986; Witkin, Lee D., and London, Barbara. *The Photographer Collector's Guide*. New York: New York Graphic Society, 1981. Persky, Robert S. *The Photographer's Guide To Getting & Having A Successful Exhibition*, New York, The Photographic Arts Center; 1987., *Linked Ring Letter (quarterly newsletter)* Photographic Arts Center, New York, NY., *The Photograph Collector (monthly newsletter)*, Photographic Arts Center, New York, NY, Persky, Robert S. Photographic Arts Market Series (Auction Price Guide) The Photographic Arts Center, New York, NY 1992.

TRADE ASSOCIATION • Assn. of International Photography Art Dealers, 1609 Connecticut Ave., NW, Washington, DC 20009; Council on Fine Art Photography, c/o L.A. Kenyon,5613 Johnson Ave., W. Bethesda, MD 20817.

Fine Arts Photographer

His all but unknown name almost became a household word across America. News of his photography to be exhibited in the Nation's Capitol were repeatedly exhorted on the Nightly TV. Congressmen (who had never seen his photography) railed against his work, his name and his lifestyle. So his long planned retrospective show in the Nation's Capitol was canceled; new legislation was written to limit artistic freedom. 99% of his photography was of flowers in delicate light, male portraits, full length photos, studio photos of people rather than of places or events. His 1% of sexually explicit (homoerotic, what some called perverse) photography led a trial in Cleveland for a museum director at a time when his museum enjoyed the largest attendance in Ohio history of a photo exhibit.

Do you recall his name? He was the Fine Arts Photographer Robert Mapplethorpe. His photos are sold today at spectacular auction prices and his work may be seen today in America's major museums and in local bookstore in more than one coffee-table book.

It's easy today as a walk downtown to see the work of the world's finest Fine Arts Photographers. At any framing shop which also offer framed posters you'll see the Ansel Adams *Moonrise*. Prints of that photo of the Southwest have auctioned at over $40,000. You'll see work of Berenice Abbott, usually New York scenes. You'll see Andre Kertesz European street scenes. (A postcard photo by that Fine Arts Photographer sold in 1991 for a $250,000.) The works of Edward Weston, Alfred Stieglitz, Duane Michals, Bill Brandt, Imogen Cunningham ... all Fine Arts Photographers ... are in high demand. Their classic images sell year after year not only as posters but also as postcards, book illustrations, desktop calendars and greeting cards.

To see some of the major classic Fine Arts Photographers in a single volume, check your library for a book such as Beaumont and Nancy Newhalls's *Masters of Photography* or Gene Thornton's *Masters of the Camera.*

These photographers earned their right into these pages as they individually searched for and celebrated eternal values.

They are not to be confused with commercially motivated contemporary photographers from the worlds of photojournalism, fashion, travel, catalog photography and science. Brilliant achievements with cameras and film emerged from successful coverage of events at fires, at battlegrounds, in contrived studio set-ups or in the socio-documentary environs. Robert Capa on a battlefield; Dorothea Lange in a migrant workers camp; Arthur Rothstein in a dustbowl environment created story-telling drama for magazine covers and for Congressional legislative concern. Dr. Harold Edgerton made eternally memorable and relevant images in his quests for scientific achievement. Arthur "Weegee" Fellig touched everyone with the pathos of a family's home ravaged by fire.

The Fine Arts Photographer has always marched to a different drumbeat, unconnected for the most part with immediate considerations of human experience or personal well being. Their world is the world of light, shadow, shape, form, conflicts in composition and harmonies in visual elegance.

JOB DESCRIPTION ● Operates from home or studio with any of a range of cameras from miniature up to the super-size of the Polaroid 20x24-inch special camera made available in Cambridge MA on special occasions to experimental photographers. Maintains a compulsive zest for and comprehensive knowledge of light, exposure, darkroom follow-up and limits of actinic values of emulsions on paper and film.

TYPICAL ASSIGNMENT ● As a group, the Fine Arts Photographers share a personal passion that commits them to the need to create images; there is no client and there are no deadlines. The perfect photo is the end product of the day, hour or week. Robert J.

Steinberg captures the breathtaking beauty of a wall of ivy one day; on another, in *White Linen Suit* he stuns the viewer with a partly nude vision of a partly clad woman. Without a single exception they share a near-reverence for photographic perfection. Unwilling to accept the limitations of everyday photo technologies, they persevere in making the negatives with longer tonal scales and prints of tonal perfection that cannot be reproduced in mass-production printing processes ... in a darkroom or on a printing press.

CLIENTS AND EMPLOYERS ● Driven by the creative urge, coaxed by their sales agents, artistic representatives and image dealers, the Fine Arts Photographers are a unique group of photographers, client-free, employer-free. Some achieve art prominence and financial success in their own lifetimes. Many achieve modest acceptance and finally ultimate financial success only after their demise.

TRAINING ● If a poet can be given a voice in a class and if great literature can be the end product of a summer vacation school of writing, then there is a ray of hope that a school may teach or inspire a potential Fine Art Photographer to a lifetime career of creative brilliance and dedication. In the meantime, the photo student or the amateur practitioner can only dedicate his or her photographic efforts to perfection of a personal projection of creative inspiration through a camera lens and onto film in the most self-centered way.

RECOMMENDED READING ● Art magazines such as *ArtForum;* Visits to the major photo collections at the Metropolitan Museum in New York or the Getty Museum in California; to the Art Institute of Chicago, or down to the Museum of Fine Arts in Houston or at the University of Texas, Austin.

Fire Photographer

Fire Photographers have saved lives by helping to capture arsonists, and have uncovered unsafe conditions that would have threatened future victims. Fire Photographers document the dramatic events that test engine equipment, safety devices, training success and fire-control methods.

While many communities have equipped police cars with cameras to document crime and accidents, no fire engine or support vehicle carries a camera. But in every major city, a special unit of the Fire Department is a photography section offering round-the-clock service. These skilled photographers, equipped with hand-held cameras and wearing protective clothing, are fire fighters too. A team from the twenty-four-hours-a-day, seven-days-a-week Photo Unit of the New York City Fire Department races to all two-alarm and larger fires in the city. These photographers are five-year veteran fire fighters -- the prior experience required before their application for transfer to the Photo Unit will even be considered. Other communities usually have less demanding criteria for a photographer's qualifications.

The fire fighter-photographer shoots in color and in black-and-white. His still or video camera documents the events in the style of a news photographer or an insurance investigator. His pictures become part of the permanent records that play a vital part in the ongoing review of major fires.

The Fire Department cameraman also photographs equipment to provide an accurate record for the department's budget director. He makes portraits at the various stations to satisfy the personnel director. He maintains files, identifies negatives, writes captions, prepares a kit of photographs for a local newspaper story or giant photos for a local TV show. As a civil servant, he is subject to the same working conditions as any other city employee, and he enjoys the city's medical and pension benefits.

The International Fire Photographers Association has a membership of fifteen-hundred amateur and professional Fire Photographers.

You cannot take a course anywhere in fire photography, but in recent years, the Maryland Fire and Rescue Institute at the University of Maryland, College Park, Maryland 20472 has conducted annual two-day programs on fire photography, a short course that centers on the needs of the profession.

See also Police Photographer, Insurance and Legal Photographer.

JOB DESCRIPTION • Provides still, motion picture and video camera coverage. Maintains and staffs a departmental laboratory and often provides all photofinishing. Serves departmental needs for public relations, accident and arson investigation, and other photography.

TYPICAL ASSIGNMENT • A warehouse fire on the river has made necessary a four-alarm call, including fireboat and helicopter service. The photographer takes photographs of all equipment in action and reports to the Fire Chief and/or the Fire Marshall of the Division of Fire Investigation to make any necessary arson evidence photographs. He finds all angles possible for total photographic coverage of the fire and submits his coverage for departmental review.

CLIENTS AND EMPLOYERS • Fire Photographers are usually experienced firemen who have transferred to the Photo Unit. Visit or write local Fire Departments for entry-level criteria.

TRAINING • College photography school or military service photography will be prerequisite to any application.

SALARY • Fire Department salary levels will prevail.

RECOMMENDED READING • Lyons, Paul Robert. *Techniques of Fire Photography*. NEPA Fire Protection Assn., 470 Atlantic Ave., Boston, MA 02210.

TRADE ASSOCIATION • International Fire Photographers Assn., P.O. Box 8337, Rolling Meadows, IL 60008.

Forensic Photographer

"The Drug Enforcement Agency (DEA) is coming by tomorrow. They need your help photographing money for an instruction manual. They're bringing $50,000 in $100 denominations to the studio." (*Photomethods*, October 1991; by Carolyn Dooley.)

It was the start of a program of students enrolled in the Dade County (Miami-area) Medical Examiner's Department's Forensic Imaging Bureau. In Florida, that group is known as the FIB; it's just as deadly a group in catching criminals as the similarly named but better known national FBI.

A day with those students explains the full range of photographic problems that the Forensic Photographer will encounter anywhere: documenting a fatal accident; detailing an actual autopsy; even conducting high-speed photography tests to examine stippling patterns of a handgun. But the glamour and the queasy stomach will be left behind when the camera is used to assist medical or government officers in bringing life into an educational slide presentation.

The forensic facility in southern Florida that accomplishes some of the routine and almost magical photo miracles is a $14 million brick and glass specially designed structure. Within it, 2500 square feet of studio space, darkrooms, labs and office areas make life for the photographic team a pleasure.

Elsewhere across America, the Forensic Photographer may have a corner of the typical Coroner's Office or a backroom at a police department. But the strict adherence to the discipline of seeking knowledge that only a photographer can reveal remains at the heart of this fascinating occupation. The Dade County operation was funded so broadly since it was destined to serve the specialized needs of the University of Miami Medical School; the local hospitals; the county and state Departments of Health, Police and other activities; the government agencies such as the DEA and the Tobacco and Firearms Units; Customs; and even the Secret Service.

Most Forensic Photographers will be serving local and area needs spelled out by officers of various investigative bodies: police, health, traffic, the Department of Agriculture, or the Environmental Protection Agency. They all need technically precise photography. Probably there is more freedom for the photographer in these situations than in numerous other fields; he chooses the methodology: Type of camera, type of film, type of lighting, plans for the unusual such as infra-red or high-contrast special effects. Photography is not only the most accurate evidence; it may also be the only available evidence to clinch a case against a person or group which has committed a truly heinous crime.

Forensic Photographers work in small departments; the photographer may have to share darkroom duties and administrative tasks. He will have a specialized field of knowledge that will always assure a career almost anywhere in the country, especially as a civil servant.

See also Commercial Photographer, Fire Photographer, Insurance and Legal Photographer, Police Photographer.

JOB DESCRIPTION • Requires a familiarity with a broad use of 35mm, medium-format and large format cameras; special knowledge of close-up and microscopy; working knowledge of special purpose films and filters; and a comprehensive familiarity with darkroom procedures relating to films, papers and special purpose emulsions.

TYPICAL ASSIGNMENT • A rainy nighttime car crash has led to two deaths. The Sheriff has asked that the Forensic Photographer complete an extensive nighttime study of the road conditions to be followed by a daytime study seeking relevant skid-marks on the road or evidence of the origins of the crash or the wreckage.

CLIENTS AND EMPLOYERS • Almost invariably the Forensic Photographer is an employee of the Medical Department, the Police Department or the Coroner's Office at major city installations and at special institutions for crime research as at the FBI and similar investigative centers.

TRAINING • Four years of specialized photography school such as at RIT; or three years experience.

SALARY • The typical Forensic Photographer's salary is comparable to that of the Police Sergeant or the Assistant to the Coroner, but usually within the $25,000 to $35,000 a year range.

RECOMMENDED READING • Duckworth, John E. *Forensic Photography.* Springfield, IL: Charles C. Thomas Co. 1983; *Law Enforcement Photography (magazine),* 445 Broad Hollow Road, Melville, NY 11747; *Photography for Law Enforcement.* Rochester, NY; Eastman Kodak Company. Publication M-200. 1990; Redsicker, David R. *The Practical Methodology of Forensic Photography.* NY, NY: Elsevier Science Publishing Co. 1991

TRADE ASSOCIATION • Association of Professional Investigative Photographers, P. O. Box 479, Charles Town, WV 25414.

Horse Photographer

Horse photographs bring big dollars because these are the photographs that adorn the walls of the owners' dens and become the basis for oil paintings to hang one day in fine hostelries and award rooms. To bring the horse to the precise position necessary to show its best points takes a photographer's patience with the trainer or the owner who is trying just as hard to be patient with the photographer. The usual 35mm approach to outdoor photography is not suitable. Larger cameras increase limitations that are inevitable with the fixed position tripod. Medium-format cameras provide a compromise solution.

Most people don't know, for example, that the horse training industry is the third largest industry of the State of Maryland! No wonder in all that activity that the photographer is as important as the horse trainer! He will be on call at the private estates and also at the track on those days when foam-flecked horses are led into the Winners' Circle for the traditional owner-horse-jockey portrait.

Photographers who know how to talk stable lore with trainers and have the good sense to be at the track just after dawn when jockeys test potential winners will make the first-name friendships that lead to assignments from horse owners. A portfolio of such track photographs means that the local press and the national newspapers and magazines that regularly promote the sport may become important additional markets for the photographer.

Horse photography should not be confused with the scientific system of photo-finish photography which uses motorized cameras located atop the grandstand over the Judges' Booth.

Horse photography has its own appeal and its own reward. There's an excitement in days at the track, and there's a beauty at the training farm where a number of horses may be photographed in a single morning's shooting session.

The way to start a career is to be seen with a camera when the crowds are not on hand to interrupt walks with owners and trainers. A few pictorial photographs of horses in training are sure to win a request for a few photographs of the owner's current favorites.

See also Pet Photographer, Wildlife Photographer.

JOB DESCRIPTION ● Combines expert knowledge of medium-size and larger cameras with a knowledge of horse training and grooming.

TYPICAL ASSIGNMENT ● The owner of a quarter-horse has an opportunity to sell the animal to a distant buyer who knows the horse by its breeding history and race performance. The owner has requested a number of posed horse photographs to send to the distant prospective buyer and to keep as a record of the animal which has been a profitable investment for the stable.

CLIENTS AND EMPLOYERS ● Horse Photographers are generally independent operators maintaining a business from their homes, willing to travel to distant stables, tracks and auction centers for job possibilities.

TRAINING ● Horse Photographers must have a thorough understanding of the points that make a fine animal outstanding in its class, plus two years of full-time private photography school, two years of college and/or one or two years of commercial photo studio practice, or three years of military photographic experience.

SALARY ● Self-employed photographers will make a satisfactory career from a mix of press photography, posed animal studies, and special track-related, training-related assignments from horse owners, publishers, race track associations, and so forth.

RECOMMENDED READING ● Campbell, Kevin. *Make Money with your Camcorder.* Amherst, NY: Amherst Media, 418 Homecrest Dr., Amherst, NY 14226. ($17.95 + 2.50 s/h.); Cribb, Larry. *How You Can make $25,000 a Year with your Camera (No Matter where You Live)* Writer's Digest Books; *Professional Photographic Illustration.* Rochester, NY: Eastman Kodak Company Publication O-16. 1989.

Industrial and House Organ Photographer

Each year, the Eastman Kodak Company and the Professional Photographers of America co-sponsor a competition to honor the top photographic operations conducted within America's industrial plants. Some past winners were Otis Engineering, Dallas, Texas; Felt Division/Albany International, Albany, New York; Pacific Northwest Telephone Company, Seattle, Washington; Fenwal, Inc., Ashland, Massachusetts; Aetna Life & Casualty, Hartford, Connecticut; E G & G Idaho, Inc., Idaho Falls, Idaho; and the Film Projects Branch, Naval Weapons Center, China Lake, California.

You don't need a college degree to see that these plants cross America's industrial horizon and that prize-winning abounds in every field including engineering, utilities, fabric making, steel working, nuclear energy, insurance and the building industry.

One of the nation's most industrial photographic operations is that of Pratt & Whitney, makers of the power plants that support American leadership in the sky. While the corporation's headquarters and five of its manufacturing facilities are Connecticut-based, the "Visual Communications" challenges for still and video photography also must cover P&W operations in Florida, Georgia, Maine and even Canada. The photo teams of still and video photographers operate semi-independently in three states. Together as a pool they add up to 20 on call for documentation, engineering development, public relations, marketing, and house organ coverage.

The back-up personnel for all those camera people numbers about 40 more who keep the darkrooms, the video editing centers and other operations humming to meet schedules. According to Steven Fletcher who is responsible for direction of the E. Hartford, CT operation, 90% of the photography is simply tough photographic problem solving. "Perhaps 10% will qualify as glamorous," he points out, noting with pride a double-exposure involving a jet engine's fan and a wonderful sunset: "It made the cover of *Aviation Week*, a leading publication of the industry." While most photos or video

material will never reach public eyes, PBS-TV nationally is a regular seeker of aircraft and skies footage for its educational television programs.

The smallest studio among the Kodak in-plant photographic winners is a two-man operation that ingeniously used photography to cut a two-thousand-hour drafting room project down to an eight-hundred-hour finished product, thus hastening the introduction of the company's new product. The in-plant photo team of the insurance company created a fifteen-minute motion picture that ultimately found a TV audience of millions.

The Pacific area telephone company sent photographic teams into actual area homes to create documentary color photographs showing the company's new telephones in use. These photos became the basis for a catalogue carried in thirteen hundred trucks used by installation/maintenance personnel. The photographic teams in Idaho created a vast photographic index-file-card system as part of a nuclear reactor safety program.

John Deere and Company's plant in Waterloo, Idaho, is but one of four plants served for the past twenty years by a team of two people. Today, a nineteen-person department provides not only photography, but also art, printing, audiovisual programming, and even photographic typesetting. Photographers at one plant have a ninety-foot by fifty-foot, two-story studio in which a giant turntable can support a four-wheel drive vehicle.

Industrial Photographers for company publications of the largest corporations roam the world for companies with oil, chemical, agricultural and other investments. George Kalinsky is the house photographer for Madison Square Garden in New York City. His photographs of entertainers, celebrities, circus, basketball, hockey, horse and dog meets is a review of who's who in the American spotlight. He does it all, day after day in the same building.

On the other hand, Western Electric once sent photographer Morris Gordon to live with the Eskimos up at the edge of the Arctic Circle. He was to document winter conditions of electronic gear set in place for military security purposes.

The House Organ Photographers have the freedom to repeatedly demonstrate their skills using the finest photographic equipment and with the technical backing of the most modern laboratories. Their photographs appear in corporate house organs with circulations as large as those of some big-city newspapers. Corporate communications in and of itself often requires an entire department.

The Industrial Photographer may take banquet pictures at the retirement dinner for an honored executive one night; the bowling team for the sports page of the local newspaper the next; and then shoot damage to a loading dock following a parking accident for the company's insurance office. He often takes portraits in the morning and shoots production-line procedures for a training manual in the afternoon. He might even be asked to run the company's slide or sound projector for a finance committee meeting.

Company medical plans, pensions, regular vacation schedules, and other benefits make a lifelong association with a large industrial firm a desirable way to achieve both photographic success and financial stability.

Your first job with an in-plant studio or the corporate communications center could be at the plant, mill, factory, or company facility near you. After some years as a working photographer, the promotion to unit supervisor or chief photographer will pay more than a foreman's pay in most plants.

See also Commercial Photographer, Corporate Photographer, Documentary Photographer, Exhibit Photographer.

JOB DESCRIPTION ● Operates 35mm, 6x6cm, and large view cameras. Understands lighting, exposure, and special infrared, X-ray and other sophisticated tools for technical photography. Provides electronic flash photography indoors at corporate activities.

TYPICAL ASSIGNMENT ● Assembly-line employees have traditionally been trained by side-by-side demonstration on the production line with step-by-step assembly guidance by a foreman or a line-worker. The company seeks to create a slide sequence to demonstrate a variety of the assembly-line problems to acquaint new employees with the actual job conditions prior to the on-line instruction. The photographer will use a 35mm camera to shoot slides of the various sequences necessary to fulfill each aspect of the assembly-line production stations.

CLIENTS AND EMPLOYERS ● The photographer will be an employee of a large corporation or work as a freelance photographer serving a plant communications department.

SALARY ● The supervising photographer and team head will earn $25,000-$30,000 per year in a very large plant. Photographers under his direction will earn $20,000-$25,000. Darkroom personnel and finishing room employees earn $18,000-$20,000 as a rule.

RECOMMENDED READING ● Corbell, Tony. *The Ultimate Commercial Photographer's Handbook, Vol. I and II.* San Diego, CA: Corbell Publishers, Inc; *Professional Photographer*, 1090 Executive Way, Des Plaines IL 60018; *Professional Photographic Illustration.* Rochester, NY: Eastman Kodak Company. Publication O-16. 1989.

TRADE ASSOCIATION ● American Society of Magazine Photographers, 419 Park Ave. So., New York, NY 10016.

Insurance and Legal Photographer

You don't have to be an avid fan of Matlock TV crime programs to know that for every lawyer friend famed for skills in corporate, criminal or family law, you know another whose practice starts with broken legs, broken windows or broken furniture. Call any of them; ask how many cases have been won or lost because the jury believed the photographs.

Medical malpractice? Call the photographer. Two bent fenders? Call the photographer. Slippery sidewalks? Call the photographer. Isn't that what Matlock did?

Wherever lawyers practice and courts hear cases, Legal Photographers play key roles in three primary areas where police evidence does not normally apply: personal injury, property damage and theft or loss of property. The headlines and court calendars are quick reference guides to the cases where photographs will play a part in the presentation of the cases to the jury.

If someone has been injured in a fall, in an assault or in an automobile or industrial accident, the photographer will be dispatched to the hospital while damage is still visible. The same case will require follow-up photographs to establish the duration of the recuperation or the limitations of the healing. Discoloration and torn tissue must be recorded. Since court cases and settlements will be reached long after the victim has recovered, photographic evidence prior to scars will be vital to the protection of the victim's rights.

Settlements are often huge. A few hundred dollars for the photographer is only a tiny part of the costs for attorneys to prove that the victim was as innocent as the falling snow. The insurance company will not allow stockholders to be hoaxed by false claims, and photographs protect their interests.

Property damage from the car-truck accident may include ruined shrubbery, scarred lawn and a crushed fence. One photograph tells it all. Fire damage can't be denied when color prints show charred remains of furniture and blistered walls to

indicate the extent of the heat. Color shots of purple facial bruises show the extent of painful injury.

Legal or insurance photography may be originated by the attorney or doctor. Both need to locate a dependable photographer quickly.

Insurance photographs my be sanctioned by the distant insurance company or its local representative, the adjuster. Their team wants a permanent record of any case that may be resolved without the cost of court action.

Numerous insurance companies, attorneys, doctors, adjusters and others would be in a position to make the necessary phone call for your services. Some of these companies may be contacted through their local offices by personal visits and phone calls. Others are more distant, and an introductory letter and a business card can be enclosed for later reference. Such distant companies can be further asked to identify their area adjuster for local follow-up by the photographer.

Attorneys are located through the telephone book. Most require an introductory letter and a business card for ready reference. Some indication of potential costs should be given. A friendly attorney in the family may offer clues to prevailing rates for day, night or weekend service; travel; additional prints and similar data for a new rate schedule.

A regular active clientele takes time to establish. The first assignments may be ones that other photographers have already refused because of bad weather, late hours or extreme distances. Getting started may mean an extra investment in time and effort.

There is no race for the darkroom to make a newspaper deadline. Attorneys and insurance companies expect that prints will be delivered routinely. This kind of photography doesn't involve the punishing darkroom hours followed by a delivery rush of a weekend convention.

See also Fire Photographer, Forensic Photographer, Police Photographer.

JOB DESCRIPTION • Operates 35mm and medium-format cameras and related equipment suitable for indoor and outdoor photography in black-and-white and color at any time of the day. Provides darkroom services as required for court presentation.

TYPICAL ASSIGNMENT • A truck hit by an automobile leaving a driveway has been driven through a fence and into the porch of a nearby home. The driver of the automobile has been injured and is en route to a local hospital for medical attention. The family has immediately notified the victim's personal physician and family attorney. The attorney has directed the photographer to document the immediate medical care required by the victim, the damages to the car, the truck, the fence and the porch. He will have enough experience to know that he is to establish vehicle directions, skid marks that will indicate extent of impact, and so forth.

CLIENTS AND EMPLOYERS • Legal Photographers make themselves known to all members of the legal profession within their work territory. They will be paid by the photograph and by the assignment under arrangements mutually agreed upon prior to any assignment. Insurance companies engage photographers to document damage in order to prevent overstatement or confirm claims.

TRAINING • Minimum of two years of college courses in basic photography, or one year at a full-time photography school, or three years in military service photography.

SALARY • The Legal Photographer is a self-employed photographer whose earnings will directly relate to his ability to establish working relationships with local attorneys and distant insurance companies.

RECOMMENDED READING • *Applied Infrared Photography*. Rochester NY: Eastman Kodak Company. Publication M-28. 1981; *Assignment Photography (pricing guidelines)*, 419 Park Ave. So., NY, NY 10016. ($14 + 2.00 s/h); *Photography for Law Enforcement*. Rochester, New York: Eastman Kodak Company, Publication M-200. 1990.

TRADE ASSOCIATION ● Assn. of Professional Investigative Photographers, P.O. Box 479, Charles Town, WV 25414.

Interior Design Photographer

The Interior Design Photographer, more than the Architectural Photographer who preceded him, has to have the visual ability to interpret proportion, volume, color, texture, lighting and room arrangement of the office. With such photographs, the interior designer has a permanent record of each installation and a portfolio of design success to attract new clients. With each new client for the designer, the photographer also has new contacts. Photographs are also likely to be submitted by the designer to such publications as *Architectural Digest, Interiors, House and Garden*, or to the local newspaper where new business offices and interesting private homes make news on real estate pages and even feature pages of the Sunday rotogravure section.

Clients, according to one especially successful California photographer, James Chen, are to be found by demonstrating photography skills to architects, interior designers, space programmers, manufacturers of building materials, furniture, rug and accessory makers, and even among the owners of commercial property or homeowners. If the newly designed interior is a hospital, hotel, motel, restaurant, or a building of a major corporation, there are further sales opportunities with the real estate section of the corporation, with the public relations department, or with the editor of the house organ or trade paper of the related industry.

Hotels will need the photographs as part of their advertising to promote the newly decorated facility, and expansion photographs are regularly part of annual reports of corporations. Restaurants illustrate menus and folders by which they seek to sell banquet arrangements. Some photographs become postcards provided to hotel or restaurant patrons.

Photographers will be paid under a variety of arrangements, but one of the most common is the per-day fee (plus costs), since this provides the photographer with a minimum guaranteed income while potentially providing the client with many photographs. Film, processing, travel, lodging and meals are additional charges to the

client. All transparencies and prints, negatives, and related materials are the property of the client, but the photographer may derive some additional income by providing custom laboratory services sold at a substantial mark-up as a further profit to the studio.

A visit to the site before the actual shooting session is common since the amount of lighting equipment, the need for special lenses, and the availability of daylight should be determined before the photographer actually packs his bags to begin the assignment. "A typical assignment," Chen said, "requires two to three days of work for one photographer plus an assistant."

Interior design photography is studied, technically sophisticated work with a view camera. Exposures are long, often as much as fifteen and thirty seconds. Mood effects require careful planning, and experimental photographs are created with filters, hidden floodlights, and even electronic flash. For some purposes, the 35mm camera with its fisheye and extreme wide-angle lenses is very useful.

A career in interior design photography usually starts after some experience with the routines of general commercial studio photography, and then, architectural photography. It is a specialty that will beckon the photographer with a feeling for art and decor, one with a disciplined mind and patience.

See also Architectural Photographer, Exhibits Photographer.

JOB DESCRIPTION • Provides the knowledge of color, light, film and camera angle. Masters use of view cameras in both daylight and artificial light. Provides experience with extreme wide-angle lenses for 35mm cameras.

TYPICAL ASSIGNMENT • The local headquarters of a national insurance company has been expanded, and the interior designer requires photographs of the new lobby, conference room, administrative offices, computer room, employee dining room and the new office of the chief executive officer. The work must be completed during a Saturday and Sunday so that photography will not interfere with normal work schedules. The photographer makes a weekday visit to the installation and takes light meter

readings in rooms under daylight and closed-curtain conditions. After a follow-up meeting with the client and the public relations officer of the corporation, the decision is made to make most views on 4x5 color film and the more difficult rooms photographed with the 35mm camera, which offers more extreme wide-angle coverage.

TRAINING ● Similar to architectural photography but with special emphasis on knowledge of color, filtration, lighting measurement and arrangement. Minimum of two years of photography school and an apprenticeship in a commercial or architectural studio.

SALARY ● The employee of an interior design photography studio may start at an apprentice level and move rapidly to $15,000-$25,000. The owner of such a studio may earn $25,000 per year and up, depending on his business acumen and expertise.

RECOMMENDED READING ● *Architectural Digest (magazine)*, 5900 Wilshire Blvd., Los Angeles, CA 90036; *Display and Design Ideas (magazine)*, 180 Allen Rd., NE, #300, N Bldg., Atlanta, GA 30328; *Photography with Large-Format Cameras.* Rochester, New York: Eastman Kodak Company, Publication O-18. 1988.

TRADE ASSOCIATION ● Professional Photographers of America, 1090 Executive Way, Des Plaines, IL 60018.

Magazine Photographer

What is your favorite magazine? Something in photography? In outdoor sports? Fashions? Travel? One of the popular men's or women's publications? Would you like to see your best photographs appear on the pages of one of these publications? There is no surefire approach, but here are some possibilities.

1. Win a full-time job! Plan ahead on how to get that job as a staff photographer on that magazine. The staff of *National Geographic* is over 20 men and women; most have far less.

2. Freelance! All of the output of *National Geographic's* top-skilled group still does not fulfill all of the needs of that auspicious publication. Result? NG employs freelance talents for story needs best fulfilled by talented specialists in local areas or with special skills. You could be one too!

3. Earn an Assignment! Start as a contract photographer for your favorite magazine. This means they don't have the money to offer a full-time role or its pay scale, but the editor does want you to remain on hand, loyal to his needs. For a few thousand dollars a year, he gets first call on your time and your story ideas. This may mean an end to a vacation plan, or a 200-mile drive in the rain, because you are the nearest photographer to a distant photo opportunity.

4. Sell your Story Ideas! Be cagey; get yourself an assignment from the magazine by submitting the perfect idea at the perfect time with a promise of the perfect pictures. This means you'll be submitting endless ideas to numerous magazines; it only takes one idea to pique editorial board interest. Do that assignment and submit ideas for the next ones.

5. Submit Photos for Picture Inventories! Load an active stock photo house with photographs you believe meet the general editorial needs of the magazines reflecting your area of specialty. Horse magazines buy horse-theme pictures; garden magazines endlessly need startling flowers in bloom; how-to magazines seek demonstration photos.

In time, one or more of your photographs will ultimately grace the pages of your target publication.

There are hundreds of magazines on the newsstands. Check the masthead page (where editors and other responsible members of the staff are listed). Note how few ever list photographers.

An hour or two with back issues of the publication you aim to work for is the fast track to an education in what its editors seek or expect.

See also Documentary Photographer, Photojournalist, Press Photographer, Travel Photographer.

JOB DESCRIPTION ● Provides expert small- and medium-format camera handling in both indoor and outdoor situations, following scripts and editorial objectives set by the publication editor. Owns and maintains suitable cameras, lenses, lighting equipment.

TYPICAL ASSIGNMENT ● A vacation resort has reconstructed and repaired a working railroad on the resort grounds as a novel source of youth and adult entertainment. Guests learn to operate a steam locomotive, open and close switches, and play at railroading. The photographer has been asked by a travel magazine to provide a number of photographers depicting children and their parents playing together in what will appear to be unposed situations.

CLIENTS AND EMPLOYERS ● Magazine Photographers are either salaried employees, contract photographers with regular assignments, or free-lance photographers selected for their special knowledge, special location or for their ability to provide workable ideas to the editor.

TRAINING ● A minimum of four years of college photography courses, two years of photo school courses, and/or two years of military photography. Some skills in writing, communications and business judgment.

SALARY • Magazine Photographers may earn from $18,000-$25,000 as employees. Free-lance photographers are paid by the assignment or by per-diem arrangements. Contract photographers may be retained for $5,000-$10,000 per year.

RECOMMENDED READING • *Assignment Photography (pricing guidelines).* American Society of Magazine Photographers, 419 Park Ave. South, NY, NY 10019 ($14 + 2.00 s/h.); Bleich, Arthur H. and McCullough, Jerry. *The Photojournalist's Guide.* Milwaukee, WI: Tech/Data Publications; Cribb, Larry. *How You Can Make $25,000 a Year with Your Camera (No Matter Where You Live).* Writer's Digest Books; Kerns, Robert L. *Photojournalism: Photography with a Purpose.* Englewood Cliffs, NJ: Prentice-Hall, 1980; Rothstein, Arthur. *Photojournalism.* New York: Amphoto, 1979.

TRADE ASSOCIATION • American Society of Magazine Photographers, 419 Park Ave. So., New York, NY 10016; with 35 local chapters across U.S.

Medical Photographer

Sometimes working in teams of six, eight, and more in large institutions, Medical Photographers or biophotographers provide doctors with a broad variety of services that fall into three essential categories: patient care, research, and medical education.

The 1,500 members of the Biological Photographers Association are only a small part of the nationwide membership of this profession. Members are primarily employees of hospitals, America's 160 medical teaching centers, and Veterans Administration facilities. Many of these photographers are state, municipal and federal employees; some are civilians assigned to military institutions since the military services have ended their use of uniformed photographic personnel for medical support services.

Their job requires expert knowledge in such diverse situations as photomicrography (photography through the microscope), operating room reportage, clinical photography, autopsy room services, and, even at times, general photographic capabilities for the institution's public relations needs. In an institution which is also a teaching center, photographers work closely with doctors to create photographs to help instruct medical students. Photographs help confirm new medical breakthroughs and are playing an increasing role in diagnosis.

Smaller hospitals occasionally require medical photography, and, to a limited extent, there are a number of independent photographers with background and skills required by the institution. More often a member of the hospital laboratory (or even a physician) will provide the part-time photographic service required.

JOB DESCRIPTION • Operates hand-held small-format and medium-format cameras for laboratory and operating room documentary coverage. Skilled in photomicroscopy and tissue imaging. Offers general photographic skills: portraiture, public relations photography, and basic darkroom practice in black-and-white and color. May be required to operate video equipment.

TYPICAL ASSIGNMENT ● A staff doctor has been asked to provide a lecture on a new operating room procedure, and the photographer will make 35mm slides of the patient in the examining room so that the lecture slide sequence may commence with diagnosis. The photographer will take photographs of the necessary surgery, photomicrographs of the diseased tissue, and close-ups of the organ removed from the patient. Caption material may be prepared on a hospital personal computer.

CLIENTS AND EMPLOYERS ● Medical Photographers are primarily employees of large hospitals and teaching institutions. A small number of free-lance photographers are on call for facilities without full-time photographic installations.

TRAINING ● On-the-job training following two years of photography school, commercial photography or military service photography.

SALARY ● Starting salaries are about $20,000 per year with advancement to $28,000 over a number of years. See Appendix for VA salary schedules.

TRADE ASSOCIATION ● Biological Photographers Association, 115 Stone Ridge Drive, Chapel Hill, NC 27514.

Museum Photographer

The photo team effort of the Metropolitan Museum of Art on Fifth Avenue in New York City started back in 1906. Today's team of twenty-two includes five photographers, five printers and numerous support aides.

In Chicago, at the Art Institute facing Lake Michigan, the Photography Department has a permanent staff of three photographers plus a support staff. Art museums require photography for the permanent files of the collection, for the slides to be sold to visitors, for the books and papers published by the museum curators, for the public relations needs of the institution.

Photography is a much more scientific tool in the Photography Department of the American Museum of Natural History on Central Park West in New York City. This museum not only conducts research and education but also sponsors worldwide expeditions and special activities.

The atmosphere of the museum provides both opportunity and advantages for the budding photographer. As a teenager, Lee Boltin knew that he wanted a photographic career. He developed his skills as a member of the Photography Department at the American Museum of Natural History. By the time he completed a twelve-year stint there, he had learned how lighting can be used to bring out almost lost detail in a Stone Age weapon or a shard of pottery.

In 1955 he left to start an art photography service to museums too small to maintain their own in-house photographic departments, and to the owners of private collections requiring photography of items to be loaned to exhibits or to be illustrated in publications.

With this talent and experience, he was commissioned by various museums, private owners, and publishers to photograph important artifacts and objects in fifteen countries. His photographs have illustrated nearly thirty books and catalogues. He regarded his crowning achievement as having been selected to provide the photographic

work necessary for the various Nelson Rockefeller collections. Boltin photographs illustrated Rockefeller Masterpieces of Primitive Art (1978) and Gold of El Dorado (1979). His next assignment was the definitive work on the Rockefeller collection of twentieth century art. He died at age 73. Somewhere in some institution there is a successor now following his lead into the world of art and museum photography.

Museum photography includes the public relations photography required for the announcement of exhibits, the inevitable portraits required for security or file purposes, the photography of the various buildings, wings, rooms and sub-displays.

Photographs from these institutions are rarely credited to the photographer; they are likely, instead, to be simply credited to the museum. The photographer may be anonymous, or he may become as famous as Lee Boltin, but he will spend his life in surroundings of art, culture, history and education. His work can lead to the doors of the Rockefellers, to tombs in the desert, or to palaces in Vienna.

See also Archaeological Photographer, Art Photographer, Commercial Photographer, Exhibit Photographer.

JOB DESCRIPTION ● Provides expert knowledge of still-life photography. Specializes in polarized light, infrared and other lighting sources. Offers skilled performance in darkroom procedures for black-and-white and color.

TYPICAL ASSIGNMENT ● The museum has acquired an art collection from a family estate. All paintings, drawings, sculpture and related items are to be photographed in black-and-white for the filing system in the administrative offices, in color on 35mm slides for the library and use of the curators, and, in some instances, with infrared to provide hidden details which may lead to confirmation of the art source.

EMPLOYERS ● Museum photographers are employed by private and public museums, scientific institutions and some universities.

TRAINING ● The photographer will require a college education in the arts plus a minimum of two years of college photography courses or one year of actual studio

experience or one year of private photography schooling. Military photography experience is of limited value.

SALARY ● Employment starts at about $20,000 per year and, after some years of experience and added duties as a photo administrator, may rise to $30,000 - $35,000 annually.

RECOMMENDED READING ● *Applied Infrared Photography*. Rochester, NY: Eastman Kodak Company. Publication M-200. 1990; Collins, Sheldon. *How to Photograph Works of Art*. Nashville, TN: AASLH Press. 1986; *Professional Photographic Illustration*. Rochester, NY: Eastman Kodak Company Publication O-16. 1989.

TRADE ASSOCIATION ● International Museum Photographers Association, c/o L.A. Kenyon, 5613 Johnson Ave., Bethesda, MD 20817.

Oceanographic Photographer

Working in and above the ocean, talented biologists and agronomists document on film the changes in plant life, which hold the future of sea life as we know it today. In their skin-diver's gear, they work at depths requiring the knowledge of the underwater world combined with a technical knowledge of photography to bring back the information vital to scientific advances.

Oceanographic Photographers are active in a thousand marine study stations around the world; aboard special scientific vessels such as Jacques Cousteau's *Calypso*; on special missions for such bodies as the scientific commissions of the United Nations and research groups operating out of a hundred or more universities; and on behalf of giant corporations now studying ways of developing undersea farming, mining or oil ventures. Private research groups are using underwater photography to seek to protect endangered species or simply to cope with manmade pollution.

The start of oceanographic photography skills is to be found in the university biology and chemistry laboratories. A knowledge of plant and marine life precedes any steps to first-hand experience below the waves.

Learning to identify, handle, and take specimens is taught aboard specially equipped craft in America's warm waters under the tutelage of oceanographers and marine biologists. Photography is a separate skill which, like a knowledge of shorthand, typing or operation of a shortwave radio, simply extends your abilities for a further variety of assignments in the field.

The studies of tides, of wave action, of the shape and nature of the ocean floor, of the evidences of oil fields or other resources ultimately important to industrial production, also will require skilled underwater photography. Some of these studies will not require a scientist of marine biology.

Scuba diving in shallow waters may provide a basic introduction to the general field of underwater photography suitable for the undersea photography courses now

taught at some photography schools. The sophisticated self-propelled cine or video cameras will be mastered under a program of study with experienced undersea experts. Few if any schools have the specialized gear necessary for teaching deep-water photography.

See also Botanical Photographer, Wildlife Photographer.

JOB DESCRIPTION • Provides expert knowledge of the special underwater equipment. Offers expert knowledge of the biological sciences and the earth sciences relating to the ocean floor.

TYPICAL ASSIGNMENT • A government agency is investigating damage to marine life in a tidal basin where wastes from an industrial complex have apparently made it impossible for local oystermen and shallow water fishermen to properly harvest catches. The changes in the oyster beds, availability of sea life to support the fish population, and other possible influences on the local marine life are to be documented in photographs to accompany a scientific report that will suggest reasons for the decline of the area's sea crops.

CLIENTS AND EMPLOYERS • Photographers with special underwater skills are employed as members of research teams for university, government agencies and private corporation laboratories. Often photography is a secondary skill required of the employee.

TRAINING • Four years of college in geophysical or biological sciences plus a basic background in photography will be required. Photography training should be a minimum of two years of college, or one year of photography school, or two years of military photography.

SALARY • Science research workers will earn salaries from $18,000-$30,000 per year.

RECOMMENDED VIEWING • *Discovering Underwater Photography*. Rochester, N.Y.: Eastman Kodak Company, 16mm film, running time 27.5 minutes; Cat. No. AV-0366.

Panoramic Photographer

According to Harold Lewis, President of Panoram International of West Newton, MA, there are three kinds of Panoramic Photographers among the 300 photographers in America who are self-identified as specialists making those yard-wide, 10-inch high sweeping photographs classified as "panoramics."

The first kind is the professional. Perhaps there are three dozen who qualify by Mr. Lewis's standards: panoramic specialists who on a full-time basis take spectacular scenes . . . up to a 360-degree sweep.

The second kind is the part-time panoramic photographer, essentially a competent commercial photographer who will assure a client that he can deliver a 110-degree or a 180-degree image of a shopping mall, a school stadium, a school graduating class and other typical modern panoramic subjects.

The third kind he dubs as "the amateurs." They have yet to learn the difference between the photographs made by a rotating camera and a large camera fitted with a wide-angle lens. Often, according to Mr. Lewis, a photographer will press into service the extra large camera of the banquet photographer. The difference in pictures between the images from the two camera types is immediately apparent to the experienced photographer: the wide-angle photo is impaired with images at the ends of the scene significantly smaller than the central image.

The qualified Panoramic Photographers start with a sizable background as a commercial photographer. This assures a comprehensive understanding of light and its manipulation.

The Panoramic Photographer owns some bizarre equipment. His major camera is the Cirkut, a camera system made before World War I and not since. These near-antiques pass from hand to hand in the panoramic photo industry at lofty prices. The largest Cirkut loads with a roll of film 16-inches tall and up to 10-feet long. The processing headache is handled by specialty laboratories in major cities of the United

states. No ordinary darkroom is equipped to develop and contact print color film of that size and length!

To avoid distortions, he routinely carries on his car or van roof an extension step-ladder that gets him up to 25-feet above the ground. Its tiny platform for tripod and giant camera barely leaves room for the photographer.

There are smaller (handheld) cameras for panoramicists, some as petite as 35mm, some which use #120-size rollfilm. Lenses which pivot during exposure set these cameras apart from extreme wide-angle cameras. A taste of the panoramic effect has been made possible for millions of amateur photographers by low-cost one-way cameras from Kodak and Fuji which create images 3.5-inches x 10-inches, actually 83-degrees of coverage which simulates the panoramic effect.

See also Banquet Photographer, Real Estate Photographer.

JOB DESCRIPTION ● Operates specialized photographic equipment to achieve the special effects of photos covering fields ranging from 110-degrees to a full 360-degree rotation in b/w and color.

TYPICAL ASSIGNMENT ● A local land developer planning a golf course with adjacent homesites requires a full color photograph for use as a mural in his Sales Center. It will also be a large image in the color brochure to be sent to realtors and others who can find home buyers for the property. The photograph must be taken from a high angle so as to show the lake in the foreground. Tree shadows are to be minimized by shooting as close as possible to noon when the sun is overhead.

CLIENTS AND EMPLOYERS ● The client to be served is likely to be a school seeking campus or stadium photos, group images as at graduation and other special-purpose scenes; or a land developer requiring scenic effects; or a commercial property owner seeking to promote a hotel, motel, golf course, bridge location, etc.

TRAINING ● There are no formal classes in private, public or military schools. All Panoramic Photographers begin as assistants to practicing successful photographers.

SALARY ● Most panoramic photographers practice this specialty as an adjunct to a commercial photography enterprise. Earnings are commensurate with local commercial photographic business success. An assistant may be employed at $12,000 - $15,000 for the first period.

RECOMMENDED READING ● *Newsletter of the International. Assn. of Panoramic Photographers*. Panoramic camera product literature from manufacturers.

TRADE ASSOCIATION ● International Association of Panoramic Photographers, 1739 Linwood Lane, Orlando, FL 32818.

Pet Photographer

There was no way that Peter B. Kaplan could have used his studio for the animal photography assignment he was awarded from *The Dial Magazine*: make five tight-head portraits of gorillas now in U.S. zoos. Kaplan hauled four cases of electronic flash and five motorized Nikon cameras on his tour, along with a battery of sixteen lenses to capture facial expressions that had the look of formal studio portraiture. His tour took him to meet Jim-Jim in Detroit's zoo; Chuma in Los Angeles; Niki in Washington, D.C.; Sinbad in Chicago; and Congo in New York.

Earlier, one of the great animal photographers of the twentieth century was a photographer named Ylla, a woman whose skill with hand-held cameras led her abroad to the wilds of Africa and locally to the zoos of most large cities. Her incredible photographs appeared in *Life, Look* and many other major magazines, and in numerous books requiring wildlife illustrations.

"Main Street" studios know that child poses with a favorite animal easily win orders for profitable large-size prints. Photography with a pet often makes work with the youngster easier on both the parent and the photographer. Some studios actually keep trained animals on hand for sittings. One studio, the New Jersey studio of Oscar and Elizabeth Bro, had a trained parakeet named Silly Sour who would pose on a child's finger.

There are over 25 million dogs and over 20 million cats in the United States, which means a giant annual investment in breeding centers and pet shops plus many thousands of veterinarians and dog grooming shops and a half-billion dollar pet food industry.

An exhibit-size photograph and a standard calling card can be left on pet shop bulletin boards wherever local shows are promoted. Photos can be mounted on the walls of the local dog groomers. The local Pet Photographer can also advertise in the dog show publications. Owners of prize-winning pets can be approached at pet shows for

portraits to be made later with the winner and his newly won honors. Meetings with veterinarians, dog breeders and owners of boarding kennels can lead to mutual benefits. They can often refer their clients to you as the established local Pet Photographer, and you are in a position to recommend their facilities and services to the studio's clients.

The Pet Photographer need not own a studio; the photographs can be taken in the home of the pet owner.

The Pet Photographer also has an unusual opportunity denied to the Child or Bride Photographer; he can easily obtain a standard release from the animal's owner. This permits one-time use only of reproduction rights to photographs to others such as pet magazines, calendar companies, product advertisers and book publishers.

See also Horse Photographer, Wildlife Photographer.

JOB DESCRIPTION • Provides skill with hand-held cameras and long-focus lenses for outdoor photography. Offers skills with controlled electronic flash lighting for indoor photography.

TYPICAL ASSIGNMENT • A black Doberman pinscher has won the "Best of Breed" award at the local dog show. The owner is interested in having the animal photographed to show the dog's best breeding points, as these were noted by the judges. The photographs are for the national magazines of the pet field and for the owner's trophy shelf. The photographs must be made against a background which silhouettes the body lines. Lighting and contrast must be appropriate for the detail in glossy black body hair.

CLIENTS AND EMPLOYERS • Pet Photographers cannot often find full-time employment in this field. They may be employees of commercial or portrait studios that offer pet photography services as a sideline. Pet Photographers are generally self-employed.

TRAINING • One year in general photography school or two years in college photography. Three years in military photography.

SALARY • Self-employed photographers will enjoy earnings according to the size of the community and their business acumen.

RECOMMENDED READING • Chandoha, Walter. *How to Photograph Cats, Dogs, and Other Animals.* New York: Crown Publishers, Inc., 1973; *Pocket Guide to Photographing Your Cat.* Rochester, NY: Eastman Kodak Company. Publication AR-27. 1985; *Pocket Guide to Photographing Your Dog.* Rochester, NY: Eastman Kodak Company. Publication AR-28. 1985.

TRADE ASSOCIATION • Professional Photographers of America, 1090 Executive Way, Des Plaines, IL.

Photo Editor

Today's newspapers, magazines, television stations and publishing houses are using more illustrative material than ever before! More art, more color, and more photography.

From newsweeklies to slick fashion magazines, the Photography Editor has often come to his expertise in the world of pictures through the medium of the camera. Photographers understand what can and can't be quickly done when considering enlarging an illustration or recropping a photograph for greater visual impact. A photographer at the photo editor's desk knows more about what he can expect from the cameraman in the field than the editor who has never had to focus a camera in pitch blackness, or to grab a second exposure when a subject is on the move.

For the Photo Editor, the decision-making process is the very key to a publication's success. Selecting the right cover art or the one picture that best instantly communicates a message for the front page is a vital responsibility. With responsibility comes prestige, and with prestige, money. Photo Editors make more money per year than chief photographers, reporters, or rewrite men. And as Photo Editor, it's not unheard of to even give yourself the best camera assignments.

The route up the ladder to such responsibility starts more often with the job of Press Photographer than in the role of journalistic reporter.

Photo Editors have three major areas of potential employment: newspapers, especially those with major weekend editions and those with four-color printing capability; magazines, especially those in which illustrative matter is key to reader interest; and finally, the news services used by the printing and broadcast media.

The Photo Editor reviews photographs developed daily from a variety of sources outside the photographic department of the company he serves. Photographs arrive from publicity organizations, government agencies, wire services, stock houses, and from the general public. Photographs tumble across the desk from the staff photographers on

planned assignments and from free-lance photographers on special projects. The Photo Editor has to check proof sheets for the negative that best captures the theme of the accompanying story and to suggest news story material to the editorial board from the random sources that have proposed photographic stories. He must be responsible for the liaison with the Photography Department for stories in development and for interviewing representatives of freelance photographers and the numerous stock photography organizations.

Training starts with a background in journalism and actual field experience in reportage and documentary photography.

See also Photographic Administrator, Photographic Writer.

JOB DESCRIPTION • Provides expert knowledge of photography from photo concept to darkroom. Offers past journalistic experience in actual photographic problem-solving.

TYPICAL ASSIGNMENT • The Mayor has decided he will run for a second term in office. The newspaper wants to present a photographic history of the achievements of his administration. Three years of photographs of the Mayor, City Hall, and key city events where the Mayor has been a participant, speaker or presiding officer must be reviewed for selection of the ten or twelve pictures that will ultimately be printed as part of the story. All photographs must be selected within two days from boxes of photographs that have been brought to the Photo Editor from the file room.

CLIENTS AND EMPLOYERS • The Photo Editor is a salaried employee of a newspaper, magazine, wire service, or other large user of photographs.

TRAINING • The Photo Editor must have experience as a photographer or photo researcher, along with a background in journalism, either as a four-year student or as an employee of a newspaper or in military photojournalism.

SALARY • The Photo Editor will earn from $20,000-$40,000.

RECOMMENDED READING • *Editor* and *Publisher* magazine at the Public Library; Rothstein, Arthur. *Photojournalism*. NY, NY: Amphoto Publishing Co.

TRADE ASSOCIATION • American Society of Magazine Photographers, 419 Park Ave. So., New York, NY 10016; with offices in 35 U.S. cities; American Society of Newspaper Editors, P.O. Box 17004, Washington, D.C. 20041.

Photo Products Buyer

You can't start as a Photo Products Buyer with a BA or an MA and with retail selling experience as Christmas help during last December. You'll have to be technically knowledgeable in both photography and merchandising before an independent store, a small chain or a mail-order firm will seek your services as the person who may well determine that store or chain's sales fate.

Many a store has been made an overnight failure because it had the right merchandise at the wrong time, or the wrong merchandise at any time. The Photo Products Buyer holds the key.

Where did he get it? To begin with, the Photo Products Buyer is a knowledgeable photographer. He knows all about the differences between focal planes and between-the-lens shutters. He knows all about sales tricks which vaunt fixed-focus universal focus cameras as autofocus cameras. He knows where on a camera to locate the depth-of-field and ISO ranges, and he knows the difference between drop-in loading and quick-loading systems.

He learned all that in college or perhaps in the military, but he has it down cold. Then, he keeps abreast of the changes in photography. He will know what products are heading for Christmas shelves by his regular attendance at the annual American trade shows of the Photo Marketing Association. If he is attached to a larger mail order or giant chain, he will have an all-expense trip to the biennial Fotokina in Cologne, Germany where the newest technologies from around the world are on display. This knowledge permits him to know when and how to sell off slow-moving older inventory before the new way of photography reaches his Main Street. He attends the spring shows to order merchandise for fall and pre-Christmas delivery.

Then he learns each day at the store what to buy by listening to the two or three visiting sales representatives of importers, manufacturers or distributors of products which his store might stock. He must balance his Open-to-Buy (available inventory

dollars) with his actual cash position. He dare not run out of film, for example. But he also dare not miss an opportunity to be the first store in town to offer a newly "hot" item for the amateur or professional photographer.

New York City's most famous camera store lost the opportunity to launch the Polaroid camera system for all of America -- because the Buyer (then the store's President) had no confidence in the first (1948) Polaroid images: brown and sticky! Buyers all over America laughed at that gaff; then they wondered when they would commit hari-kari with a similar goof!

Department stores, chain stores, discount stores, catalogue outlets, mail order companies, wholesalers, small retail chains, and, finally, the large camera stores themselves cannot make profitable sales in the photographic field without a knowledgeable buyer who shapes store inventories to meet the needs of the clientele.

The Photo Products Buyer trains salespeople to sell the goods he has acquired. If they do not share his enthusiasm for a product, it not only sits profitlessly on the shelf, but it also ties up inventory dollars that might have been used to acquire goods with a higher turnover rate. The buyer is thus endlessly holding school.

The buyer is a negotiator since his store seeks the best possible price, the maximum support in advertising, the most service support, and the fastest delivery to meet the store's sales flow. The buyer is a friend to the visiting salesmen since it is from them that he learns what is selling well elsewhere and which goods have the best profit potential.

See also Retail Salesman.

JOB DESCRIPTION ● Combines a working knowledge of general photography with sales skills. Recommends suitable photographic products to meet the consumer's budget and use considerations. Generates store profits through related sales of films, accessories, frames, and other aids. Plans sales, product offerings, and inventory suited to the community.

TYPICAL ASSIGNMENT • A new store is opening in a shopping center. The new clerk or buyer will be responsible for the better cameras and related lenses. He will organize shelves from the store inventory, learn how to mount various lenses to the proper camera bodies, and demonstrate differences in wide angle and telephoto lenses. Greets customers and matches needs of travel and family photography to the customer's budget. Operates store inventory control and often plans related advertising.

CLIENTS AND EMPLOYERS • Retail clerks and merchandising personnel or buyers are employed by independent retail stores, chains and discount stores with camera counters and by department stores with photo departments.

TRAINING • Buyers start with a college education in business administration with special emphasis on retail operations and merchandising. A further six months to two years of education in photography, either in college or photography school, will acquaint the buyers with all tools and supplies of the working photographer.

SALARY • Clerks will start at $10,000-$12,000 but with possible quick promotion to department head with buying responsibilities, branch management, and business participation. Buyers start at $20,000 - $25,000.

RECOMMENDED READING • *Photo Weekly*, 1515 Broadway, New York, NY 10036; *Photograph and Video Trade News*, 445 Broad Hollow Road, Melville, NY 11747.

Photographic Writer

It takes a photographer to write about photography. Who else can best explain how a camera works or how a photograph is improved with proper selection of filter, film or flash? It takes a photographer to regularly create enthusiastic words for a weekly newspaper or a monthly magazine column advising America's millions of families who own cameras on how to best enjoy their use. It takes a photographer to write the advertising copy that sells these cameras, and it takes a photographer to select key features for catalogue sheets which induce a dealer to stock and sell certain cameras.

Photographic Writers regularly bring trade news to store owners, studio owners, and working photographers in plants, laboratories, hospitals, wedding salons, etc. They create most of the articles that appear in the leading magazines of amateur and professional photography.

The Photographic Writer's career can even be international. L. Andrew Mannheim was Technical Editor of *Focal Press* in London, England where he wrote and edited various projects including the *Focal Encyclopedia of Photography*. His career started with freelance writing on photography and working as a photo industry consultant. Today he is living in America, currently active as technical editor, contributing editor, and regular columnist for *Functional Photography*, in the U.S., *Canadian Photography* and *Photo Canada* in Canada, *British Journal of Photography* in the U.K., *Australian Photography* and *Industrial & Commercial Photography* in Australia, *Camera* in Switzerland, *Color Foto Journal* and *Zoom* in Germany, and *Nuova Fotografia* in Italy.

Hundreds of companies sell photographic products. Almost every one has a Communications Department or a technical writing staff to maintain contact with dealers, salesmen and the consumer. Dozens of magazines and newspapers employ photographic specialists. Publishing houses are anxious to receive proposals for books that further explain or illustrate the capabilities of the camera.

The Photographic Writer may travel as a photographer-travel writer. The skier-photographer can often sell sports essays about his winter vacations. The underwater photographer can illustrate that world in a way that the typical scuba diver can never describe.

The first steps on the road to photographic writing are courses in journalism, creative writing, and actual practice on school or local publications. The end of the road can be authorship of best-selling books, editorship on a major magazine, and a by-line in hundreds of newspapers, but it all starts with skilled use of the camera.

See also Advertising Copywriter, Photographic Educator, Technical Photography Writer.

JOB DESCRIPTION ● Applies a seasoned photography background to the editorial requirements of publications, catalogues, technical manuals, and other informational writing.

TYPICAL ASSIGNMENT ● A publication seeks to inform readers planning a winter vacation how to best capture the winter (snow) mood. The writer describes cold-weather photographic problems (weakened batteries, frostbitten cameras, brittle film) and suggests ways to protect the camera. He advises on film selection and care, suitable filters, and the use of electronic flash in the sunshine to bring more detail into shadow areas. He illustrates the article with photographs from his own winter vacations and poses a few additional photographs with a model in winter ski wear.

CLIENTS AND EMPLOYERS ● Writers are employed by publications or photographic marketing companies and will be selected based on experience and proven writing skills, along with knowledge of the subject. Self-employed Photographic Writers contract for articles and books under terms set by publishers. (They are often represented by agents who closely follow the needs of the market and are aware of individual publishers' predilections.)

TRAINING • Two years of photography in college as part of an overall journalism course. Two years of private photography school plus experience as a writer for a newspaper or other publication.

SALARY • The employed Photographic Writer will earn $15,000-$35,000 per year, depending on the company or publication. Self-employed writers need ongoing assignments and a series of royalty-paying books to annually earn a magazine editor's pay.

RECOMMENDED READING • The Photographic Writer should be an avid reader of all consumer, industrial and specialty magazines of the photographic world, all available by subscriptions or complimentary from publishers, many at local libraries.

TRADE ASSOCIATION • Society for Photographic Education, Box 1651, FDR Station, New York, NY 10022.

Photojournalist

"My first week there (Vietnam), I was at a firebase that was attacked at night by one hundred Vietcong sappers (soldiers specializing in explosives). There was tremendous incoming mortar fire, too, and because it was so dark, I couldn't take pictures. An officer handed me a gun. I said, 'Sorry. I'm a noncombatant.' He told me to tell that to the VC. I said, 'I'll take it.'"

Those are the words of David Hume Kennerly who returned from his United Press combat photography assignment to the White House where he became personal photographer for President Gerald Ford. Kennerly was only twenty-four when the Photography Department of UPI tapped him for the dangerous overseas frontline coverage work. Pleased with his contribution to the UP coverage of that war, they sent him to further combat situations in India-Pakistan, Mozambique, and then to Northern Ireland.

Photojournalists are not usually destined for combat, and only a handful will ever enjoy visits to the White House in connection with their duties. Most will serve on the staffs of local newspapers where the day's big story is the lawn party of the garden society. The action is a bit heavier for the Photojournalist on the staff of a big city newspaper or at a key branch of the wire services. The day's assignments from the Photo Editor may range from coverage of the political scene, the inevitable fire or crime story, or the interview with the visiting theatrical or television personality, to the ongoing coverage of social problems.

There are nearly two thousand members of the American Society of Magazine Photographers, a largely photojournalist group, which for the past thirty years has sought to establish minimum working standards for the freelancers. Press Photographers

who accept full-time employment on a major daily are usually members of the National Press Photographers Association and the American Newspaper Guild. See Appendix.

See also Documentary Photographer, Industrial and House Organ Photographer, Magazine Photographer.

JOB DESCRIPTION ● A new housing development will feature solar-heated homes and a community-owned windmill for additional electrical power. A number of construction, energy and general interest publications have agreed to publish the story. Photographs are needed of the homes, the installation of the solar panels, the building of the windmill, an aerial view of the locale, and some "inquiring photographer" interviews with early residents of the community must be included. The Photojournalist given the assignment has two days in which to complete the necessary photography.

CLIENTS AND EMPLOYERS ● Photojournalists (Press Photographers) employed by newspapers earn from $15,000-$30,000, depending on union contracts, length of service, etc. Freelance photographers are generally paid at the day-rate plus costs, the schedules established with major publications by the ASMP.

RECOMMENDED READING ● *Assignment Photography (pricing guidelines).* American Society of Magazine Photographers, 419 Park Ave. So., NY, NY 10016; $14.00 plus 2.00 s/h; Bleich, Arthur H. and McCullough, Jerry. *The Photojournalist's Guide.* Milwaukee, WI: Tech/Data Publications; Kerns, Robert L. *Photojournalism: Photography With a Purpose.* Englewood Cliffs, NJ: Prentice-Hall. 1980; Rothstein, Arthur. *Photojournalism.* New York: Amphoto, 1979.

TRADE ASSOCIATION ● National Press Photographers Assn., Inc., 3200 Crossdale Drive, Durham, NC 27705.

Police Photographer

For most police departments in the United States, the route to the Photo Unit or to the Crime Scene Search Unit starts at the level of uniformed patrolman.

"If a young man or woman wants a part in interesting photographic work, performed under the most difficult conditions," said a high official of the Nassau County Police Department in Long Island, New York, "there's plenty of opportunity in a crime investigation unit. But first the applicant will have to be a police officer." Most police departments seek healthy young men and women from about twenty-one to twenty-nine years of age with a minimum of two years of college education.

As in many fire departments, the Police Photographer is a police officer first and a cameraman second. However, there are states where civilian employees are responsible for all police photography requirements, from the mundane identification photographs (mug shots) to crime scene documentation.

At the Nassau County Police Department over thirty thousand felony arrest prisoners are photographed each year. Public relations photographs are also made each week depicting the role of the law enforcement divisions for local newspapers, magazines and television stations. The five-days-a-week police photo center creates glamour portraits of the department's top executives and also the "look-here" Polaroid instant portraits for the ID cards worn by every headquarters employee.

The technical services section is where actual crime investigation is conducted by detectives and police scientists in the fields of physics, chemistry and biology, including the twenty-one man Crime Scene Search Unit. This twenty-four-hours-a-day, seven-days-a-week operation is completely mobile with three police vehicles fully equipped to gather on-scene evidence. Skilled police professionals bring back small tangible courtroom evidence and photographs of everything else.

Each man or woman on this police team has been trained in a 240-hour departmental course that includes everything from aerial photography to morgue

photographs. The call for one of these teams is initiated by the patrol officer or the investigating detective at the crime scene. Each will use a police-car radio to alert the Crime Scene Search Unit. A one-man or two-man team then responds like a fire station crew. Their van is equipped with #120 roll-film systems, complete 35mm outfits, and the Polaroid special fingerprint camera. Their time at the scene may be as brief as twenty minutes or as long as sixteen hours in search of clues in a homicide case. Many of their color and black-and-white photographs remain as negatives forever; only the most significant photographs will be presented as evidence in court.

Assignment to the Crime Scene Search Unit is usually the result of a letter requesting transfer from other departmental duties, most often after at least three years of routine police work in a patrol car. The candidate is usually checked for a science background and two or three years of college. He must have demonstrated evidence of initiative and imagination in his earlier police career and have had some off-duty experience in photography. If accepted, he will have a one-to-one relationship with an instructor for the 240-hour training period. He will learn aspects of photography never taught in standard photography schools: for example, photography by infrared or by chemical fluorescence which may reveal vital clues. The Photo Unit of the department handles all processing and photofinishing. He will learn forensic photography, which will include photomicroscopy, photography of wounds, and details of violence usually too grim to be made public in newspapers or magazines.

Some members of the team will qualify for extra training by the Federal Bureau of Investigation in special courses at Quantico, Virginia. All participate in the occasional two-day seminars provided by makers of various camera equipment so that knowledge of new technologies reaches all team members.

Law enforcement agencies have photo contests for the best photos made at crime scenes. In addition, the New York State Chapter of the Evidence Photographers International Council has an annual contest. The Nassau group has garnered a number

of plaques from such competitions. The individual winners receive Merit Letters for their permanent department file, significant assets in the competition for promotion, and higher pay.

Nassau County is one of the bedroom communities just outside of New York City. Its many suburban towns and villages shelter 2.5 million citizens, making this county larger than most American cities. Its police department is headquartered in Mineola where a modern installation with four darkrooms, a giant finishing area, an impressive photographic studio and a seasoned corps of police officers handle the numerous photographic projects of the department.

See also Fire Photographer, Forensic Photographer, Insurance and Legal Photographer.

JOB DESCRIPTION ● Operates 4x5 sheet film cameras for portraiture; provides skilled knowledge of small cameras for evidence photography, forensic photography, photomicroscopy and occasional public relations photography. Operates video cameras for suspect interviews and surveillance photography.

TYPICAL ASSIGNMENT ● A radio call from the accident scene on the state highway requests the Crime Scene Search Unit to gather evidence. A multiple car crash has resulted in deaths, injuries and extensive property damage at night in the snow. The photographer takes views showing the extent of the damage, photographs the contributing highway ice conditions, and makes such other record shots as the investigating team may request.

EMPLOYERS ● Police Photographers are usually police department personnel paid at the rate and schedule of their rank and seniority. In some communities, photographers may be civilians: civil service employees, local professionals and free-lance photographers.

TRAINING ● On-the-job training for crime scene work. General photo unit duty training is at the one-year photo school or three-year military service proficiency level.

SALARY • Police officers start at about $18,000 per year, sometimes less, and promotions can rise to the $25,000 level.

RECOMMENDED READING • Goddard, Kenneth W. *Crime Scene Investigation.* Reston, Virginia: Reston Publishing Company, 1977; *Law Enforcement Technology (magazine)*, 445 Broad Hollow Road, Melville, NY 11747; *Photography for Law Enforcement.* Rochester, NY: Eastman Kodak Company. Publication M-200. 1990; Resicker, David R. *The Practical Methodology of Forensic Photography.* New York: Elsevier Science Publishing Co. 1991.

TRADE ASSOCIATION • Evidence Photographers International Council, 600 Main Street, Honesdale, PA 18431; Assn. of Professional Investigative Photographers, P.O. Box 479, Charles Town, WV 25414.

Press Photographer

There was a time when the next Press Photographer was the youthful messenger or darkroom employee who was shoved into a cab by a harried news editor at a time when all of the staff photographers were already out on assignment. "Get that picture, kid!" he bellowed through his cigar smoke.

With a successful image for the front page, a new Press Photographer was born. Needless to say, that was the scene fifty or more years ago; today the young cameraman has his start with his family's 35mm camera on the high school newspaper staff. He sharpens his skills as he earns some money with his camera on weekends and during summer vacations. He learns the more difficult moments of photo life as a working photographer on a college or military newspaper. His first steps following graduation or discharge come as a professional with a part-time assignment on a county weekly or a smalltown daily.

Today's lucky new Press Photographer has options that the pre-TV press photographer never enjoyed; he can be a press photographer for a television station, toting a video camera on his shoulder; or he can be involved in the miracle of electronic journalism starting with an image made in a camera about the size and shape of the family 35mm camera. It has one important difference; there is no light-sensitive film; the image was captured on magnetic oxide in a VSC (video still camera) from Canon, Casio, SONY and others.

But what does he photograph regardless of the camera? Fires, accidents, murders, courtroom drama, holiday scenics (pumpkins at Halloween and lighted trees at Yuletide!) His concern is still the organization of the material forming on the groundglass or in the viewfinder. A Press Photographer is a speed demon with accuracy not only in getting the image but also in getting the names of those in the scene!

See also Documentary Photographer, Photojournalist, Travel Photographer.

TYPICAL ASSIGNMENT • The nearby major park of the city has its coming 100th Anniversary, and the Photo Editor has asked for the earliest file photographs of the park activities to compare them with the current scene. The Press Photographer will visit with children in a playground area with swings, etc.; adults in a sports setting; walkers striding through tree-lined lanes; and Park Attendants maintaining the property.

CLIENTS AND EMPLOYERS • The Press Photographer is a staff employee of a daily or weekly newspaper or magazine, operating within codes and salary schedules established by the employer. See Appendix: Newspaper Salary Schedules for minimum major city pay scales.

TRAINING • Prior experience on school newspapers or freelance activities which have been published. Two or more years of college photography courses or three years of military photography will provide a technically sound background for indoor and outdoor photo assignments.

SALARY • Local union scales or the American Newspaper Guild scale; see Appendix.

RECOMMENDED READING • Bleich, Arthur H. and McCullough, Jerry. *The Photojournalist's Guide.* Milwaukee, WI: Tech/Data Publications; Kerns, Robert L. *Photojournalism: Photography with a Purpose.* Englewood Cliffs, NJ: Prentice-Hall. 1980; Rothstein, Arthur. *Photojournalism.* NY, NY: Amphoto, 1979.

TRADE ASSOCIATION • National Press Photographers Assn., Inc., Box 1146, Durham, NC 27702.

Race Track Photographer

When the cry is "Photofinish!" and the crowd is screaming, and the tote board is flashing impatiently for the judge's call, there's one far overhead working feverishly in a race of his own: load the 35mm film into the heated developing tank for a ninety-second processing, five seconds of wash, and finally a thirty-second fix.

When developed, the still wet film is slipped into a waiting enlarger and projected through a hole in the floor. The image is flashed down to a giant white-topped table for the judges to see. There is then no possibility for an error in human judgment. The finish-line image is not only perfect, but a second (repeat) image of the horses has been captured in a mirror on the finish-line pole to reveal a far-track-side view of the moment. The judges rule. Moments later the photograph is printed and mounted on the bulletin board for post-race analysis or anguish. With thousands and thousands of dollars in prize money and betting earnings, there can't be a mistake.

The Race Track Photographer caught it all? Yes, and no.

High above the grandstand, exactly over the finish line as accurately as a surveyor's transit can confirm, is a line to the finish post across the track, where two motorized 35mm cameras have lenses and backs aligned for eight races a day. A 1/100th-of-an-inch slit in the camera back reveals all that this camera can "see." The slit is the finish line. Imagine it as a gap in a curtain on a window overlooking the parade; anyone peeking through it can see but one marcher at a time. As the horses gallop around the track, the 35mm cameras also move a long length of film past the slit. The first horse to pass the slit will be the first horse on the film.

Should one camera fail, the second "safety" camera positioned above it records the race.

The Race Track Photographer is responsible for film, exposure, development, and filing of the film with the correct annotation of the event. His tour of duty is the

three-hour race day. He follows the horses to seasons at Hialeah, Santa Ana, Monmouth Park, and other race centers as an entire industry moves from coast to coast.

Beyond the U.S. borders, the companies that hold the contracts for the photo-finish photography such as Crowley-Jones Company, provide systems and personnel to tracks in Mexico City, Rio de Janeiro, and San Juan. Track managers do not hire the photographers. The applicant with basic darkroom skills, good dexterity, and steel nerves can learn from local officials who holds the contract for the photo-finish operation.

See also Horse Photographer, Pet Photographer.

JOB DESCRIPTION ● Maintains, services, and operates custom-built 35mm motorized cameras. Processes short film lengths in a heated system.

TYPICAL ASSIGNMENT ● The photographer will load film, test motors of two cameras, and start cameras some seconds before the running horses approach the finish line. Processes and dries film before filing one film length representing the positions of each horse as it crossed the line. In the event of a call for a photo finish, the film is rush-processed and is projected while wet to the judges' box below the darkroom. The photographer makes a photoprint (positive) for the public to see the result before the end of the race-track day.

CLIENTS AND EMPLOYERS ● The photographer is an employee of the firm contracting to provide photo-finish services which include camera installation, alignment, provision of personnel, and services for all races. All of these systems are in process of revision to electronic photography.

TRAINING ● Anyone with a basic knowledge of darkroom procedures including college, photo school, or military training, can be trained for the special equipment created for the photofinish requirements.

SALARY ● The starting salary for Race Track Photographers is approximately $15,000 per year.

RECOMMENDED READING ● Cribb, Larry. *How You Can Make $25,000 a Year with Your Camera (No Matter Where You Live)*. Writer's Digest Books.

Real Estate Photographer

It's hard to believe, but every second year one American business executive in five moves his wife, children, furniture, TV, ping-pong table, and family cat to another bedroom community. Two houses are going to be sold for each move: the one they left behind and the one they must select. Because time is of the essence, as empty houses cost money, photographs of the properties are distributed to numerous realty firms in the hope that a well-manicured lawn, an imposing front door, or an inviting backyard pool will capture the eye of an interested couple who will say to the realtor, "We'd like to see this one."

At one time, realty firms were big users of Polaroid instant pictures for scrapbook photos of the properties in their inventory. But with competition getting keener and realtors anxious to sell homes in their listings quickly, it has become apparent that clear photographs and even video footage are better than a thousand words. The man with the camera has become as necessary a selling expense as the title search that assures the buyer that the land and house are being sold free and clear.

If the property is a commercial building or an estate or a farm with buildings, an orchard, a silo, and other assets, a number of key photographs may be required, perhaps even an aerial view. With a commission of ten or twenty thousand dollars in the offing, the agent is more than willing to spend hundreds of dollars for advertising to attract potential buyers plus $50 or $100 for the photographs that will bring distant prospects to the area.

Photographs are the basis for the office properties album or slide projector tray, for newspaper or magazine advertising, and for show window or wall display.

Photographs are almost invariably taken on bright days when the major face of the structure is attractively illuminated. Trees that offer shade and a pleasant setting will be included in a view that shows how accessible the garage is to the house.

While Architectural Photographers will frame photographs only on a ground glass of a camera with a tilting lens and back to prevent perspective distortion, Real Estate Photographers with 35mm cameras and a video camera for sweeping panoramic and slow zoom-in effects are less photographically fastidious. The new cameraman will soon learn tricks such as seeing that the camera is aimed forward, not upward, to hold linear distortion to an acceptable minimum level, and to use filters to dramatize skies in both color and black-and-white views. In short, a modest understanding of photography equips you to launch a career of Saturday afternoon tours of nearby communities on behalf of local realtor clients.

Beginner Real Estate Photographers can practice on buildings in their hometowns and prove with variety and some dramatic effects that the realtor will get the quality images at a modest price. To make a living in the field, the aspiring photographer must hustle to real estate offices, attend local real estate business luncheons or seminars, and advertise in the statewide or citywide trade publications of the realty board.

In this field, college degrees and a portfolio of photography school fashion and still-life photographs won't open doors. A sample job "on the house" and a pleasant manner will take a photographer into a new career of real estate photography.

See also Architectural Photographer, Construction Photographer, Interior Design Photographer.

JOB DESCRIPTION ● Selects the appropriate camera, film, filter and vantage point to make a single photograph that best presents salient features of a private home or commercial property. Offers video service in edited VHS cassettes for major properties. On occasion, the assignment may require photography experience from a low flying aircraft.

TYPICAL ASSIGNMENT ● The client will require photographs taken on a suitable day and at a time when the building will be illuminated by a morning or afternoon sun. A single photograph is needed on 35mm color film for the realtor's planned slide

projection. A black-and-white study is also to be made for local advertising. The realtor may or may not advise that overhead wires will mar the skyline, that an adjacent building must not be included in the picture nor cars parked in front of the premises. The structure may be within a thirty-mile radius of the realty office, and it may be occupied or vacant at the time that the photograph is to be taken.

CLIENTS AND EMPLOYERS ● The client is almost invariably a local realty firm since a private seller rarely uses more than his own photographs of his property to entice a sale. The photographer may occasionally be employed by an assessor of property or by a distant prospective purchaser of commercial property who locates the photographer through the *Yellow Pages* telephone directory or through the recommendation of the local realtor.

TRAINING ● One or two years of college photography, six months to one year of photography school, and/or basic military photography.

SALARY ● Freelance photographers will be paid $10.00 and up per photograph or slide, and when travel is necessary, some mileage to cover car costs and unusual amounts of travel time.

RECOMMENDED READING ● *How to Cash in on the Glamorous Photographic Real Estate Market.* Newport House, 24911 Spadra Lane, Mission Viejo, CA 92611; *Photographing Building and Cityscapes.* Rochester, NY: Eastman Kodak Company. Publication LC-10. 1990; *Photography with Large-Format Cameras.* Rochester, NY: Eastman Kodak Company. Publication O-18. 1988.

Resort Photographer

Vacationers welcome inexpensive souvenir photographs, especially if these are offered in a novel manner, totally unlike the prints or slides they are likely to produce with their own cameras. Dinnertime, as on a cruise, when guests are fancy-dressed and seated at a table with friends and family, is a major daily opportunity to make posed photographs of small groups.

The diners are pleasantly surprised if the photographs can be seen the very next day on a bulletin board, along with a price list and order forms. Extra profits lie in offerings of slides in tiny plastic viewers; prints sealed in coffee mugs; mounted on pocket mirrors; and framed in trim fold-up plastic for later mail delivery to the homes of the vacationers.

The independent Resort Photographer can gain experience working for companies currently providing such photography to resorts. One upstate New York resort town, Liberty, has numerous hotels. A nearby photographic company employs thirty photographers every summer, equipping each with a 35mm camera and electronic flash. Every evening, all film is brought to a central laboratory where film developing and proof printing is completed within eight hours.

There are secondary sales opportunities in establishing a small temporary studio during weekend days from late afternoon through post-dinner hours in a hotel lobby. Here the photographer takes seated and standing portraits posed with more care than the impromptu photograph at the dinner table. The hotel's special activities such as golf or bridge permit more shots. Profits from a single exposure can be high if even only two of each foursome photographed order a print.

The novice photographer usually starts with a 35mm camera, often one of the half-frame designs of the 1960s, for maximum economy.

See also Cruise Photographer, Exhibit Photographer, Specialty Studio Photographer.

JOB DESCRIPTION • Visits a large resort by lunchtime to photograph groups at indoor tables or outdoors under umbrella-shaded lawn tables. Photographs individuals and couples at golf, the swim pool, at afternoon dance lessons and at bridge tables, etc. Provides pre-dinner dress-up portrait service at a temporary studio facility established in the hotel lobby or major hallway. Photographs diners at their tables. Returns to his processing center for overnite processing. Brings the results for bulletin board display on the following day to receive orders.

TYPICAL ASSIGNMENT • A hotel has been booked by a company for a weekend convention of distributors and retailers within driving distance. The photographer is requested to provide total photographic coverage for a post-Convention brochure to be mailed to all participants. Photographs of formal speeches, dining room moments, leisure time activities and posed portraits desired by the company's Public Relations Manager will be part of the coverage.

CLIENTS AND EMPLOYERS • The employer in major resort areas is generally a firm which has contracts with all area hotels. In small vacation areas, the employer is either the hotel which will share profits with the photographer from print sales or the company or private association booking the facility for a weekend stay.

TRAINING • A basic education in photographic practice, especially in color; or prior employment as a studio assistant or on a novice photojournalist or press photographer; or three years of military photography service.

SALARY • The Resort Photographer is primarily an independent entrepreneur whose earnings depend on the number of days of actual work at resorts in his or her area to determine the earnings potential. In larger areas, established photography firms hold contracts with hotels and resorts.

RECOMMENDED READING • Cribb, Larry. *How to Make $25,000 a Year with Your Camera (no Matter Where You Live)*. Writer's Digest Books; *Professional Photography (magazine)*, 1090 Executive Way, Des Plaines IL, 60018.

Retail Salesman, Photographic

Almost all Photographic Retailers are members of the national organization, the Photo Marketing Association in Jackson, Michigan and, in large communities such as New York City, of the Guild of Photographic Dealers. At any meeting, at any time, dealers ask each other: "Do you know a good salesman for me?"

The Photographic Salesman, a young man or woman with a working familiarity with a camera, has a wide world of opportunity ahead. For years the downtown camera stores and the shopping plaza discount houses with a camera counter have greeted applications for positions behind the counter with enthusiasm.

The camera store clerk has privileges denied to every other photographer in town. He gets to handle every new camera; in fact, he makes points with his boss by taking the new cameras, the new lenses and the new films home for trial runs. How else can he have the working familiarity with products that leads to sales?

The camera store clerk has an opportunity to learn the retailing business, one day to become a buyer of goods, then partner, successor, or possibly, a competitor of his first employer. The store clerk with a proven sales record will logically become the manager of the store's next branch.

For years the Eastman Kodak Company has maintained a training school for retail salesmen. Theirs is a one-week course at no cost to the store but the travel and hotel bills for the trip to Rochester, NY. Training in the complexities of cameras, lenses and electronic gadgetry often happens at the store when manufacturers' representatives visit for one- to two-hour sessions.

Positions in retail stores are easily changed. An experienced clerk can pick any city. The friends he makes among the traveling salesmen for the major camera lines often will do the job hunting for him. The position of store clerk led Ben Berkey to ultimately launch what became his $200-million Berkey Photo Company. Divisions of

that company were headed by other young clerks of his time, in photofinishing, distribution, mail-order, import-business and even manufacturing.

For Ray Broth, who started with Willoughby's in New York, his experience as Sales Manager led to ownership of the largest camera shop in Sarasota, Florida, a store already diversifying into reproduction arts and professional supplies.

See also Photo Products Buyer.

JOB DESCRIPTION • Combines working familiarity with photographic products to confidently assist customers in a photographic department of a retail store or chain photo department to select appropriate equipment within a budget.

TYPICAL ASSIGNMENT • A store with successful sales of electronic audio products seeks to expand by adding a Photography Department offering a variety of cameras and video products to meet the needs of the store's established clientele. The new clerk must have a working familiarity with the basic products to be acquired for resale, with photo technologies to assist customers with use of their equipment, and with information learned from sales representatives visiting the store in order to guide the growth of the department.

TRAINING • Two years of college photography or three years of military photography experience will provide the hands-on knowledge of current equipment. One or more years of retail selling experience, perhaps initially at part-time Christmas season or summer positions will provide the start-up retail experience for the job applicant.

SALARY • The new employee will be paid according to sales salaries of the employer but with the incentive of bonuses or commissions for sales of costlier items.

RECOMMENDED READING • *Photo Weekly (magazine)*, 1515 Broadway, New York, NY 10036. *Photograph and Video Trade News (magazine)*, 445 Broad Hollow Road, Melville, NY 11747.

Retoucher/Oil Colorist

Many of the first American photographers were painters: Samuel F.B. Morse, Mathew B. Brady and Albert S. Southworth. With photography they could achieve an exact likeness in miniature portraits (cameos) without lengthy sittings and at a lower price per client.

Even today, photographers are drawn to the world of the camera, lenses, lighting and processing because of an artistic bent toward expressing light and texture. Some enjoy the coloring of their work, changing black-and-white images to the suggested reality of color portraiture by the use of oil colors specially created for easy application, easy alteration and, durability.

The Oil Colorist has a lifelong career because studios continuously require the special blending of oil colors to reduce or enhance a background, illuminate or subdue golden curls, deemphasize clothing or treat collar colors.

To see examples of oil coloring, check framed family "color" portraits obviously made in the period before color photography of the home portrait was a technical reality. Stop by any local portrait studio and ask to see samples of oil-colored portraits; you'll be amazed at how many have been created by the studio's master photographer.

The colorist has remained an active part of a photographic development, from the time when transparent colors and flecks of gold were added to the very first images of the 1840s. Coloring has been skillfully applied from the Daguerreian Era through the ambrotype, the tintype, and then the albumen prints, which prefigured today's photographic age. At one time, all photographers practiced these skills as part of their trade craft. As studio volumes increased, it became necessary to employ Retouchers and Oil Colorists to keep up with the demand for photographs free of imperfections.

Today's studios employ finishing-room employees with the ability to "spot" remove occasional dust specks that otherwise mar perfect prints. In studios where large negatives are made for formal portraits, the Retoucher will work from a proof print

following the photographer's careful instructions on print improvement. Electrically driven pencils apply the right amount of pencil lead to modify the negative in those areas where the photographer seeks changes. Careful retouching of a portrait will often mean the difference between a modest sale and a substantial order in prints.

The art of retouching can be learned at home or at special schools under the guidance of specialists. Until a photographer has personally mastered the rudiments of the art of the use of pencil, brush, airbrush and razor blade, it is next to impossible for him to understand what the Retoucher can achieve on a negative, a print, or a copy negative. With a deft stroke of the pencil on the negative, an untidy hair can be removed without leaving a trace. The same pencil can soften, subdue or totally remove wrinkles around the eyes, pockmarks on the cheek, and other blemishes on the skin.

With modern tools such as the artist's airbrush providing a fine mist of gray-tone materials, shadows can be lightened or darkened. Clouds can be added to a sky or emphasized when only barely visible. Objectionable overhead telephone lines, bright white reflections on eyeglasses, and other distinctions can be removed. Suitable soft touches of color can be added to enrich a child's portrait. With proper chemicals, color transparencies can be altered so that some colors are subdued and others are made more significant. Dark transparencies can be lightened, and two or more transparencies can be combined into a single image.

To find out if retouching or oil coloring as a career would suit your own personality and lifestyle requirements, visit your local photographic studio and ask to meet the staff retoucher. Also, for information about learning retouching and oil coloring as a career, write to Veronica Cass National School of Retouching, Box 1018, Hudson, FL 33568 for details on their one-week training program. A course of study by mail is offered by Hamilton Studios, Inc., Claymont, DE 19703.

JOB DESCRIPTION • Provides expert understanding of retouching with pencil and airbrush; print toning; application of oils and preservatives for simulated color photography effects.

TYPICAL ASSIGNMENT • A copy photograph of a deceased person has been made from an existing small portrait. The addition of some color has been recommended as a means to enhance the attractiveness of the otherwise bland photographic tones. The Retoucher will remove blemishes from the negative; the Oil Colorist will add a background color, suggest clothing colors, and add flesh tones and other subtle color effects to enhance the appeal of the photograph.

CLIENTS AND EMPLOYERS • Retouchers and Oil Colorists are employed by portrait studios. Independent specialists in large cities serve numerous studios.

TRAINING • Retouchers and Oil Colorists may learn by apprenticeship, home study courses, or through special courses at many photography schools.

SALARY • From $15,000-$20,000 per year, depending on the volume of work and other such factors.

RECOMMENDED READING • *Photographic Retouching*. Rochester, NY: Eastman Kodak Company. Publication E-97. 1987; *Retouching from Start to Finish*. VC Photo Art Supplies, 3779 New Jersey Ave., Hudson, FL 33568.

TRADE ASSOCIATION • American Photographic Artisans Guild, 212 Monroe, Ft. Clinton, OH 43452.

School Photographer

Think for a moment of your own education. Kindergarten, grade school, junior high school, high school and, then, probably college. That took you from age five up to your twenties. You may have been part of classes photographed in every grade through high school for a possible total of thirteen sittings.

Each year you sat for the camera of the School Photographer. Perhaps he had set up a temporary studio in the school gymnasium, on the auditorium stage or in a large hallway. You were given a numbered order form to facilitate later delivery of proofs to you and your parents. Your family had the opportunity to order enlargements, usually at prices lower than those charged for a one-person sitting at a local studio.

According to Don Small, a past President of the Southern Sierra Professional Photographers, and President of Rorex Photography in Bakersfield, California, there are two kinds of School Photographers. One is the employee of a chain photography group that has won contracts with numerous public, parochial, military and private schools. He provides mass-production photography under a contract which assures that chain exclusivity for that school year. In return, the school benefits with a donation of a fixed fee or a percentage of sales or some other mutually agreed-upon arrangement.

The other kind of School Photographer is the employee or owner of the local professional portrait studio. As a local person, he is in a position to supply the school with photographs of ballgames, plays, club activities and other school events. This coverage is a part of the arrangement that furnishes individual senior portraits, made in a well-established downtown studio rather than under temporary conditions in the gymnasium.

The local studio vying for the profitable school business has the edge in creativity because students are waiting comfortably; and Mother may even be on hand to assist. If the final photograph is very flattering, there is great opportunity for sales of prints. A school contract provides a solid base for meeting every family with a

youngster. A family pleased with a school portrait will likely also request subsequent communion, wedding and new baby photographs.

Paul Miller of Longview, Texas, extends his school business without a "Main Street" studio. He parks an air-conditioned 36-foot trailer in front of the thirty-six schools he serves within 250 miles of his home. While some students don't place orders for the yearbook portrait ne makes, his studio, Paul's Photography, averages $80 per senior. Since he produces about three thousand senior portraits a year, his school operation provides a gross income of $250,000 per year.

The chain photographer operates in the school itself, usually with a special camera loaded with 100-foot lengths of 35mm or 70mm film. He carries three electronic flash units and a few colorful backgrounds. Announcements for "photography day" are made in advance, but second appointments are usually necessary to immortalize those few students who arrived at school in the wrong clothing or who were unavailable on Photography Day.

The chain photographer is a photographic vagabond, moving from city to city on a schedule set up by his distant office. In the giant photofinishing laboratory where film is developed and proof prints made by automated equipment, there is a million-dollar installation of stainless steel tubs, belt drives, motors and temperature control devices.

If you like portraiture and enjoy working with youngsters, you can have either the open road or the security of a small portrait studio of your own in the lifelong career of School Photographer. It is the open sesame to a well-rounded photographic career.

See also Baby and Child Photographer, Home and Studio; Bridal and Wedding Photographer; Specialty Studio Photographer, Novelty.

JOB DESCRIPTION • Operates a semi-automatic camera system. Sets up electronic flash lighting suitable for each sitting. Maintains contrast and exposure systems suitable for automated film processing.

TYPICAL ASSIGNMENT • The photographer is scheduled to make 240 portraits of the Saint Joan of Arc Parochial High School in a midwestern city. His appointment has been confirmed one week earlier (to permit student notification) and one day earlier (to confirm stage-use arrangements with the school custodian). He arrives when school opens and within the first hour sets up background and wires, tests electronic flash systems, loads camera, and arranges for receptionist-clerks from among school volunteers. Photography of one class per hour will include individual identification, clothing and hair adjustment, posing and taking two exposures of each student present.

CLIENTS AND EMPLOYERS • The School Photographers are trained by the chain or by the portrait-studio owner. Write Professional School Photographers of America, Inc., c/o Photo Marketing Assn., 3000 Picture Pl., Jackson MI 49201 for a list of firms functioning near you.

TRAINING • Many enter the field without any prior photographic experience. A two-year college study course, a six-month general photography course, or military photography experience will be helpful.

SALARY • A School Photographer will start at $15,000 and will earn considerably more based on extent of travel, sales commissions and other benefits extended by the studio or chain owner, which could include a free automobile and related expenses.

TRADE ASSOCIATION • Professional School Photographers of America, c/o Photo Marketing Assn., 3000 Picture Place, Jackson, MI 49201.

Specialty Studio Photographer: Novelty

From Sausalito's tourist traps to the top of the Empire State Building in New York, from Chicago's Old Towne to Provincetown's (Massachusetts) Commercial Street, thousands of dollars are spent each year on "tintypes" created in "old tyme' specialty portrait galleries. According to the *Chicago Tribune*, at Great America, an amusement park outside Chicago, the GM Hostage Tintype studio attracted two hundred customers per day in season. With today's less complicated chemistry of instant pictures and direct-positive papers, and with a wardrobe of slip-on, one-size fits-all-clothing, vacationers can pose as sheriffs, cowpokes, ministers, and dudes, and their pictures will dry even before the customer can shed the temporary garb.

Derck Orme of Linden, Michigan, relies on a simple process that provides a low-cost 8 x 10 diffusion transfer photograph of his costumed subject by using Agfa-Gevaert paper (Copytone Positive and Copytone CTN Negative). After exposing the paper negative in the camera, the negative and a blank positive are developed simultaneously in a copy proof processor. The chemistry provides automatic brown tones to the positive print which is further enhanced by the brown oval mount he provides to the customer. This two-minute operation using a table-top developing box produces a negative (which is discarded), and the finished (positive) print is quick-dried for immediate delivery in the mount. The photographic skill involved is just beyond that of the beginner-amateur.

The Polaroid instant camera is often the choice of the Novelty Portrait Photographer operating in a hotel lobby at a convention since it provides speed and convenience, but for a permanent setup, standard plate-loaded view cameras and a wet-process system are preferable. Electronic flash or photoflood lights plus a wardrobe of fifteen or twenty breakaway costumes complete the inventory of the $2,500-$3,500 investment necessary to set up shop.

The newest operations feature "glamour shots" of women created in a gallery that is 50% beauty salon and 40% photo studio. Costuming precedes all-electronic camerawork with the customer selecting final images from an array on a TV monitor.

A good starting point for the would-be modern tintypist is an inquiry to "Professor" Bloodgood's Photographic Emporium, 207 W. Verne St., Tampa, FL 33606. His "do-it-yourself" free information package provides details of procedures, wardrobes, camera equipment, add-on sales of frames and other suggestions. It is available by calling 1-800-762-8435.

See also Baby and Child Photographer, School Photographer, Specialty Studio Photographer, Novelty.

JOB DESCRIPTION • Provides expert knowledge of small view camera, instant camera and stabilization processes of a small darkroom.

TYPICAL ASSIGNMENT • A young couple seeks to be depicted as a Civil War general and his lady. The young man is fitted into a military tunic. His companion is attired in a bodice and ballroom skirt and is posed with a hat, parasol and a chain purse. The photographer will adjust three lights (front light, top-back light, and a light directed to the background).

CLIENTS AND EMPLOYERS • Specialty portrait studios are owned and operated by the photographer. Assistants are hired at a modest starting salary.

TRAINING • The cameraman may have completed a two-year college photo course and portrait training in a private photography school, a one-to-two-year apprenticeship in a baby, portrait, wedding or commercial studio, or comparable military photo experience.

SALARY • Self-employed photographers' incomes will be determined by such factors as business volume, overhead and related costs. Employee photographers will start at $10,000-$12,000 per year.

RECOMMENDED READING ● Cavallo, Robert M. and Kahan, Stuart. *The Business of Photography*. New York: Crown Publishers, 1981; *Professional Portrait Techniques*. Rochester, New York: Eastman Kodak Company. Publication O-4. 1987.

TRADE ASSOCIATION ● Antique and Amusement Photographers International, 107 Sacred Herat Lane, Reistertown, MD 21136

Specialty Studio Photographer: Passport

In recent years, approximately 3.7-million Americans made application for and received a valid passport according to the United States Department of State, which regulates entry and departure of citizens from and into the U.S. Every one of these passports contained a portrait of its bearer. A second (matching) photograph joined the other multimillion papers which the government finds necessary to confirm passport validity.

Because the photographs must be of a specific size and shape and also conform to technical standards that would eliminate most photographs taken on Sundays for the family album, a business of passport photography has emerged over the years. Those millions of passports alone generated studio income of over $37-million year after year. Now perhaps you understand why you have passed numerous "Main Street" portrait studios, camera shops, and even "1-hour processing" and photocopy centers where the sign PASSPORT PHOTOS hangs prominently in the front window.

Passport studios can be found in many airport lounge areas. They can be found near the Post Office or Federal Building of most large cities. One studio thrived for years in a minor entryway of Grand Central Station in New York City keeping a team of two busy from morning rush hour till the last commuter had left at day's end.

Probably the most active passport center in the East is the studio in the Rockefeller Center arcade below street level. The State Department Passport Office, a few flights above, insures that this mass-production picture factory will never run out of customers for its one-a-minute operation. At this studio, the technology is a reflection of the past: the cut film in holders (rather than the instant pictures made possible by the special Polaroid camera) developed for passport imagery many years ago.

Since a simple two-lamp photoflood or electronic flash lighting will, without any significant investment of time, make the $5-$10 per set of pictures a high-profit-per-invested-minute operation, numerous camera stores have found it

advantageous to encourage quick-service portraits. In many cities these tiny studios also provide chauffeurs' photographs and other identification photographs.

A small investment in rent and equipment can be the passport to a start-up career in this type of portrait photography.

See also Specialty Photographic Studio, Novelty; and Specialty Photographic Studio, Videographic.

JOB DESCRIPTION ● Operates Polaroid system or wet-process studio equipment to create head and shoulder portraits, usually in confined quarters.

TYPICAL ASSIGNMENT ● A couple seeks passport photographs while they wait for the finished result. While one is seated behind the camera, the other person is seated on a chair set two feet before a neutral light-colored clear background. The special passport photographer's Polaroid camera on a tripod has been pre-focussed for the distance to the seat. The camera is raised or lowered to the level of the subject's eyes. The trip of the shutter flashes pre-set electronic lamps which are at set distances. The camera provides the legally required two images so that a single shot may provide a satisfactory pair of images. Results may be checked at once as the Polaroid system requires no darkroom system. If the result is satisfactory, the next person is seated and the process is repeated.

CLIENTS AND EMPLOYERS ● Passport studios are generally two-person operations, and a new employee may be a trainee of the studio operator.

TRAINING ● The simplest instant photo systems are learned in a one-day training period. The more advanced systems requiring darkroom experience may take a week or longer to totally absorb.

SALARY ● The self-employed Specialty Photography Studio operator will earn $15,000 a year and much more depending on the location and the daily volume. The employee of such a studio will start at apprentice wages for the first months.

RECOMMENDED READING ● *Professional Portrait Techniques*. Rochester, NY: Eastman Kodak Company. Publication O-4. 1987.

Specialty Studio Photographer: Videographic

In airport lobbies, at resort hotels, on boardwalks and wherever crowds will gather for vacation or beach-front fun, there are Specialty Photographers: Videographic who offer an amazing array of portrait novelty products. All these are lifesize, happy faces on T-shirts, on calendars and on a wide variety of take-home items, all priced under $10.00 each.

These instant photo T-shirts are created by the combination of a video camera (mounted on a tripod) linked to a computer system which converts the full-color images into digitalized data. This can be transferred in moments in a printer onto paper or fabrics at any desired size.

As with park or boardwalk artists who create instant pastel portraits and color marker cartoons, the Specialty Studio Photographer: Videographic has a waiting audience curious to applaud the unique end-result. It is one of the most remarkable tangible evidences of the twentieth century's electronic marriage of photography to the novelty world. And it is profitable. In the Denver airport lobby, the T-shirt portrait income was supplemented by Polaroid Passport Photos and portraits for identification passes, similar to the portraits now made at Auto Licensing Bureaus in many states.

Following a successful summertime operation, after paying rent, the small studio owner may well be able to live without working at any other job until the next season. Most likely, at season's end, the entire system may be carried in a car trunk to another sunny resort or indoor mall center for the next months of the year. Half of all revenue may be the profit; the other half pays for the T-shirt supplies, amortization of the equipment (which is well under $5,000) and the rent.

See also Baby and Child Photographer, Chain Store; and Specialty Photographer, Novelty.

JOB DESCRIPTION ● A couple making application for a passport seeks immediate assistance. The woman is asked to remove a hat, to seat herself up straight, to look

directly into the camera with hair removed from the face. The exposure is made and it is satisfactory. The man seats himself. He is taller; the camera must be raised to eye level. He attempts a broad smile; he is cautioned to keep a straight face. The second exposure is made. The process has taken under 5-minutes.

CLIENT OR EMPLOYER ● The typical operation is owned by the studio operator. A trainee assistant is often employed to permit lunch hours, days off and other assistance.

TRAINING ● The typical trainee has had little or no prior photography experience. On the job training is completed in one or two days.

SALARY ● Starting salary is on average at the opening salary of a local shop clerk but improves rapidly depending on studio volume.

RECOMMENDED READING ● Polaroid product literature for special-purpose equipment.

Sports Photographer

Sports Photographers are specialists who have integrated their know-how with a particular playing field. They must be specially equipped with long, telephoto lenses, high-speed winders that advance film automatically after each frame, and a knowledge of sports action that makes it possible to instinctively react at the exposure instant to capture the key action. A motorcyclist knows where to find the best vantage points for gripping action. A tennis player or skier has the feeling for the moment that translates into telling precision work with the telephoto lens. While the newspaper photographer may have on occasion found himself assigned to the Sunday ball game, the Sports Photographer of today does not generally share the day-to-day routines of the typical Press Photographer.

Since weekends are a poor time for political news and business reports, the wire services, weekly publications and television news- rooms depend on year-round weekends of sports. This means the life of a Sports Photographer is an endless round of Tuesdays and Wednesdays off with plenty of weekend work. His Saturday and Sunday nights are mainly spent in laboratories waiting to edit color slides or enlarging sections of 35mm negatives for waiting messengers.

The Sports Photographer knows all about squeezing life out of film exposed in a late afternoon gloom or in the shadow side of the playing field. He is most familiar with the light-gathering capability of the long telephoto lenses. He is a genius at modifying tripods and inventing camera rests that add to his aiming stability. He carries more loaded cameras on his body than a combat photographer. He changes lenses, film and cameras faster than anyone else.

Contrary to some opinion, women have scored high as Sports Photographers. *Road and Track*, one of racing's speed journals, depends on the artistic talents of Ellen Griesedieck for creative photography. She is expert with extreme wide angle lenses, slow shutter speeds and shallow-focus telephoto lenses that spice pages with other than

documentary presentations of key auto-world events. Ellen is one of six masthead-credited photojournalists serving that magazine.

Sports Photographers get started in the field with portfolios assembled from published photographs of high school and college games. At school games it is easier for the novice to win the necessary access to the playing field; few great sports photographs are made from the bleachers. With a parade of published action shots from the school paper, yearbook and the local city press, it is easier to approach a major newspaper, wire service or magazine with a job application.

Photographs are acceptable in the form of 35mm slides in a job approach and as material for a publishable story. Speculative photography at auto, motorcycle, bicycle and track events brought to publication Photo Editors on a periodic basis can eventually open the door to a trial assignment or a trial employment period for you.

The large number of outdoor and sports publications on the newsstand indicates how vast an opportunity awaits determined, capable career photographers.

See also Magazine Photographer, Photojournalists and Press Photographers.

TYPICAL ASSIGNMENT ● A Sports Photographer assigned to a basketball game will be expected to provide personality moments such as conferences with the team coach before the event. He will make photographs to indicate the size of the crowd and will attempt to find celebrities whose names help make the event more significant to the home audience. During the actual game he will capture general views of the action along with the special moments when scoring changes or player conflicts provide breathtaking peaks of excitement. He ends his day's work with locker-room scenes, award ceremonies and posed photographs with team owners, players' wives and teammates.

CLIENTS AND EMPLOYERS ● The Sports Photographer is responsible to the editor or picture page manager of a publication or sponsor.

TRAINING ● Sports Photographers usually have two to four years of college or one to two years of photo school training.

SALARY ● The Sports Photographer may earn from $15,000-$30,000 depending on publication employment scales, union contracts and other conditions. See Appendix.

RECOMMENDED READING ● *Pocket Guide to Sports Photography*. Rochester, NY: Eastman Kodak Company. Publication AR-23. 1984.

TRADE ASSOCIATION ● American Society of Magazine Photographers, 419 Park Ave. So., New York, NY 10016.

Stock Photo Photographer

"It's certainly the most profitable aspect of photography sold for use in publications," says Jim Pickerell, editor of the field's authoritative newsletter, *Taking Stock*.

According to Al Francekevich, a prominent Big Apple commercial photographer who has long specialized in imaginative photography for the drug and pharmaceutical industry, Stock Photo Photography now provides about half of his income. "We learned to put the studio's down-time to use making speculative images for stock photo houses."

"One of these," said Al, "has already earned $25,000 from repeat sales." Advertisers and promotion companies cannot resist his photo of a fist clutching lightning bolts. It was a three-image composition on 8x10 film in the color darkroom successfully fulfilling a concept. It will continue to sell for years.

A few of the largest stock photography businesses, promoters of great photos like Al's, started their multimillion dollar operations selling stock photographs of basic illustration ideas. Consider how many bank booklets will be designed around photographs of hands holding money, making change, flipping coins; how many oil companies require promotional photographs of smiling attendants pumping gasoline into auto gas tanks; how many advertisements need brilliant sunsets, ducks on the pond or vacationers packing luggage into shiny new cars.

Nearly every major city has stock photography centers. They provide the tens of thousands of photographs purchased each year by printers, publishers, trade journals, display makers, calendar houses, greeting card manufacturers and advertising agencies. Because hair and clothing fashions change, because autos and gas pumps are datable by their design, and because even stock photographs of standard subjects such as the flag over the Capitol, the Statue of Liberty at twilight and the city skyline become too well known, there's an endless need for new photographs made by fresh talents who show fresh ideas.

With the increased cost of travel, air fares and related expenses, editors turn to the stock photo house. Stock photographers make sales through the services of the stock photo house which represents them on an exclusive basis, with the photographer generally getting better than 50 percent of each sale. This could range from a $50 minimum up to $2,000 for a single color slide to be used in a major publication.

Stock photographers specialize. Some travel extensively and provide thousands of color slides from exotic corners of the earth. Some follow one sport and have captured all the nuances of the action. Industrial photographers cover mining, railroading or life around a modern airport. When someone elects to create a book on ice hockey or ice sailing, hang gliding or free-fall parachuting, photographs are requested by the author or publisher and then sent out by the stock house.

There are stock photograph potentials in the commonplace: a policeman writing a ticket for a car parked at a hydrant; the fire engine leaving the firehouse with half-dressed fire fighters; school kids at a crossing at day's end; the ferry-boat leaving its passengers at the slip; library windows at night; snowy steps.

A career as a stock photo cameraman starts with acceptance of five hundred to one thousand of his photographs by a stock house. This company undertakes the expense of filing each slide, submitting work to prospective buyers and negotiating use fees. Earnings don't start right away. No one pays in advance for the slides that become the stock of the photographer's representative.

JOB DESCRIPTION ● Photographs a broad spectrum of subject matter or specializes in single themes for the photo library or a sales agency.

TYPICAL ASSIGNMENT ● The stock photography agency which has filed over one million slides and photographs cross-indexed by subject matter has received a rush call. A color photograph of a painter on a ladder painting a private home exterior fresh white is required by a paint company. The agency fulfills the request for the slide from one

of a series created two years earlier when the Stock Photographer visited his brother during a summer vacation.

CLIENTS OR EMPLOYERS ● Stock photographs are retained by the stock agency which maintains a contractual relationship with the photographer. This provides for payments only when actual sales of the photographer's work have been made.

TRAINING ● A minimum of two years of college photography, or one year of photography school, or service as a military photographer.

SALARY ● Commissions are usually 50 percent or 60 percent of the amount received by the stock agency. In the active Washington DC market where photographers have a golden future, stock photos earned a typical magazine photographer $30,000 of his earnings a few years ago - and it has gone up since then, according to Jim Pickerell.

RECOMMENDED READING ● Herwig, Ellis. *Stock Photography: How to Shoot it, How to Sell It.* NY, NY: Amphoto, 1981; *The Guilfoyle Report (for nature photographers.)* AG Editions, Box D, 142 Bank St., NY, NY 10014; Persky, Robert S. Editor *Stock Photo Deskbook (4th Edition)*, New York, NY: The Photographic Arts Center, 1992.

TRADE ASSOCIATION ● American Society of Magazine Photographers, 419 Park Ave. So., New York, NY 10016.

Surveillance Photographer

There are three kinds of Surveillance Photographers. Few are ever seen by the public; they hide in cars behind newspapers; in vans behind two-way glass; in specially constructed rooms along the lines of the television program, "Candid Camera."

The first kind is a government employee serving at one or another agency: for the FBI in the war on crime; for the DEA (Drug Enforcement Agency) for the war on narcotics; for local police departments for wars on street crime, auto thefts, etc.; for the Treasury Department which operates like a police force against violators of Alcohol and Firearms Laws.

The second kind is an independent photographer. He is employed by private investigation firms (private eyes, exactly as on TV) with cases that center around marital problems, industrial theft, industrial counter-espionage, hidden camera services for department stores, and other private employers seeking visual evidence. He may be employed by a law firm to assist in gathering evidence. He may be employed by a large firm checking on parking lot thefts or inventory shrinkage (internal theft), etc.

The third kind is a special kind of photojournalist; he is a member of the *paparazzi*. (That's Italian for a freelance photographer who seeks photographs for the entertainment press and the newspaper-magazine industry.) This photographer is one of a pack making candid photographs of celebrities which can be offered to the news weeklies and tabloids. The photographs verge on sensationalism in that they capture moments prominent individuals mostly seek to conceal. (Jacqueline Kennedy Onassis had no idea that an underwater photographer would surface unseen off-shore carrying a telephoto camera to capture her sunbathing nude at a private Mediterranean beach!)

The opportunity for surveillance exists for the still and video photographer.

See also Documentary Photographer, Magazine Photographer, Photojournalist and Press Photographer.

JOB DESCRIPTION • Skillfully operates unseen or hidden still and video equipment with super-fast films and long telephoto lenses for photography at all hours of the day or night.

TYPICAL ASSIGNMENT • A number of automobiles parked in a company parking lot on private grounds of a major industrial center have been robbed over a period of weeks. The company's Security Service has employed a Surveillance Photographer to set up a time-lapse camera for 24-hour surveillance. It is hoped that photographs taken at 5-minute intervals when the lot is not in use will reveal how entry has been made to the areas where cars have been parked.

CLIENTS AND EMPLOYERS • The Surveillance Photographer may seek employment with one or another government agency (FBI, DEA, Treasury, etc.); or he may opt for freelance operations serving lawyers, detectives, security forces, etc.; or he may opt for documentary or news or features photography opportunities where celebrities gather.

TRAINING • Long telephoto or photography under difficult light conditions are lessons learned as part of most two-year photo school or college photography programs.

SALARY • Government photographers are paid under salary schedules common to all U.S,. agencies (see Appendix.) Freelance service earnings depend on factors of sales successes to lawyers, etc or to Photo Editors.

RECOMMENDED READING • *Applied Infrared Photography*. Rochester, NY: Eastman Kodak Company. Publication M-28. 1981; *Assignment Photography (pricing guidelines.)*. ASMP, 419 Park Ave. So., NY, NY 10016; *Existing Light Photography*. Rochester, NY: Eastman Kodak Company. Publication KW-17. 1990; *Photographing the Daily Drama of Life*. Rochester, NY: Eastman Kodak Company. Publication LC-9. 1990; *Photography for Law Enforcement*. Rochester, NY: Eastman Kodak Company. Publication M-200. 1990.

TRADE ASSOCIATION • American Society of Magazine Photographers, 419 Park Ave. So., New York, NY 10016. With 35 local chapters.

Technical Photography Writer

A vital career lies ahead for the photographically educated advertising agency, engineering department, or consumer relations department as consultants of the larger photographic concerns. An endless need exists for Technical Photography Writers who will create the technical data sheets to be developed from information provided by the engineering department; for response letters to consumers seeking equipment information; and finally, for the endless contact with dealers who require price sheets, catalogue pages, detailed product folders and the inevitable training programs that support each introduction of cameras, lenses, electronic flash units and other equipment.

The Technical Photographic Writer, a photographer with the skill to explain and teach photography in the simplest terms for the prospective or actual owner of new equipment, is a vital link in the chain of sales that has made photography the nation's tenth largest industry.

The entry of complicated electronic gear into the studio sales areas has been achieved with such products as the Kodak Photo CD System, or it has entered the darkroom with automated equipment. Along with this complicated technology is the need for technical information to a degree far beyond silver band systems.

See also Photographic Advertising Copywriter, Photography Editor, Photography Educator.

JOB DESCRIPTION ● Based on a prior understanding of photographic equipment and processes, the Technical Photographic Writer grasps new concepts about equipment and procedures sufficient to communicate this new information to readers of manuals, catalogue sheets and other product performance data sheets.

TYPICAL ASSIGNMENT ● The plant has developed a new model of an existing device to further automate production of prints in photofinishing plants. A new product manual, salesman information bulletin, sales department catalogue sheet and a letter

simplifying the system to be sent to the Presidents of all photofinishing plants now using the earlier equipment are required from the Technical Photograhic Writer.

CLIENTS AND EMPLOYERS ● Technical Photograhic Writers are sought primarily by makers of photographic equipment for amateur, professional, industrial or government use. They will be employed by plant advertising, customer relations and engineering sections.

TRAINING ● Two years of Basic Photography at college and skills with writing, usually as a journalism or advertising student; or work as a regular contributor to the photographic press or as a photo editor for a photographic industry publication.

SALARY ● The pay scale will relate to the plant pay scales for new employees but usually with a starting salary of $22,000 - $25,000.

RECOMMENDED READING ● *Successful Technical Writing by Tyler G. Hicks; McGraw-Hill Book Co., NY. (Dewey 808.066)*

Travel Photographer

Bob Krist was 19 years old when he won a dream assignment as an actor with a Europe-bound repertory theater. With a nine-month tour ahead, Bob purchased a Minolta 35mm camera to capture photographs of the cities and countries on the schedule. The rest is history; he is no longer an actor. He is a top Travel Photographer serving publications such as *Travel and Leisure* and today he is doing all the travelling a photographer could ever hope to enjoy.

It happened, according to Bob, because as a younger man he had been intrigued with the special photographs to be found in the pages of *National Geographic*. "Its pages were my teacher and my inspiration" has been his theme ever since. Its pages were rich with the work of legendary travel photographers William Albert Allard, John Launois and Winfield Parks, talents who were his guides into a new world of photography.

Travel and Leisure, Conde Nast Travel, Islands, Adventure Travel and *Outdoor Photographer* are typical of the numerous magazines that feed hungry audiences with the romance and allure of far-off exotic places. From *National Geographic* to the state magazines such as *Arizona Highways* and *Alaska*, and from the outdoor-world magazines such as *Ski, Sail, Backpacker, Outdoor Life*, and similar action-packed publications, to the monthly magazines seat-pocketed on every commercial airplane, there is a continual demand for more pictures.

Photographs taken on these trips that can't find space on the pages often win big money instead from stock house sales into annual reports or corporate calendars. Color slides can always be reproduced as black-and-white illustrations for the travel pages of newspapers or for illustrations in an encyclopedia. The market for travel photography is vast, and the opportunity is as good as the talents of the cameraman.

Travel Photographers sometimes have long-term relationships with specific magazines. *National Geographic* has over twenty photographers in its full-time

organization and five times that number of freelancers available for assignments from the Arctic to the tropics.

Photographers fortunate enough to capture a paid assignment to a distant locale usually immediately contact other potential buyers who might require coverage of events at places en route. A photographer paid to make a new series of photographs in the Greek Isles will seek assignments from others likely to be interested in piggy-backing on that expense account. Crete, Cyprus and Israel are just a hop and a skip away.

Travel Photographers have no studios, no assistants, no helping hands from fashion coordinators or makeup artists. The camera kit is invariably heavy. Very often much of the work is "on spec," an assignment by an editor who has agreed only to look at results with no commitment to buy.

Lou Jacobs, Jr. gets his share of travel work by vagabonding around the U.S.A. in a darkroom-equipped recreational vehicle. Others travel by boat or plane on the expense accounts of sponsors. Husband- wife teams are few. Language barriers make for lonely periods and sometimes the biggest luxury of the week is a hot bath. At times a Travel Photographer might even consider a nine-to-five job, if only the next day didn't hold another adventure.

See also Magazine Photographer, Photojournalist, Wildlife Photographer.

JOB DESCRIPTION ● Provides photographs from locations using 35mm and other hand-held cameras. Highly experienced with related lenses and flash accessories. Notes names, places, dates and related information for captions and news-related identifications of photographs.

TYPICAL ASSIGNMENT ● A new hotel has been opened on a Caribbean island. The hotel has offered a free one-week vacation to a publication in return for possible editorial coverage. The photographer has been sent to the island with a reporter for a comprehensive survey of the vacation potentials: beach, water sports, underwater exploration, mountain climbing, jeep trips to the nearby village, evenings on the patio

with dancing to a native orchestra, scenic views from the rooms, dining area, etc. The photographer will make four hundred to five hundred photographs that will become the joint property of the magazine and the hotel.

CLIENTS AND EMPLOYERS ● Travel Photographers are sometimes employees of airlines, cruise ships and special interest publications. Most are self-employed freelance photographers.

TRAINING ● Two to four years of college photography or two years of photography school will provide the skills for most color photography, as will service as a military photographer or work as a newspaper or documentary photographer.

SALARY ● Staff photographers in the travel field will be paid $15,000-$25,000 plus travel benefits. Freelance photographers require both skill as photographers and good fortune as self-employed businessmen.

RECOMMENDED READING ● *Assignment Photography (pricing guidelines)*. ASMP, 419 Park Ave. So., New York, NY 10016. $14.00 + 2.00 s/h.); Dennis, Lisl. *How to Take Better Travel Pictures*. Tucson, Arizona, HP Books, 1979.; Herwig, Ellis. *How to Shoot It; How To Sell It*. NY, NY: Amphoto, 1981; *Pocket Guide to Travel Photography*. Rochester, NY: Eastman Kodak Company. Publication AR-25. 1985.

TRADE ASSOCIATION ● American Society of Magazine Photographers, 419 Park Ave. So., New York, NY 10016. With 35 local chapters.

Videographer

The video cameras today is just one more kind of camera in the American home with instant replay after daytime picnics or evening social gatherings. It has won a new keen interest in Videography as a lifetime career pursuit among American youth.

Like today's fully automatic 35mm cameras, the camcorders are light to carry, easy to operate and so successful as instruments of photographic adventure that nearly every affluent family harbors a potential professional Videographer.

What will he do? Is it just following the brides on wedding days? What other income-producing activities might lie ahead? One New York commercial photographer was so certain of success with a new video camera that he left a profitable studio career to chase a dream to a Western community where he announced himself available as a videographic artist. Six months later out of money, he turned to waiting on tables. Then he found employment in a furniture-making factory. Today he makes custom furniture. The road to a successful career as a Videographer is strewn with boulders, not rocks.

The wedding videographer is going to be successful long term only if the new video operation is dovetailed with the area's wedding studios who know how to find the potential brides and their families. These studios see lost profits when guests make amateur videotapes of the ongoing celebration.

In New York City, Harold J. Brady searches for income opportunities by offering diverse services.

Acting: He makes videotapes for self-criticism by an actor; videotapes of rehearsals for the director and cast members.

Baptisms: Families celebrating the christening of a newborn infant are a possible market with a memorable videotape that offers images of the ceremony, the grandeur of the church, possibly any after-ceremony party or dinner, just as with wedding videotapes.

Graduations: He treats such events exactly like any other family historic moment.

Insurance: Videotape an entire household, a collector's tray of jewelry, coins or stamps or antique furniture. His camcorder documents ownership that supports an insurance policy claim in case of fire or theft.

Legal: Lawyers need interviews with housebound or distant individuals who cannot come to a law office or a courtroom.

Models: A videotape of a model at a fashion show on-stage in an advertising shoot is useful to that person's career advancement.

Real Estate: A videotour of a home or estate for sale is a way for the Realtor to provide an in-office "visit" to available properties.

Sports: Videography has totally replaced cinematic coverage of sports events. The employer is the coach in every sport situation. The athlete or performer needs special video coverage to improve personal skills.

This list is growing every day.

See also Bridal and Wedding Photographer, Videographic; Specialty Studio Photographer, Videographic.

JOB DESCRIPTION • Combines expert knowledge of video photography, special effects, editing and presentation for successful record of events and documentation requirements.

CLIENTS AND EMPLOYERS • The videographer may be an employee of a photographic studio, a sports complex or team, or may be self-employed as a specialist in one or another area where part-time or full-time opportunities exist.

TRAINING • Except in rare academic areas, the major relevant training for development of commercial skills will be offered almost exclusively by schools traditionally featuring motion picture industry training programs.

SALARY • After a modest apprenticeship at a studio or with a ball team, the staff videographer may hope to earn $20,000 - $25,000 during the first years. Skilled videographers with excellent business acumen can earn much more as independent production services.

RECOMMENDED READING • Campbell, Kevin. *Make Money with Your Camcorder.* Amherst, NY. Amherst Media, 418 Homecrest Dr., Amherst NY 14226 ($17.95 + 2.50 s/h.); *Videomaker (magazine).*, P.O. Box 4591, Chica, CA 95929.

TRADE ASSOCIATION • American Society of Magazine Photographers, 419 Park Ave. So., New York, NY 10016. With 35 local chapters.

Wildlife Photographer

Like Tom Mangelsen of Jackson Hole, Wyoming, or William Plante of Warren, Michigan, you can be a Wildlife Photographer. Hunting with a camera has an excitement far beyond the drama of the kill by the hunter armed with a high-powered rifle. The successful camera hunt documents a moment that will live forever and shares this wonder with millions of others.

The Wildlife Photographer must be blessed with patience and armed with a dedication that makes it possible for him to overcome extreme heat or cold, to climb with goats and to run with antelopes. He becomes expert with the long telephoto lenses. He is as competent in stalking trickery (with the help of his remote-control radio-operated systems) as the deer hunter.

Working on assignments for magazines such as *Audubon, Natural History, National Geographic*, or for the makers of calendars, wall decor or books, the Wildlife Photographer has the earning power of the photojournalist usually combined with the bonus of time denied to other cameramen.

Successful wildlife photography or botanical photography starts with acquiring a knowledge of wildlife behavior and an understanding of the habitats of different species. Tom Mangelsen traces his love for the field to his Nebraska boyhood, hunting and fishing along the Platte River.

Mangelsen left a budding career in business administration to study biology, then zoology. College provided a training ground for both still and movie camera experience, and he provides either type of coverage for such clients as the Smithsonian Institution, Columbia Broadcasting System, American Broadcasting Company and the U.S. Fish and Wildlife Service.

Assignments as a Wildlife Photographer have taken him through most of the western United States and to Canada, Alaska and Mexico. His major subjects have been waterfowl and other wild birds, many pictures taken after hours in blinds established

on marshy shorelines of lakes and rivers. Millions have seen his photographs in the wildlife publications of *National Geographic, Time-Life* and Biological Sciences Curriculum Study.

"Focus on Nature" is a nature photography workshop conducted in such exotic environments as the Galapagos Islands, Alaska, Africa and the Canadian Rockies for those interested in actual on-site experience. For information, write to Focus on Nature, 5570 Inverness Avenue, Santa Rosa, CA 95404.

See also Horse Photographer, Pet Photographer, Botanical Photographer.

JOB DESCRIPTION ● Combines expert knowledge of wildlife behavior with skilled use of 35mm and larger cameras, lenses and lighting. Specializes in extreme telephotography, radio-operated cameras and trip-wire procedures.

TYPICAL ASSIGNMENT ● A publisher of travel books has designed a new series to feature America's national parks. A chapter in each book will describe the wildlife indigenous to each of the parks. Photographers living near the major parks will be requested to provide previously unpublished photographs of such common Western animals as the mule deer, the coyote and the elk, plus the more difficult subjects of mountain sheep, eagles and other hard-to-locate species. The photographer has six months to assemble a selection of color slides of wildlife for the book editors.

CLIENTS AND EMPLOYERS ● Wildlife photographers are employed by a number of government agencies (U.S. Fish and Wildlife Service, National Park Service, Department of the Interior, Department of Agriculture, etc.); by privately funded organizations such as the Smithsonian Institution, the National Geographic Society, and even by city zoos. Most are paid by private or government grants or commissioned by book and magazine publishers and film companies for specific projects and for contract periods at a per-day or per-period rate.

TRAINING ● College education in botany/zoology/natural sciences plus extensive undergraduate activity in nature photography.

SALARY • Government-paid photographers earn $16,000-$28,000 (See Appendix.) Freelance photography will provide earnings dependent on contracts, grants and other compensation arrangements, which vary depending on client need.

RECOMMENDED READING • *Assignment Photography (pricing guidelines)*. ASMP, 419 Park Ave., So., NY, NY 10016; Baker, Alfred A. *Field Photography*. San Francisco, CA: W.H. Freeman and Company, 1976; Freeman, Michael. *The Complete Book of Wildlife and Nature Photography*. New York: Amphoto, 1981.

TRADE ASSOCIATION • Wildlife Information Ctr., 629 Green St., Allentown, PA 18102; American Society of Magazine Photographers, 419 Park Ave. So., NY, NY 10016.

Yearbook Photographer

It's just about the most exciting day in the final weeks of the Senior Class! It's Yearbook Day! Here's the permanent record of participation as a class member, team member, award winner and in many of the great school moments.

The portraits in the alphabetized front pages of the senior class members were made available by the visiting school photography service or the contract photographer from Main Street downtown.

But who did that great front-page picture of the campus? The steps of the Front Gate at night? The silhouette of the Lincoln Statue against the sky? The Awards cabinet in the lobby? The Bulletin Board Wall? Who took the photos of the Cheerleader's warm-ups? Of the swim pool? Of the Coach seated at Basketball Practice?

All of those glamour photos that make the yearbook look so polished, so professional, so inviting were the work of an anonymous Yearbook Photographer. He visited the campus along with the Publisher's team working with the school's Yearbook Group. He brought his camera, his tripod and his experience, having visited twenty or thirty similar campuses during the year, many of which also had steps, the Awards Cabinet, the statue and a Cheerleader Squad which could be called into a practice session on short notice.

While most photographs in the yearbook were the best work of the school newspaper or magazine photographer, or were provided by the Faculty, a private printing and publishing firm won the bid to produce the Yearbook and has a paid staff photographer. He has but one job: to add the glamour photos which enrich the appeal of the yearbook in sales presentations to the Publisher's next year's targeted school customers. Those yearbooks are his best solicitation not only for future work on this campus, but also for work on the campuses down the valley. His color work may be great, but the Yearbook Photographer made the cover and most of the great full-page illustrations. The Yearbook Photographer could be you.

See also Commercial Photographer, Documentary Photographer, Industrial and House Organ Photographer and Press Photographer.

JOB DESCRIPTION ● Operates handheld and larger cameras to capture day and night high visual impact images for illustrative photography.

TYPICAL ASSIGNMENT ● His firm is visiting a Midwestern high school on a midweek schedule. He reviews past yearbooks of that school to make a list of sites for possible cover photos. He learns in advance if there is a new stadium, laboratory, gym or swim pool to feature in his coverage. He arranges to photograph during his two-day visit one or more groups assembled for simulated team activities. He plans for night exposures, high vantage points and other dramatic ways of presenting the familiar in a fresh appearance.

CLIENTS AND EMPLOYERS ● He is employed as a salaried photographer by a large printing/publishing firm specializing in the production of school yearbooks.

TRAINING ● He is an independent personality who has completed at least two years of college photo training and hopefully one or two years of local newspaper or commercial studio experience; or three years of military photography.

SALARY ● He may start at a salary in the $18,000 - $22,000 range but will advance quickly after completing his first months of successful one-day and two-day projects.

RECOMMENDED READING ● Perry, Robin. *Photography for the Professionals.* Waterford, CT: Livingston Press; *Professional Photographer (magazine)*, 1090 Executive Way, Des Plaines, IL 60018; *Professional Photographic Illustration.* Rochester, NY: Eastman Kodak Company. Publication O-16. 1989.

TRADE ASSOCIATION ● Professional Photographers of America, 1090 Executive Way, Des Plaines, IL 60018.

APPENDIX A

Schools of Photography, Colleges and Graduate Schools

Over 1000 colleges and universities offer undergraduate courses in photography; over 125 offer graduate studies. Among these, more than 350 offer Photojournalism, over 100 offer Portrait Photography, and over 150 offer Commercial Photography.

A detailed study of every college and university offering has been assembled in *The Right College* - 1990 listing colleges and universities offering higher degrees.

The following institutions offer major educational opportunities in numerous aspects of photography:

Alabama
University of Monteballo
University of North Alabama

Arizona
Northern Arizona University
California

California
Academy of Art College
Art Center College of Design
California College of Arts & Crafts
California State University, Fresno, Fullerton, Long Beach, Northridge Sacramento
City College of San Francisco, San Francisco
Golden West College, Huntington Beach
University of San Francisco
University of Southern California, Los Angeles

Colorado
University of Colorado, Boulder

Connecticut
Central Connecticut State College, New Britain
Fairfield University, Fairfield
University of Bridgeport
University of Connecticut
University of Hartford
Wesleyan University
District of Columbia
Howard University

Delaware
University of Delaware, Newark

Florida
Barry University
Florida A and M University
Florida Atlantic University, Boca Raton
University of Florida
University of North Florida

Georgia
Atlanta College of Art
Savannah College of Art & Design
University of Georgia, Athens

Illinois
Barat College
Bradley University
Columbia College
Governors State University
Illinois Institute of Technology, Chicago
Illinois State University, Normal
Southern Illinois University, Carbondale
University of Illinois - Urbana

Indiana
Ball State University, Muncie
Indiana State University, Terre Haute
Indiana University, Bloomington
Purdue University

Iowa
Iowa State University, Ames
Morningside College
University of Iowa, Iowa City
University of Northern Iowa, Cedar Falls

Kansas
Kansas State College, Pittsburg
University of Kansas

Kentucky
Kentucky State University
Western Kentucky University

Louisiana
Louisiana Tech University
Northwestern State U. of Louisiana
University of New Orleans, New Orleans

Maryland
Maryland Institute College of Art

University of Maryland
Visual Arts Institute, Baltimore

Massachusetts
Boston University, Boston
Fitchburg State College, Fitchburg
Hampshire College
Massachusette College of Art
Salem State College
School of the Museum of Fine Arts, Boston
Worcester State College, Worcester

Michigan
Center of Creative Studies, College of Art and Design
Central Michigan University, Mount Pleasant
Grand Valley State University
Lansing Community College, Lansing
Northern Michigan University, Marquette
University of Michigan
Western Michigan University, Kalamazoo

Minnesota
Mankato State University, Mankato
Morehead State University
St. Cloud State University, St. Cloud
University of Minnesota, Minneapolis

Missouri
Drury College
University of Missouri, Kansas City
Washington University
Webster College, St. Louis

Nebraska
University of Nebraska, Lincoln

New Jersey
Stockton State College, Pomona

New Mexico
University of New Mexico, Albuquerque

New York
Alfred University
Long Island University
Mercy College
New School for Social Research
New York University
Pratt Institute
Rochester Institute of Technology
St. Johns University
SUNY College at Buffalo, at New Paltz
Syracuse University
The Cooper Union College

North Carolina
Atlanta Christian College
Randolph Technical Institute
University of North Carolina

Ohio
Bowling Green State University, Bowling Green
Columbus College of Art & Design
Kent State University
Ohio State University

University of Dayton
University of Toledo
Youngstown State University

Oklahoma
Central State University
Oklahoma Christian College

Oregon
Pacific Northwest College of Art

Pennsylvania
Beaver College
Edinboro University of Pennsylvania
Moore College of Art & Design
Point Park College
St. Vincent College
Seton Hill College
Temple University, Philadelphia
University of Pittsburgh, Pittsburgh
University of the Arts

Rhode Island
Rhode Island College
Rhode Island School of Design

South Carolina
University of South Carolina, Columbia

Tennessee
Austin Peay State University
Carson-Newman College

Texas
East Texas State University
St. Edwards University
Sam Houston State University
Texas A&I University, Corpus Christi.
Texas Tech University
Texas Woman's University
University of Houston
University of North Texas
University of Texas, Austin

Utah
Brigham Young University, Provo
University of Utah, Salt Lake City

Vermont
Bennington College
University of Vermont, Burlington

Virginia
Virginia Intermont College

Washington
Eastern Washington University
Evergreen State College

West Virginia
Shepherd College

Wisconsin
Madison Area Technical College

Milwaukee Institute of Art & Design
University of Wisconsin, Green Bay

Canada
Conestoga College, Kitchener. Ont.
Fanshawe College, London, Ont.

PRIVATE SCHOOLS

A number of private schools offer three-month, six-month and one-year programs of photography with theory and practice in a technical school atmosphere. Some of these schools also offer correspondence courses.

California
Glen Fishback School of Photography, Sacramento

Florida
Veronica Cass School of Retouching, Hudson

Illinois
American School of Photography, Mundelein

Indiana
Winona School of Professional Photography, Winona Lake

Massachusetts
Hallmark Institute of Photography, Turner Falls
New England School of Photography, Boston

New York
Germain School of Photography
Parsons School of Design
Fashion Institute of Technology
School of Visual Arts

Pennsylvania
Antonelli School of Photography, Philadelphia

Rhode Island
Rhode Island School of Photography, Providence

APPENDIX B

Salaries, Newspaper Photographer Salaries

(Reported by American Newspaper Guild Contracts, January 1990)

Over 150 American newspapers have signed contracts covering reporters and photographers. These contracts provide for the minimums to be paid to staff members after two, four, or five years of service with any of these publications.

The highest paid (minimum) photographers are staff members at *The New York Times* for two years and longer: $1101.30 per week. The lowest paid photographers are with small city publications: $265-$285 per week. Most Guild photographers earn more than $500 per week.

Some representative minimum weekly wages are:

BALTIMORE: Baltimore Sun $826.00

CHICAGO: *Chicago Sun-Times* $918.78

CLEVELAND: *Cleveland Plain Dealer* $795.66

DENVER: *Denver Post* $738.00

NEW YORK CITY: *The New York Times* $1101.30

PITTSBURGH: *Pittsburgh Post-Gazette* $813.00

SEATTLE: *Seattle Times* $720.93

ST. LOUIS: *St. Louis Post-Dispatch* $897.85

Government Photographer Salaries

(Earned in General Schedules)

Nearly 3,000 photographers, employed by such departments as the Federal Aviation Authority, the Department of Agriculture, the National Park Service, and similar agencies, have positions in the salary range covered by GS-5 through GS-12.

The following data was provided by the Department of Labor, Bureau of Labor Statistics, covering salaries effective January 1991:

GS-5 $18,331

GS-6 $20,433

GS-7 $22,705

GS-8 $25,147

GS-9 $27,774

GS-10 $30,588

GS-11 $33,605

GS-12 $40,278

The United States Civil Service Commission classifies photographic occupations under such groups as Aerial, Laboratory, Medical, Motion Picture, Scientific and Technical, Still, Television, Underwater, and General.

Photographers are primarily employed by the Departments of Justice, Transportation, Energy, Environmental Protection, Agriculture, Health and Welfare, Education, and NASA and the Veterans Administration.

Veterans Administration Medical Photographer Salaries

GENERAL SCHEDULE 5 U.S.C. 5332(a)
Rates Within Grade And Waiting Period for Next Increase

STEP	52 Weeks			104 Weeks			156 Weeks				Amt. of Step Incr.
	1	2	3	4	5	6	7	8	9	10	
GS1	$11,015	$11,383	$11,749	$12,114	$12,482	$12,697	$13,058	$13,422	$13,439	$13,776	Varies
2	12,385	12,679	13,090	13,439	13,590	13,990	14,390	14,790	15,190	15,590	Varies
3	13,515	13,966	14,417	14,868	15,319	15,770	16,221	16,672	17,123	17,574	$451
4	15,171	15,677	16,183	16,689	17,195	17,701	18,207	18,713	19,219	19,725	506
5	16,973	17,539	18,105	18,671	19,237	19,803	20,369	20,935	21,501	22,067	566
6	18,919	19,550	20,181	20,812	21,443	22,074	22,705	23,336	23,967	24,598	631
7	21,023	21,724	22,425	23,126	23,827	24,528	25,229	25,930	26,631	27,332	701
8	23,284	24,060	24,836	25,612	26,388	27,164	27,940	28,716	29,492	30,268	776
9	25,717	26,574	27,431	28,288	29,145	30,002	30,859	31,716	32,573	33,430	857
10	28,322	29,266	30,210	31,154	32,098	33,042	33,986	34,930	35,874	36,818	944
11	31,116	32,153	33,190	34,227	35,264	36,301	37,338	38,375	39,412	40,449	1,037
12	37,294	38,537	39,780	41,023	42,266	43,509	44,752	45,995	47,238	48,481	1,243
13	44,348	45,826	47,304	48,782	50,260	51,738	53,216	54,694	56,172	57,650	1,478
14	52,406	54,153	55,900	57,647	59,394	61,141	62,888	64,635	66,382	68,129	1,747
15	61,643	63,698	65,753	67,808	69,863	71,918	73,973	76,028	78,083	80,138	2,055
16	72,298	74,708	77,118	79,528	81,396	82,697	85,060	87,424	89,787		
17	83,032	85,800	88,568	91,336	94,104						
18	97,317										

General Schedule Effective January 13, 1991, Office of Personnel and Labor Relations, Department of Veterans Affairs

APPENDIX C

Special Publications of the Photographic Trades

Audio-Visual Photographers

AUDIO-VISUAL COMMUNICATIONS,445 Broad Hollow Road, Melville, NY 11747
AV-VIDEO, 25550 Hawthorne Blvd., Torrance, CA 90505
PRESENTATION PRODUCTS, 513 Wilshire Blvd., Santa Monica, CA 90401

Bridal, Wedding, Child and Specialty Studios

PROFESSIONAL PHOTOGRAPHER, 1090 Executive Way, Des Plaines, IL 60018
STUDIO, 1090 Executive Way, Des Plaines, IL 60018
TECHNICAL PHOTOGRAPHY, 445 Broad Hollow Road, Melville, NY 11747
PHOTO ELECTRONIC IMAGING, 1090 Executive Way, Des Plaines, IL 60018

Darkroom Professionals

PHOTOGRAPHIC PROCESSING, 45 Broad Hollow Road, Melville, NY 11747

Educators and Technicians

FUNCTIONAL PHOTOGRAPHY, 45 Broad Hollow Road, Melville, NY 11747

Industrial and Commercial Photographers

INDUSTRIAL PHOTOGRAPHY 445 Broad Hollow Road, Melville, NY 11747

Press and Photojournalists

NEWS PHOTOGRAPHER, National Press Photographers Association, School of Journalism, Bowling Green State University,Bowling Green, OH 43402

Retail Clerks and Photo Merchandisers

PHOTOGRAPHIC AND VIDEO TRADE NEWS, 445 Broad Hollow Road, Melville, NY 11747
PHOTO WEEKLY, 1515 Broadway, New York, NY 10036

Video Publications

VIDEOGRAPHY, 2 Park Avenue, New York, NY 10016
VIDEOMAKER, P.O. Box 4591, Chica, CA 95929

Bibliography - Books

Abel, Charles. Photography: Careers and Opportunity for You, Modern Camera Guide Series, Philadelphia, PA: Chilton Co., 1961.

Applied Infra-red Photography. Rochester, NY: Eastman Kodak Company. Publication M-28. 1981.

Assignment Photography (pricing guidelines). American Society of Magazine Photographers, 419 Park Ave. South, NY, NY 10019, 1990

Baker, Alfred A. Field Photography. San Francisco, CA: W.H. Freeman and Company, 1976.

Bennett, Edna. Careers in Photography. New York, NY: Amphoto, 1962.

Bleich, Arthur H. and McCullough, Jerry. The Photojournalist's Guide. Milwaukee, WI: Tech/Data Publications.

Blumenfeld, Milton J. Careers in Photography. Minneapolis, MN: Lerner Publications Co., 1979.

Campbell, Kevin. Make Money with Your Camcorder. Amherst, NY. Amherst Media, 1991

Cavallo, Robert M., and Kahan, Stuart. The Business of Photography. New York: Crown Publishers, 1981.

Chandoha, Walter. How to Photograph Cats, Dogs, and Other Animals. New York: Crown Publishers, Inc., 1973.

Clarke, Robert G. Profits in Aerial Photography. 125 University Avenue, E. Hartford, CT 06108.

Close-Up Photography. Rochester, New York: Eastman Kodak Company. Publication KW-22. 1989.

College Research Group, Concord, MA. The Right College. NY,NY: Arco, 1990.

Collins, Sheldon. How to Photograph Works of Art. Nashville, TN: AASLH Press. 1986.

Copying and Duplicating in Black-and-White and Color. Rochester, NY: Eastman Kodak Company. Publication M-1. 1985.

Corbell, Tony L. The Ultimate Commercial Photographer's Handbook - San Diego, CA: Colbur Publishers, Inc.

Crawford, William. The Keeper's of Light. Morgan and Morgan: NY, NY 1979.

Cribb, Larry. How You Can Make $25,000 a Year with Your Camera (No Matter Where You Live). Writer's Digest Books. Cinncinnati, OH 1990

Dennis, Lisl. How to Take Better Travel Pictures. Tucson, Arizona, HP Books, 1979.

Duckworth, John E. Forensic Photography. Springfield, IL:
 Charles C. Thomas Co. 1983.

Existing Light Photography. Rochester, NY: Eastman Kodak Company.
 Publication KW-17. 1990.

Falk. Photograph Collector's Resource Directory (4th Edition), The Photographic Arts
 Center, New York, NY 1992.

Farber, Robert. The Fashion Photographer. New York: Amphoto, 1981.

Forman, Harrison. How to Make Money in Photography, 2nd edition, New York,NY:
 Amphoto, 1964.

Freeman, Michael. The Complete Book of Wildlife and Nature Photography. New York:
 Amphoto, 1981.

Goddard, Kenneth W. Crime Scene Investigation. Reston, Virginia:
 Reston Publishing Company, 1977.

Gold Mine in the Sky. Plan-A-Flight Publications. Box 7014. Nampa, ID 83651.

Grill, Tom, and Scanlon, Mark. The Essential Darkroom Book. New York:
 Amphoto, 1981.

Guide to 35mm Photography. Rochester, New York: Eastman Kodak Company.
 Publication AC-95. 1989.

Gunn, Rocky. Wedding Photography. Los Angeles CA: Peterson Publishing, 1978

Hammond, Bill How To Make Money in Advertising Photography. New York:
 Amphoto. 1979

Herwig, Ellis Stock Photography: How to Shoot it, How to Sell It. NY:
 Amphoto, 1981.

How to Cash in on the Glamorous Photographic Real Estate Market. Newport House,
 24911 Spadra Lane, Mission Viejo, CA 92611.

Jacobs, Lou, Jr. Amphoto Guide to Selling Photographs. New York,NY:
 Amphoto, 1979.

Kemp, Dr. Jerrold, Planning and Producing A-V Materials. New York: Harper & Row,
 Publishers. 1980

Keppler, Victor. Your Future in Photography. New York, NY:
 Richard Rosen Press, 1965.

Kerns, Robert L. Photojournalism: Photography with a Purpose. Englewood Cliffs, NJ:
 Prentice-Hall, 1980

Kieffer, John N. Guide to Professional Photographing Assisting. New York, NY,
 Allworth Press, 1991.

Kodak Black-and-White Darkroom DATAGUIDE. Rochester, NY: Eastman Kodak
Company. Publication R-20. 1988

Kodak Color Darkroom DATAGUIDE. Rochester, NY: Eastman Kodak Company.
Publication R-19. 1989.

Lewis, Greg. Wedding Photography for Today. New York: Amphoto, 1980.

Liebers, Arthur. You Can Be a Professional Photographer. New York:
Lothrop, Lee & Shephard Books, 1979.

Lovejoy, Clarence E. Lovejoy's Career and Vocational School Guide. New York, NY:
Simon & Schuster, Inc., 1978.

Lyons, Paul Robert. Techniques of Fire Photography. NEPA Fire Protection Assn., 470
Atlantic Ave., Boston, MA 02210.

Nibbelink, Don. The Handbook of Student Photography. New York: Amphoto, 1981.

Perry, Robin Photography for the Professionals. Waterford, Connecticut: Livingston
Press, 1976.

Persky, Robert S. Photographic Art Market Series (Auction Price Guide), The
Photographic Arts Center, New York, NY 1992.

Persky, Robert S. Editor Stock Photo Deskbook (4th Edition), New York, NY: The
Photographic Arts Center, 1992.

Persky, Robert S. The Photographer's Guide to Getting and Having a Successful
Exhibition, Photographic Arts Center, New York, NY 1987.

Photographic Retouching. Rochester, NY: Eastman Kodak Company.
Publication E-97. 1987.

Photographic Studio Management. Rochester, New York: Eastman Kodak Company.
Publication 0-1. 1990.

Photographing Building and Cityscapes. Rochester, NY: Eastman Kodak Company.
Publication LC-10. 1990.

Photographing People. Rochester, NY: Eastman Kodak Company.
Publication AC-132. 1990.

Photographing the Daily Drama of Life. Rochester, NY: Eastman Kodak Company.
Publication LC-9. 1990.

Photography for Law Enforcement. Rochester, New York: Eastman Kodak Company,
Publication M-200. 1990.

Photography from Light Planes and Helicopters. Rochester, NY: Eastman Kodak
Company, Publication M-5. 1985.

Photography with Large-Format Cameras. Rochester, New York: Eastman Kodak
Company. Publication O-18. 1988.

Pinney, Roy. Careers with a Camera. Philadelphia, Pa.: J. B. Lipincott Co., 1964.

Planning and Producing Slide Programs. Rochester, New York: Eastman Kodak Company. Publication S-30. 1990.

Pocket Guide to Photographing Your Cat. Rochester, NY: Eastman Kodak Company. Publication AR-27. 1985.

Pocket Guide to Photographing Your Dog. Rochester, NY: Eastman Kodak Company. Publication AR-28. 1985.

Pocket Guide to Sports Photography. Rochester, NY: Eastman Kodak Company. Publication AR-23. 1984.

Pocket Guide to Travel Photography. Rochester, NY: Eastman Kodak Company. Publication AR-25. 1985.

Professional Photographer's Handbook. Logan Design Group. 6101 Melrose Avenue, Los Angeles, CA 90038.

Professional Photographic Illustration. Rochester, NY: Eastman Kodak Company. Publication O-16. 1989.

Professional Photographic Illustration Techniques. Rochester, NY: Eastman Kodak Company, Publication O-16. 1989.

Professional Portrait Techniques. Rochester, NY: Eastman Kodak Company. Publication O-4. 1987.

Redsicker, David R. The Practical Methodology of Forensic Photography. NY, NY: Elsevier Science Publishing Co. 1991.

Reilly, James M. Care and Identification of 19th Century Photographs. Rochester, NY: Eastman Kodak Company. Publication G-2S. 1986.

Rennert, Amy. Making It in Photography. New York, NY: G. P. Putnam's Sons,1980.

Retouching from Start to Finish. VC Photo Art Supplies, 3779 New Jersey Ave., Hudson, FL 33568.

Rothstein, Arthur. Photojournalism. New York: Amphoto, 1979.

Salomon, Allyn. Child Photography. New York: Amphoto, 1981.

Scientific Imaging Products. Rochester, New York: Eastman Kodak Company. Publication L-10. 1989.

Stockwell, John, and Holtje, Bert. The Photographer's Business Handbook. New York,NY: McGraw-Hill Book Co., 1980.

Understanding Electronic Photography. Summit PA: TAB Books.

Witkin, Lee D., and London, Barbara. The Photographer Collector's Guide. New York: New York Graphic Society, 1981.

Bibliography - Periodicals

A-V Video (magazine), 25550 Hawthorne Blvd Torrance, CA 90505.

Architectural Digest (magazine), 5900 Wilshire Blvd., Los Angeles, CA 90036.

Audio-Visual Communications (magazine), 445 Broad Hollow Road Melville, NY 11747.

Audubon (magazine), 950 Third Ave. New York NY 10022.

Camera and Darkroom Photography (magazine), 9171 Wilshire Blvd. Los Angeles, CA 90210.

Darkroom Techniques (magazine), 7800 Merrimac Ave. Niles, IL 60648.

Display and Design Ideas (magazine), 180 Allen Rd. NE Suite 300 N. Bldg. Atlanta, GA 30328.

Industrial Photography (magazine), 445 Broad Hollow Road. Melville, NY 11747

Industrial Photography (magazine), 445 Broad Hollow Road Melville, NY 11747.

Law Enforcement Photography (magazine), 445 Broad Hollow Road, Melville, NY 11747.

Linked Ring Letter (newsletter), The Photographic Arts Center, 163 Amsterdam Ave., New York, NY 10023.

Photo Electronic Imaging (magazine), 1090 Executive Way. Des Plaines,IL 60018.

Photo District News (magazine), 49 East 21 Street. New York, NY 10010.

Photo Weekly (magazine), 1515 Broadway, New York, NY 10036.

Photograph and Video Trade News (magazine), 445 Broad Hollow Road, Melville, NY 11747.

Presentation Products (magazine), 513 Wilshire Blvd. Santa Monica, CA 90401.

Professional Photographer (magazine), 1090 Executive Way. Des Plaines, IL 60018.

Studio (magazine), 1090 Executive Way, Des Plaines, IL 60018

The Guilfoyle Report (for nature photographers.) AG Editions, Box D, 142 Bank St., NY, NY 10014.

The Photograph Collector (Newsletter) The Photographic Arts Center, 163 Amsterdam Ave., New York, NY 10023.

Videomaker (magazine), P.O. Box 4591, Chica CA 95927

INDEX

DATE DUE